AVANT-GARDE IN THE EIGHTIES

Exhibition organized by Howard N. Fox
with the assistance of Carol S. Eliel

AVANT-

GARDE

IN THE EIGHTIES

Howard N. Fox

Los Angeles County Museum of Art

Published on the occasion of the exhibition
held at Los Angeles County Museum of Art
23 April–12 July 1987

Published by
Los Angeles County Museum of Art
5905 Wilshire Boulevard
Los Angeles, California 90036

This exhibition is supported in part by a
grant from the California Arts Council.

Library of Congress Cataloging-in-Publication Data

Fox, Howard N.
Avant-garde in the eighties.

Book accompanies exhibition of same title opening
in Los Angeles County Museum of Art in April, 1987.
Includes bibliographies.
1. Art, Modern–20th century–Exhibitions.
2. Avant-garde (Aesthetics)–History–20th century–
Exhibitions. I. Los Angeles County Museum of Art.
II. Title.
N6487.L67L675 1987 709'.048'074019494 86-34272
ISBN 0-87587-138-0

●

Contents

6

Foreword
Earl A. Powell III

7

Acknowledgments

9

Introduction

27

Catalogue of the Exhibition

29

Originality and Source

66

Community, Shared Values, and Culture

96

The Limits of Art

145

Artists' Exhibitions and Bibliographies

182

Lenders to the Exhibition

184

Index of Artists

On 23 November 1986 the Los Angeles County Museum of Art opened the Robert O. Anderson Building dedicated to modern and contemporary art. That event was inaugurated with the first display in many years of a vast cross section of the museum's permanent collection of twentieth-century art and a major special exhibition, *The Spiritual in Art: Abstract Painting 1890–1985*, which explored the history of abstract art from a new point of view. Now the opening year celebration for the Robert O. Anderson Building continues with *Avant-Garde in the Eighties*. This exhibition, planned with perception and enthusiasm by Curator of Contemporary Art Howard N. Fox, is the most inclusive exhibition of contemporary art ever organized by the Los Angeles County Museum of Art.

Focusing on what has emerged as a key, often controversial, issue of today's art — whether in fact there is an avant-garde in the 1980s — *Avant-Garde in the Eighties* brings together an exciting and provocative array of some of the most challenging advanced art being produced internationally today. The exhibition reveals that not only do the spirit and function of the avant-garde persist in contemporary art but also that certain fundamental issues identified with the very program of the modernist avant-garde — namely, the concept of originality, the question of the artist's relation to society and the larger culture, and the exploration of the limits of art — remain essential issues for many of today's most advanced artists. While pursuing these areas of traditional avant-garde concern, contemporary artists have formulated uniquely contemporary responses to them, giving new life and new definition to the term *avant-garde*.

It is the aim of *Avant-Garde in the Eighties* to suggest the context in which contemporary art may be understood to operate and to reveal something of the breadth of territory and response of vanguard art in the 1980s. The organization of the exhibition, as well as this publication, in three groups is not intended to imply separate categories of art but is a means to explore several related areas of special concern to many contemporary artists. If the strong interpretive basis of this exhibition stirs a consideration of the roots of contemporary art and its relation to the art of the modern period generally, then it will have succeeded in its aspiration to advance a point of view. This is an aspiration that has always motivated the finest historical exhibitions of twentieth-century art organized by the Los Angeles County Museum of Art, and this interpretive mission will continue to inspire the many modern and contemporary exhibitions being planned for the future.

Earl A. Powell III
Director
Los Angeles County Museum of Art

My first thanks go to Director Earl A. Powell III and the Board of Trustees for their complete and early support of this project. I have sincerely appreciated their ongoing interest and confidence.

A generous grant from the California Arts Council, a state agency, has enabled, in part, the realization of numerous new works created specially for this presentation; on behalf of the museum I thank the council. Additional support of the exhibition's educational programs has been provided by the Haddad Foundation.

Throughout every phase of the production of this exhibition I have depended upon Assistant Curator Carol S. Eliel's constant vigilance to details, her organizational instincts, and her many insightful judgments, which have contributed inestimably to both the development of this undertaking and my comprehension of it. I thank her warmly.

We were supported in our research, particularly on the artists' exhibitions and bibliographies, by the tenacious sleuthing and dedication of volunteers Roz Leader, who adroitly served as team captain, and Debbe Goldstein, whose knowledge of the art world and its cast of thousands served as a source of ready reference. Their participation was made possible by special arrangement with the Museum Service Council. Museum interns Jenny Anger and Linda Samuels also aided our research. We are indeed grateful to all for enriching this publication.

Special thanks go to my secretary, Lisa E. Kahn, who kept my desk and my mind in order during this project. I appreciate her good work and her good cheer. Richard Morris and Lynn Brylski of the Twentieth-Century Art Department shared the burden, and I thank them too.

The skills of many professionals throughout the museum were instrumental in the complex production of this exhibition. With confident resourcefulness, Assistant to the Director Elizabeth Huntley and Coordinator of Exhibitions John Passi oversaw, respectively, all aspects of budgeting and scheduling. Assistant Registrar Anita Feldman coordinated the shipping of the many works of art to and from the museum. Photographer Jeff Conley attended to photographic services. Project Manager Carol Scott Robinson coordinated among the departments involved in the exhibition's physical production. The able crew of the Technical Services Department, under the leadership of James Kenion, installed the works in the galleries according to consultant Bernard Kester's handsome design. Sheila Prendiville and the museum's Press Office, under the leadership of Pamela Jenkinson, initiated and coordinated the publicity. Assistant Educator Christine Dyer had the job of explaining the exhibition to museum viewers.

Very special acknowledgement indeed is more than due to members of the Department of Publications and Graphic Design. With customary expertise and flair, editor Edward Weisberger and designer Kiran RajBhandary produced this volume within an uncustomarily shortened lead time. I more than anyone am in a position to appreciate and extoll their individual and collective efforts, and I do.

Finally, the talents and efforts of the many individuals who helped put this exhibition together could not have come to fruition without the lenders and, most of all, the artists. It is with a mixture of pride and gratitude that I thank them for truly making this exhibition possible.

Howard N. Fox

The history of modern art is the history of its avant-garde. Of all the revolutionary inventions of modern art — embracing a range of styles and movements as diverse as French cubism, Italian futurism, Russian constructivism, German expressionism, American abstract expressionism, and a myriad of other aesthetics — there was perhaps none so revolutionary as the phenomenon of the avant-garde itself. A purely modern invention, the avant-garde was inspired by an ideal of deliberate progress in art: engineered change motivated by a drive for aesthetic originality, willful independence, and formal experimentation. The struggle for a new intellectual, ideological, and spiritual experience of the world was contained within the avant-garde and its program of change. Modern art is simply inconceivable minus the restless, worldly spirit of the avant-garde; this spirit was the generative force of modernism, its panorama of artistic styles, and its brave new theories.

Change itself is hardly unique to modernism. The emergence of new sensibilities, shifts in fashion and style, and the dynamics of influences on traditions and conventions are the very substance of art history. But avant-gardism conceived itself as something more than new stylistic fashions or historical shifts. The avant-garde acknowledged not only the creation of new art but also the rebellious affirmation of artistic genius and the missionary zeal with which that creativity was undertaken. Indeed the avant-garde strived for a militant and definitive break with the legacy of the past and the conventions of the present. Reacting to overwhelming social, political, and technological changes in the daily life of Western civilization, early modern artists reconceived their role, not as artists traditionally had — reflecting the values of an established culture predicated upon a continuity with the past — but as agents of a new culture that would forever look toward the future.

As the twenty-first century approaches there is widespread recognition that the authority of modernism, whose roots are in the nineteenth century, and its avant-garde ideas about art and art's function in human experience are themselves things of the past. Modernism has fulfilled its mission and is giving way. Whatever may be replacing it is a common concern with no clear answer, but the nascent stages of a new epoch of artistic activity and advanced critical thinking — as different in orientation from modernism as modernism was from what preceded it — can be discerned. Never in history has there been so much artistic activity, so much discussion of it, or such demand by its vast audience for more. Today artists and critics, institutional and private collectors, and visitors to galleries and museums are participants in the most cosmopolitan art community possible, in which any local development may become an international phenomenon and all developments on the international horizon may have local impact anywhere. The deliberate progress of art is proceeding vigorously in one of the most challenging, diverse, and fast-paced periods in the history of art.

Contemporary artists, having assimilated the broadest principles and programs of modernism, have evolved a new definition of what it means to be avant-garde in a postmodern age. Advanced artists of the 1980s are particularly preoccupied with several closely related though distinct concepts that were in fact identified by the avant-garde as the key concerns of the truly modern artist: the notion of originality and the ways it is expressed in art; the political mission of the avant-garde and the relationship of the artist to society; and the modernist inquiry into the nature and limits of art itself. However, contemporary responses to them are often very different from anything that could rightly be called modernist.

Many believe such responses constitute a deep shift to an exalted postmodern position that is very much aware of modernist principles but addresses its own

artistic and cultural issues through new art forms. This would be the logical expectation about a transitional period such as the present. Others, however, are persuaded that art is sliding into a dismal philistinism unworthy of the heroic struggles of modernism. For these dissenters it has seemed that the avant-garde position, to challenge and provoke, has been corrupted by an omnivorous audience too eager for novelty and by artists all too willing to give it to them, that today's postmodern artistic culture represents, as Hilton Kramer has described it, "a betrayal of the high purposes and moral grandeur of modernism."[1]

This suspicion, that the lofty ambitions of the avant-garde have been diluted or destroyed, has been around for a while and is hardly news. "Everyone knows," exclaimed Harold Rosenberg as early as the 1950s, "that the label Modern Art no longer has any relation to the words that compose it. To be Modern Art a work need not be either modern nor art; it need not even be a work."[2] Rosenberg went on to diagnose this cultural malady, indicting the entire art scene for pandering to the amusement of a mass audience for whom the thrill, even the illusion, of novelty was gratification enough:

> *Through Modern Art the expanding caste of professional enlighteners of the masses — designers, architects, decorators, fashion people, exhibition directors — informs the populace that a supreme Value has emerged in our time, the Value of the NEW, and that there are persons and things that embody that Value.... Modern Art does not have to be actually new; it only has to be new to somebody.*[3]

By the early 1960s, during the heyday of pop art, Rosenberg intimated the final collapse of the avant-garde, whose classic function as the antagonist of conventional culture was being compromised and depleted by a too-conjugal relationship with its audience:

> *The evolution of the Vanguard Audience, its values, its psychology, the depth and tempo of its enthusiasms, is the major phenomenon that art will have to deal with in the decades before us. This audience will — indeed, it has already begun to do so — give birth to its own species of artist happy to reflect and at times make mockery of its mental processes....*
>
> *At present therefore the trend is toward an art that accommodates itself to a prepared taste, that is to say, a trend toward an elevated commercial art, such as currently dominates architecture, fiction, the art film.*[4]

Such sentiments as Rosenberg's, that the avant-garde is in deep trouble, have become prevalent in the 1980s. A bevy of contemporary critics has trained its attention on the question of the existence of a contemporary avant-garde. Robert Hughes, for example, identified the problem as one of relationship of art to the rest of human endeavor, and he reflected on the remoteness of avant-gardism to the milieu of contemporary art:

> *Vanguard art seems to have lost its "political" role. At the same time, although we still have lots of art — a stream of it, feeding an apparently insatiable market, and providing endless opportunities for argument, exegesis, and comparison — painting and sculpture have ceased to act with the urgency that was once part of the modernist contract. They change, but their changing no longer seems as important as it did in 1900, or 1930, or even 1960. When one speaks of the end of modernism — and it is no longer possible to avoid doing so, for the idea that we are in a "post-modernist" culture has been a commonplace since the mid-seventies — one does not make a sudden historical terminus.... But its [modernism's] dynamic is gone, and our relationship to it is becoming archaeological.*[5]

Like Rosenberg, Hughes traced the dissipation of the avant-garde to a dynamic of incest between artist/

producers and audience/consumers: "The problem is not merely that the upper middle class's voracious enthusiasm for art of almost any kind 'coincides' with the inflation of minor talents into major ones, of mere promise into claims of art history. It is that the one has produced the other."[6]

Suzi Gablik echoed these familiar conclusions, but from a patently Marxist approach, in a book bearing the important title, *Has Modernism Failed?*:

> *By now it must be clear that one of the ways in which the adversary culture of modernism has failed was through surrendering its inner independence to the pressures of external, bureaucratic power. The growing dependence on a market-intensive, professionally manipulated art world has resulted in artists losing their power to act autonomously and live creatively. This particular change happened without being instigated. It was nondeliberate. It happened because late capitalism, with its mass-consumption ethic, weakened the capability of art for transmitting patterns of conscious ethical value. And, as we have seen, this was so because often the very same artists who opposed capitalist ideology in their art were not really resistant to it; at the level of personal intention, they had a double standard, and were in complicity. They were unwilling to put their own career interests at stake in the service of convictions they were ready to accept in their art. Whether or not this process can be reversed will depend on what we all now think of the hopes and ideals with which the modern era began — and whether we believe that art is related to a moral order, or that its function is purely an aesthetic one.*[7]

Although Gablik's economic interpretation is debatable, her identification of the moral problems confronting artists and their audiences today is apt and saliently put. But it may well be that, while the topical issues and the struggles of the classic avant-garde may no longer directly address contemporary concerns, the function of the avant-garde — deliberately expanding culture that reflects an awareness of the deepest concerns facing contemporary existence — is still served. It may be that contemporary artists are indeed engaged in creating an art that is related to a moral order, as were their predecessors, and that, in true avant-garde fashion, contemporary art is inspired, not by outdated modernist criteria and well-learned lessons, but by contemporary conditions and creative response.

What were those modern ideals that are said now to be lost, and how, if at all, has their promulgation through the avant-garde been compromised in recent art? It should be emphasized that the *principles* of modernism form an identifiable body of aesthetic critique — a critique embodying certain revolutionary ideas and ideals about art and its purpose — which in their purity and stridency of expression exist virtually separate from the *artifacts* of modernism. It is only by considering these key modernist principles and how they were advanced by the avant-garde that a vision of contemporary thought about art and avant-gardism is possible.

The first impulse of the avant-garde and the principal desire of modernism was to create the world anew. This motivation, this urge to rediscover the origins of art and of creative life, separated the modern artist from artists of every other epoch in Western civilization. Since ancient times the role of the artist in Western tradition had always been to sustain religious beliefs, perpetuate ethical values, maintain a historical continuity of the culture with its past, and further the artistic traditions of that culture. Modern artists, facing a world that seemed in every sphere of life to be alien to any that Western man had ever known, found the very concept of such a preservationist role of the artist to be flawed and contrary to certain revolutionary ideas of the function of art in a modern world.

For the modern artist it was essential not only to break with the fashions and conventions of the past but also to deny the authority of artistic tradition itself and,

beyond that, to seek the origins of art and art's very reason for existing as a basic human activity — in short, to discover art anew as if for the first time in the history of human experience. The impulse toward origination was a basic criterion of the avant-garde. As Rosalind Krauss observed:

> More than a rejection or dissolution of the past, avant-garde originality is conceived as a literal origin, a beginning from ground zero, a birth. [Italian futurist Filippo] Marinetti, thrown from his automobile one evening in 1909 into a factory ditch filled with water, emerges as if from amniotic fluid to be born — without ancestors — a futurist. This parable of absolute self-creation that begins the first Futurist Manifesto functions as a model for what is meant by originality among the early twentieth-century avant-garde.[8]

For Italian futurism — indeed for all revolutionary modernism — the past and its continued presence in the imagination of the Western mind were no longer perceived as the foundation upon which to build but the ruins to be cleared away. It was natural that the cultural shocks that precipitated the modern age were reflected in the arts, and it was necessary, if the arts were to remain a vital part of new civilization, that new and modern art forms be created. The essential attribute of the modernist temper was a disbelief in the past: the most forward-looking artists set themselves the task of creating a new, deliberately modern art. In this was the upsurge of the avant-garde.

The outcry for a new art was heard everywhere. In Italy the futurists, probably the most rabidly aggressive and rhetorically boisterous of all avant-garde groups, called for nothing less than the eradication of the past from modern life: "We stand on the last promontory at the end of centuries! . . . Why should we look back, when our desire is to break down the mysterious doors of the Impossible?" demanded Marinetti in his first futurist manifesto.[9] Marinetti perceived the artist as

being in gladiatorial combat against the memory and tyranny of the past. "We will destroy the museums, libraries, academies of every kind,"[10] he declared, promising an apocalyptic overthrow of the old by the new:

> It is from Italy that we are launching throughout the world this manifesto charged with overwhelming incendiary violence. We are founding Futurism here today because we want to free this land from its foul gangrene of professors, archaeologists, guides and antiquarians. . . .
>
> The beauties of the past may console invalids, prisoners and dying men, since the future is barred to them — but we want no part of it, we who are young and strong Futurists!
>
> So let them come, the gay incendiaries with charred fingers! Here they are! Here they are! . . . Come on! Set fire to the library shelves! Turn aside the canals to flood the museums! . . . Oh, the joy of seeing the glorious old canvases bobbing adrift on those waters, discolored and shredded! . . . Take up your picks, your axes and hammers and wreck, wreck the venerable cities, pitilessly![11]

Two thousand miles away in Saint Petersburg, czarist Russia's window to the West, such artists as the revolutionary painter Olga Rozanova also were struggling to escape the stranglehold of a dead past and a decadent present:

> Only the absence of honesty and of true love of art provides some artists with the effrontery to live on stale tins of artistic economics stocked up for years, and year in, year out, until they are fifty, to mutter about what they had first started to talk about when they were twenty. . . . There is nothing more terrible than this immutability when it is not the imprint of the elemental force of individuality, but merely the tested guarantee of a steady market! . . . Contempt should be cast on those who hold dear only peaceful sleep and relapses into past experiences.[12]

The spirit of renewal and individual genius, of the determined quest for authenticity in art, was the spirit of the avant-garde. Only through the reinvention of art could there be a reinvention of mankind, which was the true goal of the avant-garde. Even the contemplative André Salmon, an apologist for cubism, called for nothing less than a new artistic order to redeem the modern age: "Is not the salvation of the soul on earth to be found in a completely new art?"[13] For modern artists of every persuasion the answer was yes.

This breakaway, secessionist spirit was pervasive in the early avant-garde, and it had every bit as much to do with the discerning of new principles of artistic creation as it did with a rejection of moribund traditions and banal models. Once again the futurist program testified to the avant-garde spirit of reformation: "Far from resting upon the examples of the Greeks and Old Masters, we constantly extol individual intuition; our object is to determine completely new laws which may deliver painting from the wavering uncertainty in which it lingers."[14] Indeed individual intuition and new laws were the consummate attributes of the modernist ideal of originality.

Until the Enlightenment the basic ontological assumption of the Western world — the premise of Western religion, philosophy, and science — was the existence of a metaphysical realm of ideas, spirits, or laws that precedes and supersedes the physical realm. This was a hierarchical vision of the universe, in which the pursuit of all knowledge, whether it studied the metaphysical realm or the physical one, was understood to function within, and was directed toward the revelation of, that higher natural law that governed the behavior of mere matter and the affairs of mortals in the transient, mutable, physical world.

Certainly since the midnineteenth century every significant inquiry into natural law has tended to undermine the hierarchical organization of knowledge that prevailed throughout the prior history of Western thought. The empirical or scientific method of investigation, based on direct observation of things and phenomena that can be verified by experimentation and test, brought about a reorientation of philosophical inquiry, and this reorientation, this looking inward and at things rather than beyond them, reached its apotheosis in the modern period. If premodern thought stressed the ends of phenomena and things — the divine purpose and destiny of creation — then modern thought represented an objective investigation of the means of phenomena and things: what they are in and of themselves, how they can be identified. Modern thought was a search for origins, not for destinies.

Modern thought sought to understand the elements of the material world and only secondarily its presumed superstructure. Examining animate life as a field to be studied in its own right, Charles Darwin, for example, sought to learn the origin of species, theorizing that the origin of each life form is to be found in a more elementary life form; Karl Marx sought to explain the social and political history of the world as a process of class struggle, proposing revolution as the necessary factor in the creation of a nonhierarchical social order of universal equality; in his psychoanalytical theories Sigmund Freud formulated a concept of human psychology as an unremitting conflict between an elemental life force and civilization; Carl Gustav Jung's concept of the psyche was based on the idea of a subconscious that is shared by all members of the species.

Such modern thought was characteristically preoccupied with the analysis of the elements, actualities, and specifics upon which larger systems might be synthesized. In this philosophical climate, conditioned by a changing perception of artistic tradition, it was viable to conceive of the basis of art as the elements of composition: for example, a line or a circle. Paul Cézanne said it concisely: "Treat nature by the cylinder, the sphere, the cone,"[15] that is, by the elements of geome-

try and physical form. Cézanne, whose art and ideas served a generation of followers, prescribed a distinctly modernist aspiration toward objective truth, cleaving it from value judgment and fanciful literary interpretations: "[The artist] must beware of the literary spirit which so often causes painting to deviate from its true path — the concrete study of nature — to lose itself all too long in intangible speculations."[16] In his thinking, as in his painting, Cézanne reflects a carefully honed materialism and a belief in the supremacy of actuality over conjecture.

"Intangible speculations" might well describe the Theosophy of Piet Mondrian, whose entirely nonobjective abstractions and spiritual intentions could hardly have been further from Cézanne's materialism and belief in the supremacy of fact. And yet the modernism of Mondrian sounds palpably like that of Cézanne in seeking the abstract organization underlying natural reality:

> *The new plastic idea cannot . . . take the form of a natural or concrete representation, although the latter does always indicate the universal to a degree, or at least conceals it within. This new plastic idea will ignore the particulars of appearance, that is to say, natural form and color. On the contrary, it should find its expression in the abstraction of form and color, that is to say, in the straight line and the clearly defined primary color. . . . The new plastic idea thus correctly represents actual aesthetic relationships.*[17]

Mondrian went on to observe that "in nature all relations are dominated by a single primordial relation, which is defined by the opposition of two extremes. Abstract plasticism represents this primordial relation in a precise manner by means of the two positions which form the right angle."[18] He concluded that in such abstract art, "We shall see a reconciliation of the matter-mind dualism."[19]

What is significant in comparing Cézanne and Mondrian is, not their coincidental talk of spheres and cones and straight lines and right angles, but their mutual quest for a primordial unity that transcends cultures and traditions — a principle of origination for all things in the universe — capable of being rendered, not in parables, symbols, or fanciful representations of an invisible world, but in the presentation of actual relationships between actual forms. This was the essence of modernist sensibility, and such ideas are constant throughout the avant-garde.

In the modernist outlook natural order was found to inhere within things, not to be imposed systemically on them from without. In fact any twentieth-century system that sought a natural order outside of or beyond the actual object was, by definition, not modern, or modernist. The impulse to look inside at the nature of things, to dissect and thereby to understand, was characteristic of the most modern of the methodologies of the avant-garde. "A man like Picasso studies an object as a surgeon dissects a cadaver," explained Guillaume Apollinaire.[20]

"We have to start from the central nucleus of the object that we want to create," declared Umberto Boccioni, "in order to discover the new laws."[21] These new laws of art were based, not on traditional application of styles, conventions, and techniques, but on knowledge of the inherent properties of materials — the exploration of purely visual forms — as well as the capacity of each artist to create with them.

The new laws professed by the avant-garde, those principles of origination that were uniquely and emphatically modern, were applied to such elements of art as style, form, and material, as distinct from subject matter, which was now understood to be extraneous and imposed on such elements in order to satisfy nonart agendas. Subject matter, by its very recourse to the preexisting world outside of the art object, tended to despoil or undercut the originality of the object, and an art form that could shed civilization's excess baggage

of intelligible subject matter — while sustaining the visual originality of the object — would fulfill the modern aspiration for a new artistic order. Thus the avant-garde "invented" abstract art, primitive art, machine art, and other seemingly incomprehensible forms that skirted and often confounded the inherited traditions of Western art.

Early abstract painting tended to be rooted in representation, such as Cézanne's architectonic studies of nature or early cubist still lifes. Often as not the subject matter that persisted was chosen for its basic neutrality, as a vehicle for formal and stylistic innovation, for the "study of pictorial form and the space it engenders," as described by Albert Gleizes and Jean Metzinger, two of cubism's early practitioners and main theorists.[22] Apollinaire observed of the early cubists, "Theirs is an entirely new plastic art. It is still in its beginnings, and is not yet as abstract as it would like to be."[23] For the fact remained that "real resemblance [to external nature] no longer has any importance, since everything is sacrificed by the artist to truth, to the necessities of a higher nature whose existence he assumes, but does not lay bare. The subject has little or no importance any more."[24]

"Higher nature" was suggested in daring formal and stylistic innovations, which were incomprehensible by any traditional criteria of fine art. They became the substance of the artist's genius — the personal originality the artist instilled in the object — and the reflection of artistic virtuosity. There was perhaps no virtue more highly valorized in modern art, whatever its style, than originality of style itself. Individual genius had always been valued in the arts, but in the modernist vision individual genius came to signify much more than virtuoso talent. It became more closely associated with supreme creativity and the most exalted states of human consciousness.

The history of modernism sometimes reads like a hagiography of artists who attained aesthetic sainthood by the invention of an autographic style that brought forth an art of origins while at the same time revealing the artist's own originality and distinctive talents. The artist's revolutionary mission was to re-form the world by making the audience see it in a new way: as Apollinaire remarked of Picasso, "The great revolution of the arts, which he achieved almost unaided, was to make the world his new representation of it."[25] The potency of art is described as nearly divine in its ability to reoriginate the world. This reorigination, especially as applied to abstract art, was the product of stylistic and formal innovation based on the new investigation of pictorial space and volumes.

The attainment of a signature style, a unique style, was an accomplishment elevated to heroic status by the modern avant-garde. An artist might labor a lifetime to attain that apotheosis. Jackson Pollock's lifelong struggle to find his style of flinging and dripping paint in the arena of his canvas has the status of a virtual myth in histories of modern art. He labored for years without recognition and in near poverty and in a breakthrough finally realized his style. Pollock took the possibilities of his stylistic attainment to its limits, creating a succession of masterworks, and when he was all but canonized by critics and media and perhaps could take his style no further, he died one night, some suspect willfully, by crashing his car into a tree. This mythology is simple and facile: artistic originality is equivalent to artistic life, and perpetual originality is equivalent to artistic immortality. Thus Picasso is revered not just as a major figure, as Pollock is, but as a titan; for Picasso attained, not one original style through his long lifetime, but many original styles, and he is fabled as a virtuoso at all of them.

In retrospect, with so many truly original visions comprising the modern period, the exalted value placed on originality itself can only be questioned. For, from the contemporary vantage point, it appears that the history of modern art, with its plurality of styles and

isms, demonstrates, not the absolute necessity or rightness of any particular style or original statement, but the equivocal nature of all styles generally and the relative merits of particular styles. With each new style seeming to throw some previous one into a state of eclipse, there is historically a numbing effect. In the 1980s style is but another aesthetic option available to the protean imagination of the artist, not at all the apotheosis of artistic genius.

Pat Steir's *The Brueghel Series (A Vanitas of Style) Polychrome*, 1982–84 (cat. no. 1), is exemplary in this regard. A vast work loosely reproducing the image of Jan Brueghel the Elder's still-life painting *Flowers in a Blue Vase*, 1599, and consisting of sixty-four panels each painted in the manner of a different historical style, ranging from Sandro Botticelli's Renaissance classicism to Max Beckmann's German expressionism to Georg Baselitz's neo-expressionism, with scores of other styles along the way, Steir's opus is a virtual encyclopedia of painterly possibilities. Such a work would have been inconceivable and incomprehensible to Marinetti (whose futurist style, amusingly, is also appropriated by Steir) and to any other modernist who struggled to liberate painting from the tyranny of the past or to elevate individual genius to a position of supremacy. In fact her attitudes about the past, about art, and about being an artist are the virtual inversion of all that Marinetti and the avant-garde professed about originality. Steir has reflected:

> *To paint in the style of someone is to be a kind of transvestite, to love so much that one must endeavor to actually be the loved (or hated) object, to embrace, to devour. Where are the edges? To act as, to be as, the other; to feel the feelings of the other; to see as the other saw; to imitate, to emulate, to understand; to be the other, to act as the other might have originally acted; to see through the eyes of another, of many others; not to copy a particular picture, but to see anything as the other would see it. . . .*

> *I have discovered that all styles, all manner of painting, all acts, all sights, through my eyes and my hand are mine as well as the others': that regardless of the stylistic grid that any period agrees upon, the essential differences between one painter and another are similar to the differences between handwritings. . . .*

> *I feel there is really very little difference between the stylistic modes of art historical periods — that hints of all are evident in all and it's all the same thing — painting.*[26]

Steir's work is more than an homage to the many artists whose styles she admiringly emulates; as the work's subtitle, *A Vanitas of Style*, suggests, there is a certain vanity, a benign futilty, about the notion of originality and individual genius in the context of history. Steir questions the possibility of perpetual originality and "authentic" visual experience in this tour de force of postmodern sensibility.

The exploration of such problems is shared by many artists in the contemporary avant-garde. Sherrie Levine, for example, has consistently raised issues of originality, authorship, and authenticity through her art. In the early 1980s her work consisted of photographs of reproductions — copies of copies — of well-known paintings by modern masters. More recently her work has taken the form of striped paintings, whose forms are dictated by geometry, and a series of "knot paintings," whose forms are dictated by chance, in which paint is applied to the elliptical knots on standard plywood panels. Apparently abandoning claims to stylistic originality, Levine explores her relationship as an artist to the past, her work's relationship to the history of modern art, and the viewer's relationship to both. She has commented, "I feel my pieces are most successful when they function as membranes permeable from both sides so that there is an easy flow between an imaginary past and an imaginary future, between my future and yours."[27] There is a significant

postmodern metaphor in Levine's concept of the art object as membrane. Rather than regard the object as a discrete, autonomous entity with its own unique properties and specific origins, that is, as a *modern* object, Levine presumes that her work "only has meaning in relationship to everyone else's project. It has no meaning in isolation."[28] If the modern art object was intended to be an absolute statement, the postmodern object engages in a dialogue.

Most contemporary artists recognize that the larger culture comes with the territory. For them there simply is no escape, and no special value associated with escaping, from the culture surrounding art. In this they are at odds with the modernist avant-garde. Indeed by the 1980s visual communication has expanded dramatically beyond the confinements of modernist orthodoxies. No longer is the modernist notion of the autonomous object seen as the liberating and transcending ideal that it had been for the avant-garde. Today that aspiration seems unnecessarily delimiting, even destructive, to the possibilities of visual expression. Whereas pioneer moderns such as Kazimir Malevich called for "the supremacy of pure feeling in creative art"[29] and strived for an art that surpassed an awareness of the world external to the object, many contemporary artists wish to restore a sense of the object's continuity with the world. For many of them there is a hidden danger in the supremacy of pure feeling, which may be said to undermine certain ethical values of art by putting individual sensate experience in opposition to shared cultural experience.

Aristotle — whose teachings virtually form the basis of Western civilization's perception of art and its function in human experience — described the tandem purposes of art as delighting the senses and instructing the intellect, particularly with respect to ethics and morality. Unlike his mentor, Plato — who believed that art obscured ideal truth or the world of pure concept — Aristotle saw in art a means to the revelation of abso-lute truth. According to this Neoplatonic concept, art functions through its combined capacity to arouse both the senses and the intellect and thereby to impress truth upon the receptive soul. From classical antiquity to the twentieth century, art was presumed to serve the intellect and the teachings of the culture. Only in the modern age did it become viable to propose a purely sensate experience of art as the purest and most exalted mode of visual experience. This idea is echoed over and over in the history of modernism and is one of its cardinal precepts.

From its inception modern art was integrally bound to the exploration, almost the clinical study, of visual experience. In fact the protomodern experiments of impressionism, depicting nature as so many blurs and smears of color, were explorations of visual perception. Those sumptuous dabs of rich-hued paint were simulations not of discrete objects and physical conditions in the world external to art but rather of the human perception of that external world. For all its mannered stylization the most radical aspect of impressionism was that it replaced art's traditional referencing to the world external to the object with a preoccupation with visual perception and its stimuli within the object.

Despite such explanations as Gleizes and Metzinger's that "the only difference between the Impressionists and ourselves is a difference of intensity, and we do not wish it to be otherwise,"[30] apologists like Apollinaire knew better: "The secret aim of the young painters of the extremist schools is to produce pure painting. Theirs is an entirely new plastic art."[31] Apollinaire predicted the general thrust that became the basic defining attribute of modernist art:

> Generally speaking, modern art repudiates most of the techniques of pleasing [the eye] devised by the great artists of the past.
>
> While the goal of painting is today, as always, the pleasure of the eye, the art-lover is henceforth asked

to expect delights other than those which looking at natural objects can easily provide.

Thus we are moving towards an entirely new art which will stand, with respect to painting as envisaged heretofore, as music stands to literature.

It will be pure painting, just as music is pure literature.[32]

Apollinaire's identification of pure painting as the key issue in modern art was historically correct; no other concept in modern art has exerted the same force nor sustained such enduring critical dialogue as the ideal of an art governed by its own laws and separate from the representations and subjects of traditional art. And the identification of pure art with art that is fundamentally sensate — art intended to be experienced fundamentally by the senses and not by the intellect — was a major element of modernism. The classic avant-garde was anti-intellectual, questing for forms — pure geometries, revolutionary systems of composition, explorations of the emotive power of colors, models in primitive art — that bypassed, denied, or refuted intellectual access to the work. Even the intellection in Marcel Duchamp's dadaist absurdities was essentially anti-intellectual, calculated to confound logic, learning, and plausibility.

Robert Delaunay, whose compositions of pure color Apollinaire called "orphism," explained this modernist elevation of sensate response: "Our understanding is *correlative* to our *perception*." He implored, "*Let us attempt to see.*"[33] The futurists declared that "there can be no modern painting without the starting point of an absolutely modern sensation, and none can contradict us when we state that *painting* and *sensation* are two inseparable words."[34] In the interest of cultivating sensate response, the futurists iterated the anti-intellectualism of the avant-garde: "The public must also be convinced that in order to understand aesthetic sensations to which one is not accustomed, it is necessary to forget entirely one's intellectual culture, not

in order to *assimilate* the work of art, but to *deliver one's self up* to it heart and soul."[35] This theme of cultural amnesia is persistent in modern art: "light and space" artist Robert Irwin, among the last and most thoroughgoing modernists working today, has affirmed Paul Valery's comment, "To see is to forget the name of the thing one sees."[36] For modern artists it is as if "seeing" — the primal desire of modern art — could be accomplished only if the blinding light of civilization, culture, learning, and memory were blotted out. Such statements, which are frequent in modern art, call for a willful obliviousness to the culture from which the viewer comes. Although the avant-garde professed to engage the culture, often antagonistically, it is clear that the peculiarly modern desire, at least with respect to the visual arts, was aimed at the viewer's dissociation and disengagement from the surrounding culture. The sensate experience, so elevated by the avant-garde, seems antithetical to artistic tradition, to intellection, and to the transmission of mores, political values, history, morality, and religious beliefs — in short, all that is the basis of civilization itself.

Purely sensate experience is inherently isolationist; it is fundamentally private experience, not transferrable from one person to the next, that impedes the intellectual and cultural bonds that foster shared values and experiences among individuals. A fully sensate experience leaves people alone with their feelings. By deliberate choice of the artist little that is pertinent to the culture can be exported or brought away from a modernist work that disengages the viewer from nonart concerns; it is arguable that the only function of such a work is to be seen. Frank Stella's statement, when asked to explain the meaning of his nonobjective paintings, that "what you see is what you see," amounts to such an argument.[37] Stella's art refers only to itself and its own presumptions; it is self-evident, self-sufficient, and irrefutable. It promulgates a closed system of art, the experience of which is immediate, transient, and specific to the individual.

What is at question is whether certain precepts of the avant-garde were destructive to the very concept of transmissible culture. The avant-garde opposed the authoritarian influence of established culture, and it especially opposed any official proscription of creative endeavors; all forms of creativity were to be viable and permissible within the avant-garde. But underlying the modernist outlook there was an unstated, perhaps unrecognized, antipathy to shared experience and communal values, particularly where that "supremacy of pure feeling in creative art," which Malevich aspired to, and the determination to forget the larger culture were involved.

It was the ideal of the avant-garde that countless artists and critics would engage in the pursuit of universal visual experience that could transcend individual cultures or specific knowledge, and it is precisely this idealistic spirit that some critics have suggested is absent in contemporary art. However, that ideal seemed to end in an art of total disengagement from all other human experience, a disengagement rejected by many postmodern artists — who wish to forge a moral and ethical order — as an effete aestheticism and a philosophical dead end. One of the key attributes of postmodern thought is a reconsideration of the artist's relationship to society and the culture at large and an attempt to reunify the aspirations of progressive art with the culture in which the artist and audience exist.

The possibility of such reunification apparently runs counter to the very notion of an avant-garde, at least according to modern criteria of the artist as an antagonist of the status quo. Modern avant-garde experimentation exists more with respect to the arts and sciences — wherein experimentation, new knowledge, and new questions are virtuous in and of themselves — than to other aspects of culture, such as religion, law, ethics, or manners, which stress continuity, precedent, and tradition. In societies where the avant-garde has been tolerated, the most significant artistic develop-ments have been all but divorced from such continuity-bound endeavors as the expression of organized religion (a major source of inspiration in Western art) or the promulgation of the shared values, experiences, and mores of society (subjects that since the Renaissance have been the worldly counterpart to religious expression). It is not surprising that during the early twentieth century, when unprecedented and rapid changes in technological, economic, social, political, and scientific life profoundly disturbed the basic assumptions of Western civilization, the traditional concerns of art seemed archaic, even invalid. Traditional themes of art, culturally conservative by nature and preserving known experience, seemed not only irrelevant to avant-gardism, which resisted all political and intellectual institutions, but also were in fact fundamentally antithetical to it. Nor is it surprising that the avant-garde has often been associated with revolutionary political agendas and that various avant-garde movements had manifestos of political demands and programs for action.

But history and analysis demonstrate that by its very nature the revolutionary political ambitions of the avant-garde were largely insupportable because of a lack of sustained engagement with the concerns of the body politic. The actual politics of the avant-garde were, in fact, rather ineffectual posturings; and the real work of the avant-garde was manifested, not with respect to human behavior and experience beyond the experience of the art object, but within and with regard to objects and the stylistic and formal innovations they embody. All that is unique to modern art can be traced to concepts about the dislocation of art from sustained social and civic involvement. Though much has been made in histories of modern art about the political claims of the avant-garde, the actual principles that underly them have been obscured.

Avant-garde activity through the decades addressed a consistently more and more specialized audience of

artists, art devotees, and critics, an elite whose artistic concerns had little to do with social politics or the welfare of the general culture. There is little evidence to support a notion that any avant-garde movement had a significant impact on social or political movements. To the contrary, the most radical art movement, ideologically as well as formally — the tide of abstract painting, sculpture, design, and performance referred to as the Russian avant-garde — was the first casualty of all totalitarian defeats of progressive art in the modern era. That a euphoric and revolutionary art movement like the Russian avant-garde, which was entirely sympathetic with the aims of an all-pervasive social revolution and whose declared program was to create a new art for a new age, was virtually rescinded by the new political regime is testimony to the disparity that may obtain between cultural and political revolution.

At the other end of the political spectrum an entirely reactionary Nazism was similarly antipathetic to modernism and found nothing therein to exploit for its own political goals except a propaganda target. The best-known extravaganza of party-sponsored antimodern sentiment, the infamous *Degenerate Art* exhibition, was staged by the Nazis in 1937. A vast exposition of art works of every modernist persuasion, *Degenerate Art* was organized to make a mockery of modern art's attainments. It is difficult to know to what degree the Nazis found modern art to represent a real political danger, but even such master propagandists as they could see little to exploit in the experimental styles of avant-garde art to help them promulgate their political ideology.

Nowhere in the history of modern art was the breach between avant-garde art and the sociopolitical sphere more evident than in the United States during the late 1960s at the height of the Vietnam War era. This period coincided with the ascension of radically experimental minimalist and process art — completely nonobjective art forms that eschewed any extraformal content — as the predominant modes of avant-garde artistic exploration. Many of the artists who professed revolutionary sympathies or radically dissented with United States foreign policy could not express their moral condemnation or their political dissidence through their art, which was their lifework. Instead they were reduced to signing petitions. One artist, Robert Morris, shut down an exhibition of his sculpture at New York's Whitney Museum of American Art in protest over the American bombing of Cambodia; a gesture widely criticized as misplaced and futile, it may have been the most viable form of protest available. Certainly, that an artist's chief protest against the political powers of his society was not in showing his art but in *not* showing it, underscores how ineffectual avant-garde art may be in influencing politics.

The commonplace that avant-garde art has a practical political basis is historically proved to be, at best, grossly inaccurate. Robert Hughes has observed:

> The only avant-garde *movement in our century that can be shown to have had some formative effect on politics — and even that is debatable — acted on the Right, not the Left. It was Futurism, whose ideas and rhetoric (rather than the works of art actually painted by [Giacomo] Balla, [Gino] Severini, or [Umberto] Boccioni) bodied forth some of the mythology of Italian fascism. The Futurist ethos, as expressed by Marinetti before World War I, supplied the oratorical framework for Mussolini's rise to power and set the stage for his appearance, with its cult of speed, male potency, anti-feminism, and violent struggle.*[38]

Its political theories to the contrary the avant-garde's political practice entailed no special interaction with daily, communal, societal life. If there was a viable political component to the avant-garde, it was not in the ideological manifestos that appeared from time to time or in any program of public acts, such as the futurists' incitement to burn down the museums. For

by redefining art in terms of formal concerns specific to artists, artists had effectively extracted their art from the ongoing life of the world at large, and they exempted themselves from ministering to its vital concerns. Quite simply, avant-garde art was politically ineffectual.

In essence avant-garde politics really describe a behavioral pattern, a code of etiquette, or "disetiquette," a peculiarly modern relationship of the artist to his audience or, more accurately, a perceived relationship to it. The persona of the avant-garde artist, as it has come down through the fable of modernism, is that of the bohemian, the struggling creator in self-imposed exile at the fringes of recognized culture, the antagonist of a materialistic bourgeoisie firmly set in its complacencies and presumptions.

The most extreme artistic reaction against bourgeois society was among the dadaists, who with the onset of World War I turned against a society they understood to be corrupt and morally bankrupt. Dada, an absurdist and nihilistic movement, stood not against art, in which the dadaists saw man's true freedom, but against the institutionalization of art, its platitudes, and its prescribed forms for a conventionally minded bourgeois audience. The dadaists even rejected many modern art forms, such as cubism, which they saw as debased and effete aestheticism. An especially lucid description of the righteousness of the artist in an antagonistic role was envisioned by the German poet Richard Huelsenbeck, a founder of Cabaret Voltaire, the regular dada gathering place:

> Politicians are the same everywhere, flat-headed and vile. Soldiers behave everywhere with the same brisk brutality that is the mortal enemy of every intellectual impulse. The energies and ambitions of those who participated in the Cabaret Voltaire in Zurich were from the start purely artistic. We wanted to make the Cabaret Voltaire a focal point of the "newest art," although we did not neglect from time to time to tell the fat and utterly uncomprehending Zurich philistines that we regarded them as pigs and the German Kaiser as the initiator of the war.[39]

If Huelsenbeck's defiant tone is not universal throughout the avant-garde, its codified ritual of courting and insulting the audience is certainly germane. But if the intended audience of the avant-garde was the proletariat or such targets as the bourgeoisie, they seem not to have been listening. The only audience the avant-garde ever really addressed or that ever reciprocated with its attention were the literati. The avant-garde might indeed inspire deep disagreement among its members, as between the dadaists and the cubists, but by and large the audience of the avant-garde was hardly a coerced, unwilling one but an intelligentsia predisposed to consider, or at least to hear, its intramural arguments.

Many of today's arguments that the avant-garde has perished turn on the notion of a changed relationship between artist and audience. But because that relationship was never quite as the avant-garde imagined it to be, it would be more accurate to say that the perceived role of the artist has changed. Indeed it has changed radically. In contrast to the classic avant-garde's ritual disapprobation of its imagined audience and their values and experiences, is the sense, discernable among many contemporary artists, of engaging the interests and addressing the experiences of the audience. While it is true that such artists as Hans Haacke, Leon Golub, Barbara Kruger, Bruce Nauman, Neil Jenney, or Terry Allen may intend to provoke their audiences with overtly political or socially critical art, by and large the tenor of much of the most contemporary art that deals with communal or cultural interests is less the angry protest of the outcast dissident than that of the concerned participant. And the most pervasive politics of contemporary art are engaged with political ramifications of the artist's rela-

tionship to the audience and the ethical and moral possibilities of art after modernism.

The art of Jeff Koons, for example, does not at first suggest a political reading, nor does it lend itself to easy interpretations. Yet he is specifically concerned with the cultural and political evocations of his art as well as with its accessibility to viewers:

> *To me, the issue of being able to capture a general audience and also have the art stay on the highest orders is of great interest. I think anyone can come to my work from the general culture; I don't set up any kind of requirement. Almost like television, I tell a story that is easy for anyone to enter into and on some level enjoy.*[40]

Robert Longo has reaffirmed a more heroic role of the artist ministering to a general audience, in whose experience of contemporary life he shares: "Artists are like the guardians of culture. I'm totally obsessed with the idea of human value. I feel that I'm contributing to my culture, posing certain questions about living and the pressures of living today."[41] Longo plainly is interested in the ethical responsibilities of the artist to his audience and the culture at large.

Haim Steinbach may have precisely defined postmodern art's political condition:

> *I am curious that in many ways today the distinctions between an elite as opposed to a general audience are becoming blurred. There is an equalizing factor at work in the way things are being produced now giving an illusion of a shared freedom, of one audience. This kind of dynamic interests me, and I attempt to deal with it in my work.*[42]

Perhaps this sense of shared freedom, of one audience, is the spirit of the postmodern avant-garde. It is a spirit of full inquiry, without taboos or forbidden knowledge, into the full range of art experience. This willingness of artists and audiences to embrace subjects of mutual and perennial interest, to acknowledge all of the uses of art, stands in enlightened and benign opposition to the modernist project of defining and delimiting the proper focus of art.

Modernism had relieved art of its traditional response and relationship to the world, liberating it to follow formal and material possibilities. This was accomplished by an activity of subtraction, by progressively divesting art of extraneous subject matter, topicality, and cultural attitudes. Modernist art was modern to the degree that it excluded the prevailing aesthetic, ethical, and moral codes of the larger culture. Modernism's demands for originality and the primacy of visual experience were reflected in its persistent campaign to delimit the viable concerns of art and the artist. Georges Braque considered that "in [modern] art, progress does not consist in extension, but in the knowledge of limits";[43] Gleizes and Metzinger appealed to "let the artist's function grow profounder rather than more extensive;"[44] and a statement by Picasso most saliently expressed the ambitions and outlook of modernism: "A picture used to be a sum of additions. In my case a picture is a sum of destructions."[45]

The cubists Picasso, Braque, Gleizes, and Metzinger represent the self-consciously formalist phalanx of the early twentieth-century avant-garde. But even among expressionists, surrealists, and other camps of twentieth-century artists whose work derived from the romantic and symbolist traditions, the hope of bypassing intellect and community to get at the primal source of art in the human psyche was pervasive. The subtraction of inauthentic elements ultimately became the modus operandi of modern art; and by the 1960s minimalists, like Robert Morris, could seek or at least philosophically contemplate the possibility of creating an object with "only one property."[46] The desire for such a creation, for a wholly unified — indeed, unitary — object, is a wholly modernist desire. Although, as

Morris acknowledged, an object with only one property cannot exist, the question of its existence issues directly from modernist ideals. Such an object would refute all but a single experience and a single signification; it would be acausal, complete, and perfect, in short, quintessentially modern. The desire for this form of perfection in art is possibly an impulse toward spirituality, or mystical oneness, which was the inspiration for such nonobjective painters as Malevich, Mondrian, Adolph Gottlieb, Pollock, Mark Rothko, Barnett Newman, and Brice Marden.[47] But its manifestations in their art seem largely sublimated and obscure forms of private spirituality. Whether the art of reductivism was formal in its motivation or spiritual, such truly modernist art "looked esoteric because it was."[48]

Postmodern inquiry, no matter how arcane or esoteric its expressions may seem, takes artists in quite a different direction. At root postmodern art is neither exclusionary nor reductive but synthetic, freely enlisting the full range of conditions, experiences, and knowledge beyond the object. Far from seeking a single and complete experience, the postmodern object strives toward an encyclopedic condition, allowing a myriad of access points, an infinitude of interpretive responses. It claims as its rightful modes an unrestricted range of visual expression and experience. The contemporary object strives for a discernible connection with the rest of culture and the world external to art.

The postmodern art works of Anselm Kiefer and Matt Mullican, stylistically so divergent, are exemplary for the synthesizing, expansive momentum of their visual forms and for their revelatory aspiration to represent the world and humanity's place in it. A spirit of infinite embrace, and of the heroism and pathos of human idealism itself, inspires Kiefer's heavily symbolic art. Steeped in associations with German and classical Western civilization, Kiefer's painting and sculpture

assume a virtually religious grandeur. In *The Book*, 1985 (cat. no. 130), a vast set of heavy lead wings erupts, like a spirit ascending, from the pages of a book whose pages also are made of lead. The artist's ironic choice of material, of lead, to suggest the human spirit and the investment of human creativity in material culture, represented in the form of the book, reflects the tragic spirit of man's inevitable struggle to transcend his mortality and the habitable world. With its sure association with the myth of Icarus, who defied his earthbound humanity and died as his wings of wax and feathers melted when he flew too close to the sun, Kiefer's *The Book* is a contemporary embodiment of civilization's expansive spirit.

Mullican's paintings, banners, and granite hieroglyphs — bearing signs that represent the known chemical elements of creation, the natural order of mineral, vegetable, and animal forms created therefrom, the material, social, and ideological culture that is humanity's establishment on earth, the architecture of galaxies and the shape of space, the forces of life and death, and supreme and infinite intelligence — invoke a true vision of the material, structural, and moral order of the universe. His vast, synthesized, visual catalogues (see cat. no. 129) encode all reality known to humanity. Corresponding to every imaginable cause or condition external to their own existence, Mullican's works aspire to be nothing less than an anatomy of the entire creation.

With such evidently unmodern exemplars of contemporary art, what can be said to persist of the avant-garde? Such hallmark attributes of the avant-garde as its quest for origins, its elevation of the purely sensate experience, the mission of its political ideology, the relation of its artists to their audience, and its impulse to redefine the very concept of what art is and should be, have now become academic, have been superseded, or have been adjudged untrue to begin with. The values of modernism no longer suggest the

progressive optimism they once did. From the vantage point of the present it appears that the profound flaw of the avant-garde was its genesis in the need to escape the very culture that motivated it.

What does persist is the example, the myth of the avant-garde and its function in advanced culture. Moreover, the key issues created by the modern avant-garde — of originality, of art's relation to the larger culture, of the limits of art — are in fact the primary issues facing artists today. That the contemporary response to those issues is different from, even antithetical to, the modernist response testifies to the vitality and continuing urgency of those areas of modernist inquiry. The art of the contemporary avant-garde, in the very awareness it maintains of the historical past, does not deny its evolution from the classic avant-garde. Most of all it is modernism's integrity and independence, its opposition to accepting the legacy of the past uncritically, that has engendered that sense of shared freedom — including the freedom to rethink the tenets of modernism itself — that contemporary art has inherited.

Avant-gardism is a way of perceiving culture, in particular the culture of the present and how it relates to that of the past and future. It is a secular mythology of how humanity relates to all that was and will be. In an age bereft of a divine mythology, the avant-garde brings to bear the full authority of culture in the perception of human purpose on earth. The contemporary avant-garde has both maintained and broadened that search for purpose.

Notes 1. Hilton Kramer, "Postmodern: Art and Culture in the 1980s," *The New Criterion* 1 (September 1982): 42.

2. Harold Rosenberg, *The Tradition of the New* (New York: Horizon, 1959), 36.

3. Ibid., 137.

4. Harold Rosenberg, *The Anxious Object: Art Today and Its Audience* (New York: Horizon, 1964), 262.

5. Robert Hughes, *The Shock of the New* (New York: Knopf, 1981), 375.

6. Robert Hughes, "Careerism and Hype Amidst the Image Haze," *Time* 126 (17 June 1985): 83.

7. Suzi Gablik, *Has Modernism Failed?* (New York: Thames and Hudson, 1984), 122.

8. Rosalind E. Krauss, "The Originality of the Avant-Garde," *The Originality of the Avant-Garde and Other Modernist Myths* (Cambridge, Mass.: MIT Press, 1985), 157.

9. F. T. Marinetti, "Futurist Manifesto, Paris, 20 February 1909," in Pontus Hulten, ed., *Futurismo & Futurismi*, exh. cat. (Milan: Bompiani, 1986), 514.

10. Ibid.

11. Ibid., 516.

12. Stephanie Barron and Maurice Tuchman, eds., *The Avant-Garde in Russia, 1910–1930: New Perspectives*, exh. cat. (Los Angeles: Los Angeles County Museum of Art, 1980), 243.

13. Herschel B. Chipp, ed., *Theories of Modern Art: A Source Book by Artists and Critics* (Berkeley: University of California Press, 1968), 204.

14. "The Exhibitors to the Public, February 5, 1912," in Joshua Taylor, *Futurism* (New York: Doubleday, 1961), 127.

15. Cézanne to Émile Bernard, 15 April 1904, in John Rewald, ed., *Paul Cézanne: Letters*, (Oxford: Bruno Cassirer, 1941), 234.

16. Cézanne to Émile Bernard, 26 May 1904, in ibid., 236.

17. Piet Mondrian, "Natural Reality and Abstract Reality," in Michel Seuphor, *Piet Mondrian, Life and Work* (New York: Abrams, n.d.), 142.

18. Ibid., 143.

19. Ibid.

20. Guillaume Apollinaire, *The Cubist Painters*, trans. Lionel Abel (New York: Wittenborn, 1970), 13.

21. U. Boccioni, "Technical Manifesto of Futurist Sculpture" (11 April 1912), in Taylor, *Futurism*, 130.

22. Chipp, *Theories of Modern Art*, 212.

23. Apollinaire, *The Cubist Painters*, 13.

24. Ibid., 12.

25. Ibid., 23.

26. Pat Steir, "Notes on *The Brueghel Series (A Vanitas of Style),*" in *Pat Steir: The Brueghel Series (A Vanitas of Style)*, exh. cat. (New York: Brooklyn Museum, 1984), unpaginated.

27. Quoted in C. Carr, "What is Political Art . . . Now? . . ." *Village Voice*, 15 October 1985, 81.

28. Quoted in Jeanne Siegel, "After Sherrie Levine," *Arts Magazine* 59 (Summer 1985): 144.

29. Chipp, *Theories of Modern Art*, 341.

30. Ibid., 214.

31. Apollinaire, *The Cubist Painters*, 13.

32. Ibid., 12.

33. Chipp, *Theories of Modern Art*, 319.

34. "The Exhibitors to the Public," 127.

35. Ibid., 129.

36. Quoted in Lawrence Weschler, *Seeing Is Forgetting the Name of the Thing One Sees: A Life of Contemporary Artist Robert Irwin* (Berkeley: University of California Press, 1982), 203.

37. Quoted in William S. Rubin, *Frank Stella*, exh. cat. (New York: Museum of Modern Art, 1970), 42.

38. Hughes, *The Shock of the New*, 371.

39. Chipp, *Theories of Modern Art*, 377.

40. Quoted in "Flash Art Panel: From Criticism to Complicity," *Flash Art* 129 (Summer 1986): 47.

41. Quoted in Michael Brenson, "Artists Grapple with New Realities," *New York Times*, 15 May 1983, sec. 2, 30.

42. Quoted in "Flash Art Panel," 47.

43. Robert Goldwater and Marco Treves, eds., *Artists on Art* (New York: Pantheon, 1945), 422.

44. Chipp, *Theories of Modern Art*, 211.

45. Alfred H. Barr, Jr., *Picasso: Fifty Years of His Art* (New York: Simon and Schuster, 1946), 272.

46. Robert Morris, "Notes on Sculpture," *Artforum* 4 (February 1966): 44.

47. For discussion of this subject see *The Spiritual in Art: Abstract Painting 1890–1985*, exh. cat. (Los Angeles: Los Angeles County Museum of Art and Abbeville, 1986).

48. Hughes, *The Shock of the New*, 373.

Catalogue of the Exhibition

Gober

Anderson

Halley

Ott

Baldessari

Huebler

Bender

Polke

Bidlo

Kelley

G. Richter

Brauntuch

Koons

Salle

Clegg and Guttman

Ladda

Levine

Smith

Levinthal

Solien

Cutrone

Steinbach

Dahn

Steir

Diao

Syrop

Tansey

Maggiotto

Majore

Tillers

McCollum

Fisher

Wachtel

Frailey

One of the foremost concerns of contemporary artists is the relation of their art to the sources from which it derives and to the meanings it generates. They see their art as mediating, in effect, between the context in which it is created and exists and the significance it assumes in the viewer's mind. Many artists working today presume that the viewer's experience of their works — in fact, of all works — is contingent upon factors outside of the work of art itself, such factors as the prevailing visual conventions and artistic traditions of the culture, the viewer's awareness of and responsiveness to that context, and the artist's intentions.

In this, contemporary artists differ from early twentieth-century avant-garde artists, and their followers in later decades, who emphasized the "originality" of their novel styles and the independence of their art from past and present conventional culture. The early avant-garde attempted to create universal forms that have "authentic" meaning for all viewers, independent of a viewer's previous experience or cultural background. In contrast, contemporary artists go so far as to question the modernist value of originality itself and whether there is or can be a truly original visual experience.

In *The Brueghel Series (A Vanitas of Style) Polychrome*, 1982–84, Pat Steir, for example, challenges the modern ideal of originality and unity in an art work by reconstituting the familiar image of a still-life by Jan Brueghel the Elder as a pastiche of sixty-four paintings, each in a different style. Gerhard Richter is equally committed to both a bravura abstract style and a painstaking photorealistic representational style, a commitment through which he questions the value of a unique signature style, which is often said to be a mark of artistic originality. Imants Tillers, Roger Herman, Mike Bidlo, and David Diao freely draw upon familiar art historical imagery in a way that acknowledges how conventional meanings are assigned or stripped away from what was once considered original expression. Peter Halley's abstract painting *Two Cells with Circulating Conduit*, 1985, based on the appearance of microelectronic computer parts, intentionally recalls 1960s minimalist art to which it is visually but not conceptually related, thereby raising the issue of the meanings assigned to particular styles.

By incorporating such familiar objects as vacuum cleaners, ice chests, or a urinal, Haim Steinbach, Jeff Koons, and Justen Ladda construct assemblages that evoke a meaningfulness not normally attributed to such workaday objects. Similarly the works of Allan McCollum and Robert Gober, surrogates for other objects they resemble, accent the distinction between visual and conceptual information.

Recognizing the inescapable link between visual and conceptual meaning in art, many contemporary artists critique the concept of an authentic, or unique, visual experience. For them visual cues function like a language in which visual signs may work to suggest nonvisual messages. Sigmar Polke and David Salle, who was influenced by him, draw upon diverse sources for incongruous images, which when overlaid or placed side by side provoke a narrative or syntactic reading, though no particular interpretation is fulfilled by their imagery's content. John Baldessari, Vernon Fisher, and Douglas Huebler are among the visual artists whose work explores the role of the imagination and how the mind produces meanings for what the eye sees.

Some contemporary artists explore the interplay between art and advertising, print media, television, movies, design, and other applied and fine art that surround us at all times. Television programs and advertising, and their capacity to casually ingrain deep-rooted and often subliminal psychological perceptions, are primary sources for such artists as John Maggiotto, Mitchell Syrop, and Gretchen Bender; Mike Kelley and Alexis Smith use such popular visual forms as

comic books and movie posters to probe their influences on social attitudes and behavior.

The manipulation of visual codes — the communication of nonvisual information in visual forms — thus represents a major area of investigation for the contemporary avant-garde. Such codes do not inhere in the object but are "unoriginal" and "inauthentic," having been established by cultural convention or tacitly agreed upon by artists and viewers. Whereas the modernist avant-garde tried to liberate art from such strong though extraneous influences in the experience of its work, the contemporary avant-garde, recognizing the potency of such codes, finds in them agents of richly expressive power to be exploited in ways unique to visual art.

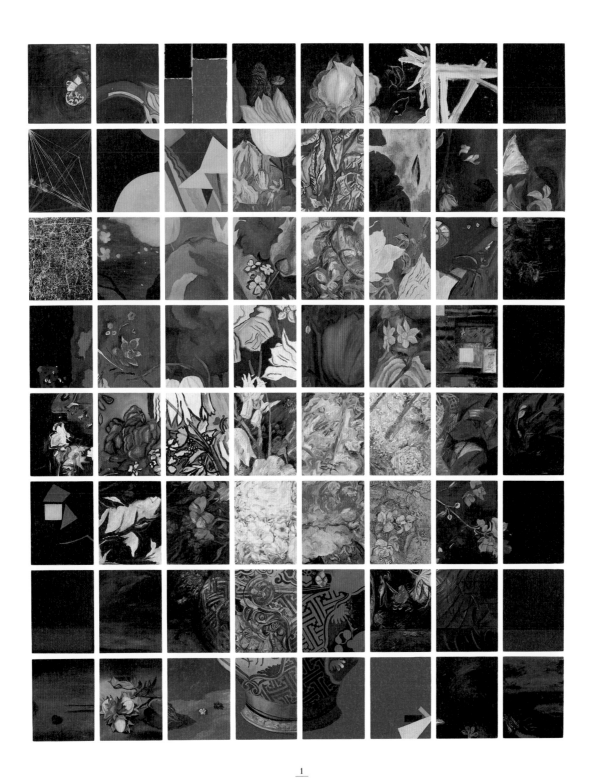

1

The Brueghel Series (A Vanitas of Style) Polychrome, 1982–84
Oil on canvas, sixty-four panels
Each 28 ½ x 22 ½ in. (72.4 x 57.1 cm)
Lent by the artist
Courtesy Michael Klein, Inc., New York

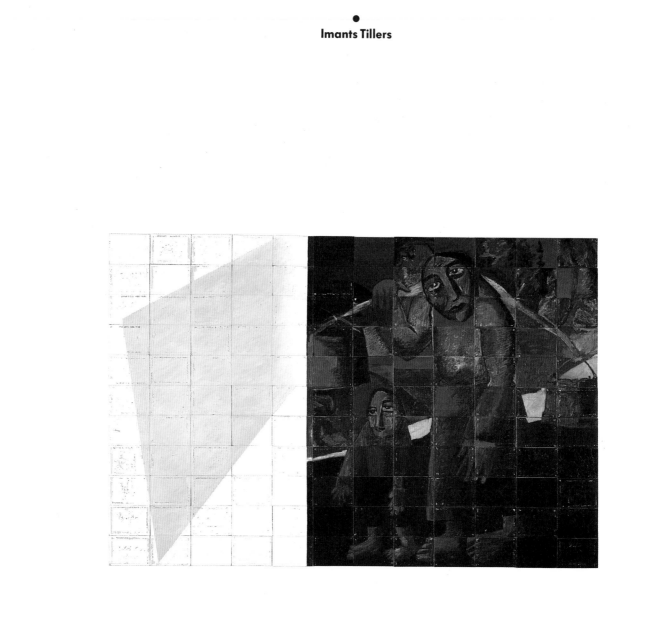

2

Portrait of Selfhood, 1985
Oilstick on canvas boards
55 x 84 in. (139.7 x 213.4 cm)
The Prudential Insurance Company of America

Roger Herman

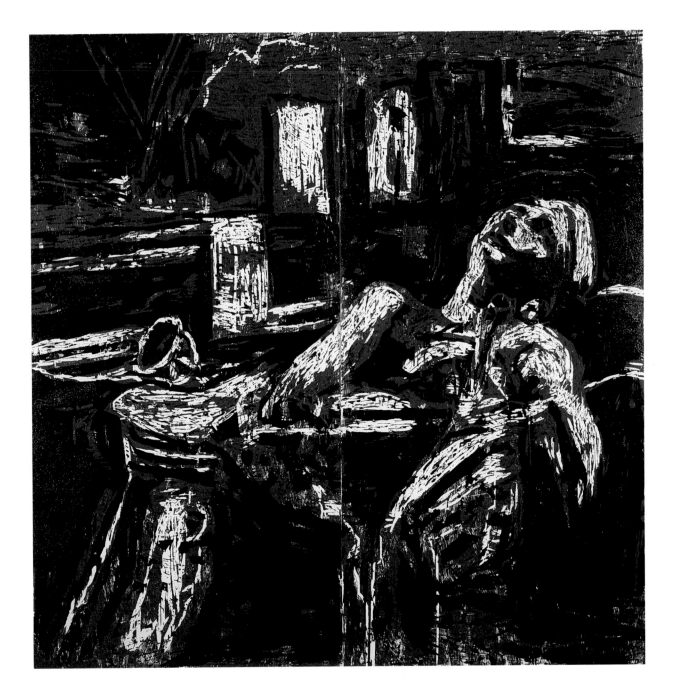

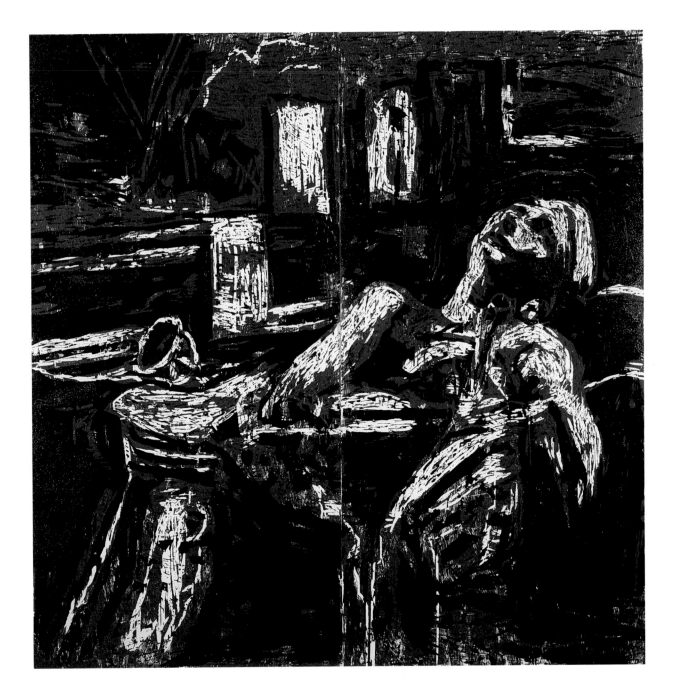

3

Marat, 1985
Woodcut on paper
114 x 120 in. (289.5 x 304.8 cm)
Los Angeles County Museum of Art
Modern and Contemporary Art Council,
Young Talent Purchase Award

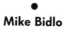

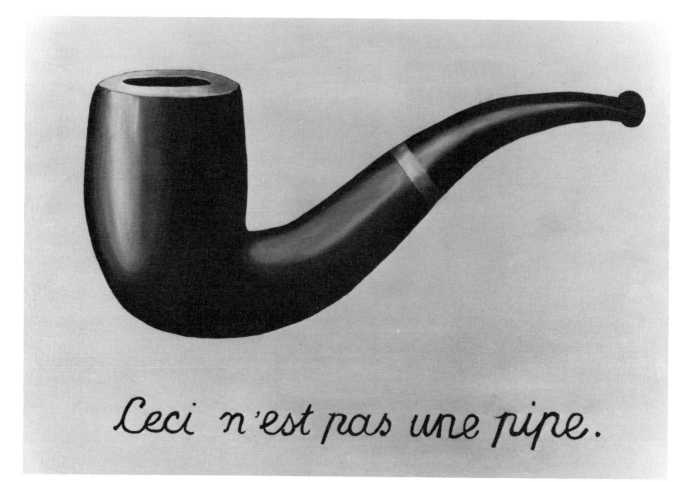

(Not) Magritte, 1985
Oil on linen
23 x 37 in. (58.4 x 93.9 cm)
Lent by the artist
Courtesy Larry Gagosian Gallery, Los Angeles

5

Abstract Painting [no. 556/2], 1984
Oil on canvas
47 ⅛ x 39 ¼ in. (119.7 x 99.7 cm)
Emily and Jerry Spiegel

6

Two Candles [no. 497/1], 1982
Oil on canvas
47 ¼ x 39 ⅜ in. (120 x 100 cm)
The Art Institute of Chicago
Twentieth-Century Discretionary Fund

Sherrie Levine

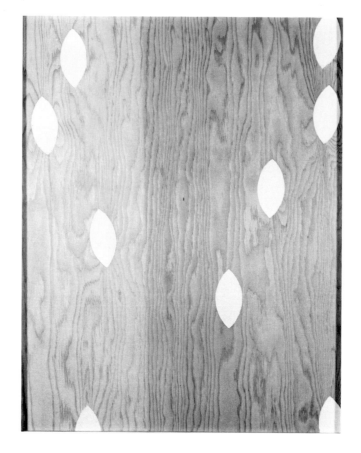

White Knot #5, 1986
Casein on plywood
31 ¼ x 24 ¼ in. (79.4 x 61.6 cm)
Robert H. Halff, Beverly Hills
Promised gift to Los Angeles County Museum of Art

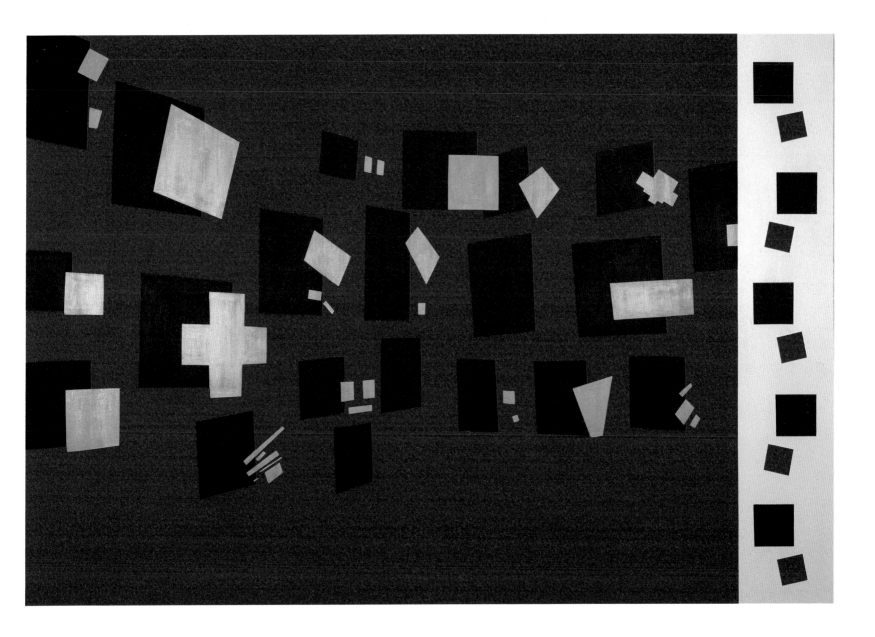

8

Margins of Philosophy, 1985
Acrylic on canvas
108 x 157 in. (274.3 x 398.8 cm)
Mr. and Mrs. Stewart Resnick, Newtown Square, Pennsylvania

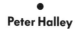

9

Two Cells with Circulating Conduit, 1985
Day-Glo acyrlic, acrylic, and Roll-A-Tex on canvas
63 x 108 in. (160 x 274.3 cm)
Michael H. Schwartz, New York

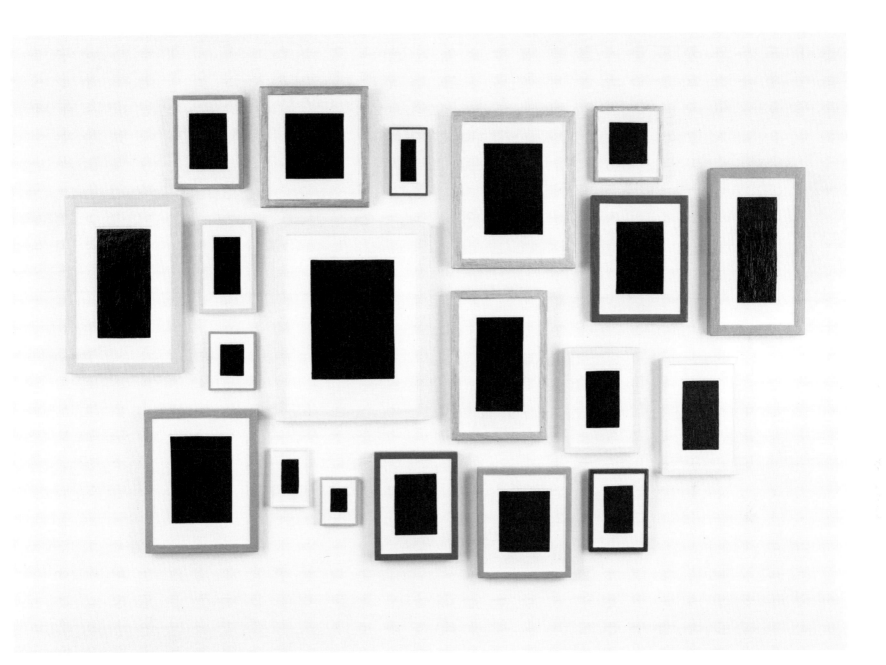

10

Surrogates, 1979–84
Enamel paint on hydrocal plaster, twenty panels
Installation 54 x 86 in. (137.2 x 218.4 cm)
Don C. Sherwood, Los Angeles
Courtesy Kuhlenschmidt/Simon Gallery, Los Angeles

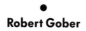
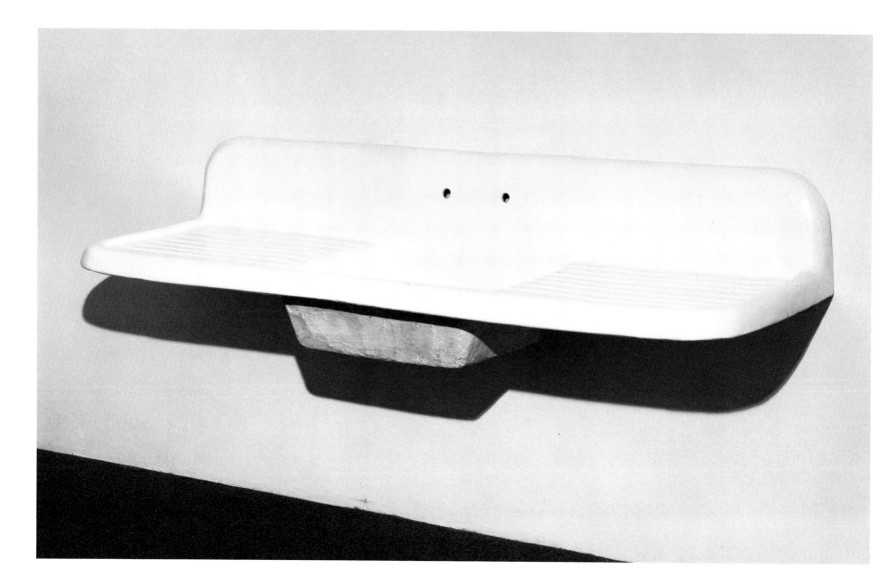

11

Single Basin Sink, 1985
Plaster, wood, steel, wire lath, semigloss enamel paint
24 x 90 x 27 in. (60.9 x 228.6 x 68.6 cm)
Los Angeles County Museum of Art
Gift of Robert H. Halff, Beverly Hills

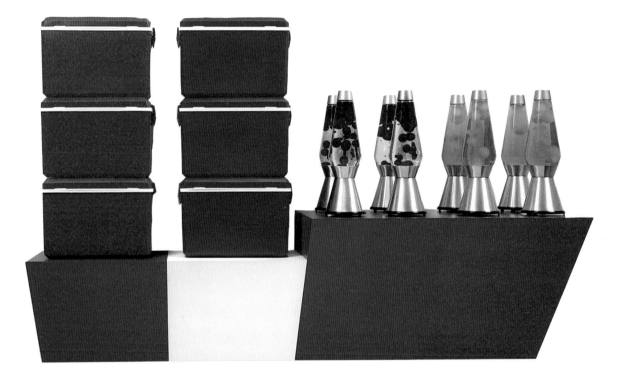

12

vinyl that already looks wet, 1986
Mixed media
49 ½ x 77 x 19 in. (125.7 x 195.6 x 48.3 cm)
Los Angeles County Museum of Art
Janet and Morley Benjamin Fund

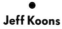

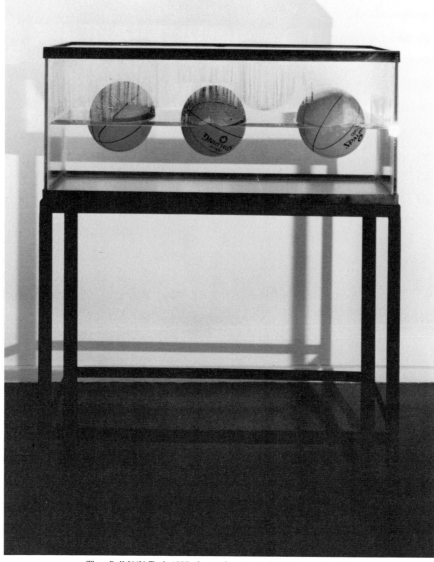

Three Ball 50/50 Tank, 1985, glass tank, water, basketballs, metal stand,
60 ¾ x 48 x 12 ½ in. (154.3 x 121.9 x 31.8 cm), Werner and Elaine Dannhisser

13

Three Ball 50/50, 1985–87
Glass tank with metal; metal stand; three balls: Dr. J. Silverseries basketball,
Wilson Aggressor basketball, and Wilson Super Shot basketball; and distilled water
60 ¾ x 48 x 12 ½ in. (154.3 x 121.9 x 31.8 cm)
Daniel Weinberg, Los Angeles
[Not illustrated]

14

Don't Ask, 1983
Vinyl emulsion, gesso, and acrylic on urinal,
plastic cherries, plastic head of Voltaire, and tiles
44 x 56 in. (111.8 x 142.2 cm)
First Banks Collection of Contemporary Art,
Minneapolis/St. Paul

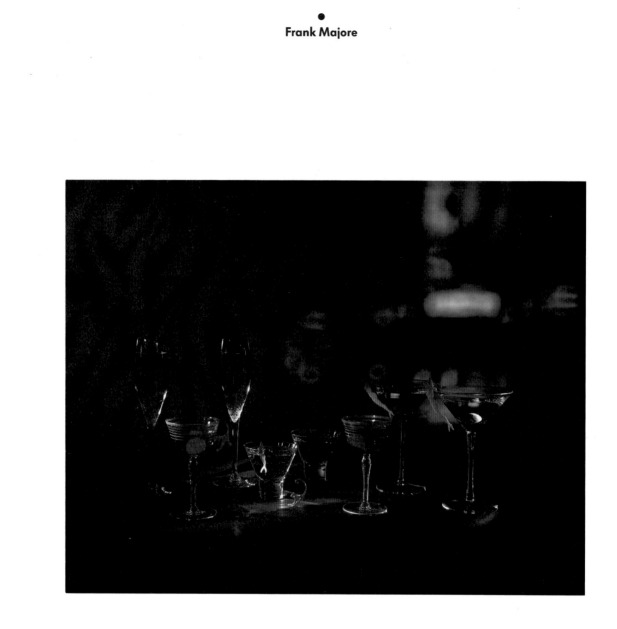

15
The Temptation of Saint Anthony, 1984
Cibachrome print
20 x 24 in. (50.8 x 60.9 cm)
Marvin Heiferman, Photographs, New York
Courtesy New Strategies, Los Angeles

16
Beyond the Reef, 1984
Cibachrome print
20 x 24 in. (50.8 x 60.9 cm)
Clayton M. Press, Jr.
Courtesy New Strategies, Los Angeles
[Not illustrated]

17
Scent, 1984
Cibachrome print
20 x 24 in. (50.8 x 60.9 cm)
Marvin Heiferman, Photographs, New York
Courtesy New Strategies, Los Angeles
[Not illustrated]

David Levinthal



18

Modern Romance Variation II, 1985
Photomechanical reproduction on canvas, no. 1/2
38 ¾ x 38 in. (98.4 x 96.5 cm)
Michael A. Morris
Courtesy R Collection/Bobbie Greenfield, Los Angeles

19

Sunlit Room, 1986
Photomechanical reproduction on canvas, no. 1/2
39 ¼ x 38 in. (99.7 x 96.5 cm)
Lent by the artist
Courtesy R Collection/Bobbie Greenfield, Los Angeles
[Not illustrated]



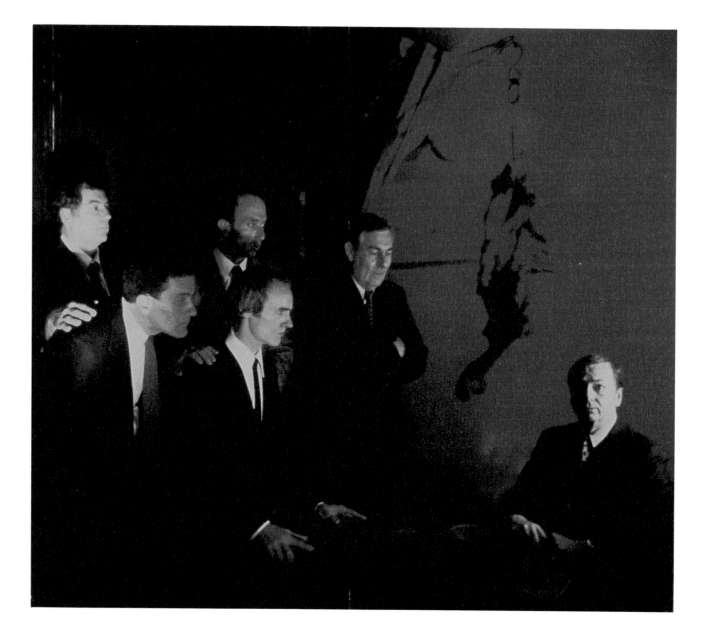

<u>20</u>
Of Certain Men Who Ate Us, 1984
Cibachrome print mounted on wood
84 x 94 in. (213.4 x 238.8 cm)
Jonathan A. Berg, New York

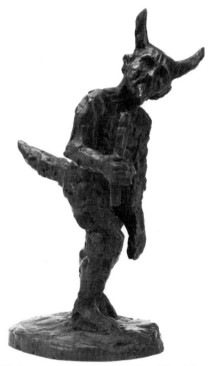

The Owner of Hell, 1984, bronze, 13 9/16 x 5 5/16 x 7 1/2 in.
(34.5 x 13.5 x 19 cm), Galerie Paul Maenz, Cologne

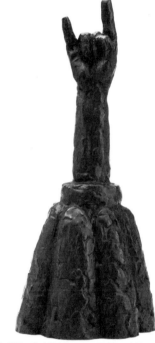

Untitled [Hand], 1984, bronze, 10 13/16 x 6 5/16 x 6 5/16 in.
(27.5 x 16 x 16 cm), Galerie Paul Maenz, Cologne

<u>21</u>

The Natural Trinity, 1985
Bronze
27 3/16 x 20 1/16 x 8 1/4 in. (69 x 51 x 21 cm)
Galerie Paul Maenz, Cologne
[Not illustrated]

<u>22</u>

Neighbor of the World, 1985
Bronze
8 11/16 x 18 7/8 x 9 7/8 in. (22 x 48 x 25 cm)
Galerie Paul Maenz, Cologne
[Not illustrated]

23

Iconograph I, 1984
Oil on canvas and pencil on paper
Painting 72 x 72 in. (182.9 x 182.9 cm);
drawing 23 x 20 in. (58.4 x 50.8 cm)
Robert and Nancy Kaye, New York
[Drawing not illustrated]

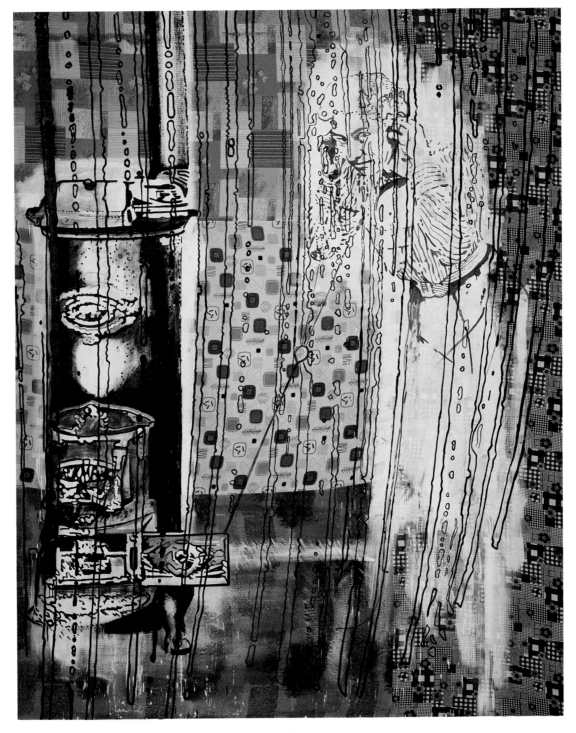

24

Lumpi behind the Oven, 1983
Mixed media on cotton
127 x 97 ½ in. (322.6 x 247.6 cm)
Harry and Linda Macklowe, New York
Courtesy Mary Boone/Michael Werner Gallery, New York

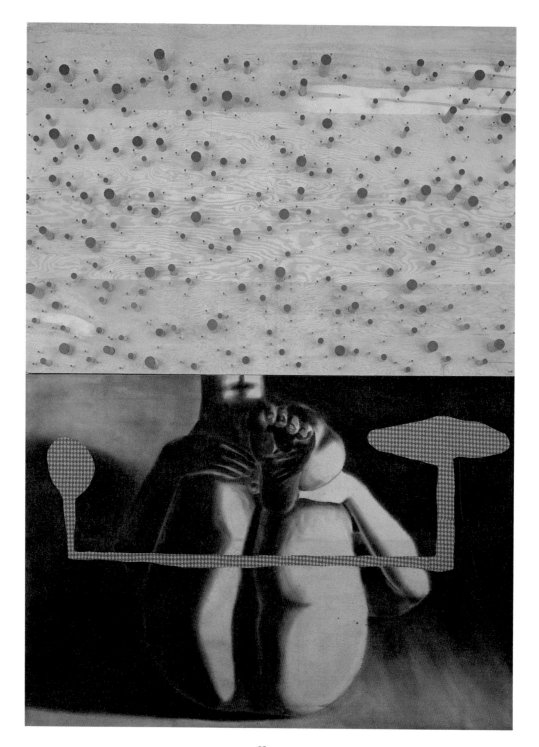

25

The Disappearance of the Booming Voice, 1984
Acrylic and fabric on canvas and wood
104 x 75 in. (264.7 x 190.5 cm)
Janet Green, London
Courtesy Mary Boone/Michael Werner Gallery, New York

●

Troy Brauntuch

Untitled, 1984
Pastel and ink on linen
96 x 96 in. (243.8 x 243.8 cm)
Ruth and Jake Bloom, Marina del Rey, California

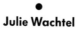

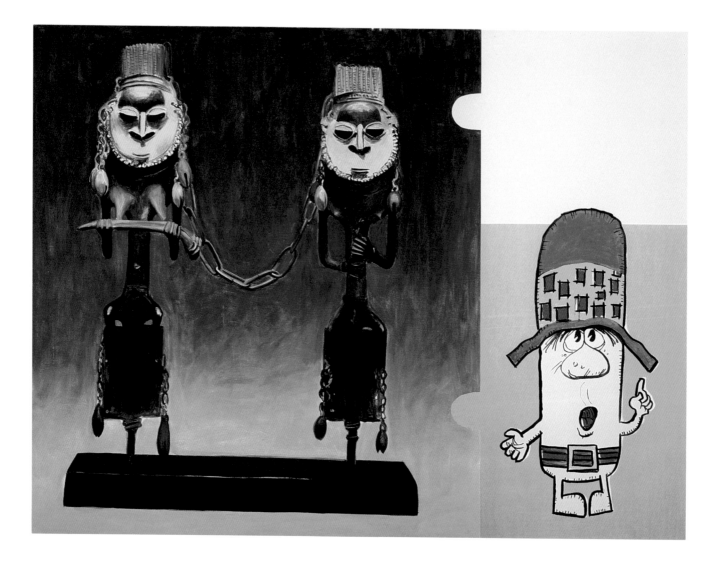

Quality of the Instant, 1984
Oil on canvas
60 x 80 in. (152.4 x 203.2 cm)
Maxine and Jerry Silberman, Chicago

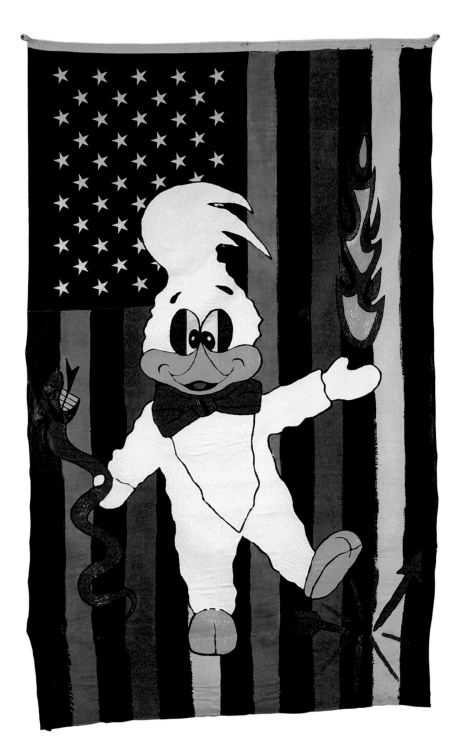

28

The Comforter, 1984
Acrylic on American flag
144 x 96 in. (365.8 x 243.8 cm)
The Eli Broad Family Foundation, Los Angeles

details

Untitled, from Spiritual America series, 1986, steel and illuminated 35mm film strips, 60 x 96 in. (152.4 x 243.8 cm), collection of the artist

Untitled, from Volatile Memory series, 1987
Steel, photograph, and thermal print strips
120 x 120 in. (304.8 x 304.8 cm)
Lent by the artist
Courtesy Gallery Nature Morte, New York
[Not illustrated]

John Maggiotto



30

Women's World, 1984
Color Polaroid photographs
30 x 40 in. (76.2 x 101.6 cm)
Elizabeth Freeman, Santa Monica, California

31

Men's World, 1984
Color Polaroid photographs
30 x 40 in. (76.2 x 101.6 cm)
Elizabeth Freeman, Santa Monica, California



32

Untitled, 1986
Ektacolor print
30 x 30 in. (76.2 x 76.2 cm)
303 Gallery, New York

33

Untitled, 1986
Ektacolor print
30 x 30 in. (76.2 x 76.2 cm)
303 Gallery, New York
[Not illustrated]

34

Untitled, 1986
Ektacolor print
30 x 30 in. (76.2 x 76.2 cm)
Arthur and Carol Goldberg
[Not illustrated]

35

Untitled, 1986
Ektacolor print
30 x 30 in. (76.2 x 76.2 cm)
Lisa Spellman, New York
[Not illustrated]

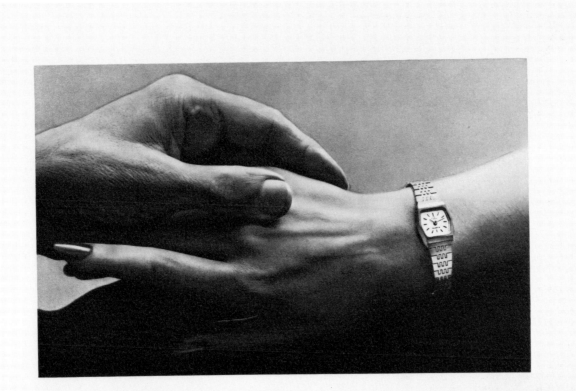

36

Make. Be. Leave. 1985
Oil on photograph
30 x 40 in. (76.2 x 101.6 cm)
Jeanne Meyers, Los Angeles

37

Stoop to Conquer, 1984
Photograph mounted on board
36 x 66 in. (91.4 x 167.6 cm)
Dr. Aaron and Ann Nisenson, Santa Barbara, California
[Not illustrated]

38

All Systems Go, 1985
Hand-colored photograph
48 x 60 in. (121.9 x 152.4 cm)
Joan Simon Menkes
Courtesy Kuhlenschmidt/Simon Gallery, Los Angeles
[Not illustrated]

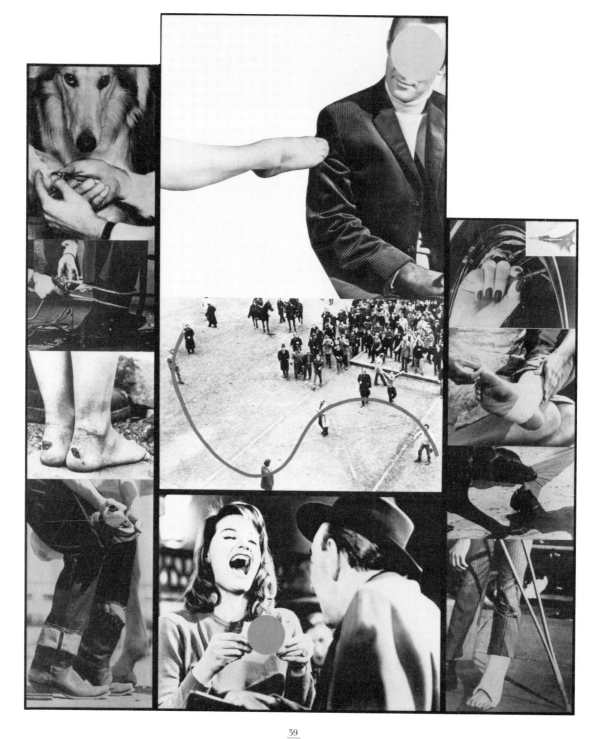

39

Heel, 1986
Black-and-white photographs with oil tint, oil stick, and acrylic
106 ½ x 87 in. (270.5 x 220.9 cm)
Lent by the artist
Courtesy Margo Leavin Gallery, Los Angeles

Laurie Anderson

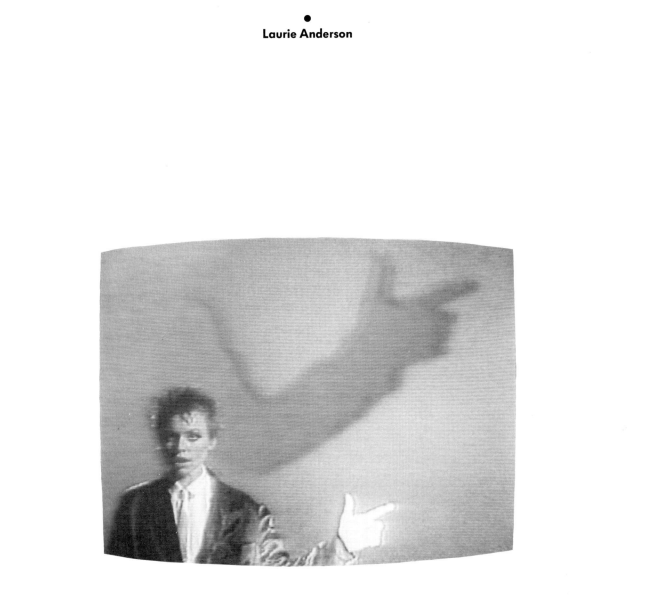

<table>
<tr><td align="center">40</td><td align="center">41</td><td align="center">42</td></tr>
<tr>
<td align="center">O Superman, 1981
Videotape
6 minutes
Lent by the artist
Courtesy The Kitchen Center for Video,
Music, Dance, Performance, and Film, New York</td>
<td align="center">Excerpt from Live at the Kitchen, benefit performance, 1982
Videotape
5 minutes
Lent by the artist
Courtesy The Kitchen Center for Video,
Music, Dance, Performance, and Film, New York
[Not illustrated]</td>
<td align="center">Sharkey's Day, 1984
Videotape
4 minutes
Lent by the artist
Courtesy The Kitchen Center for Video,
Music, Dance, Performance, and Film, New York
[Not illustrated]</td>
</tr>
</table>

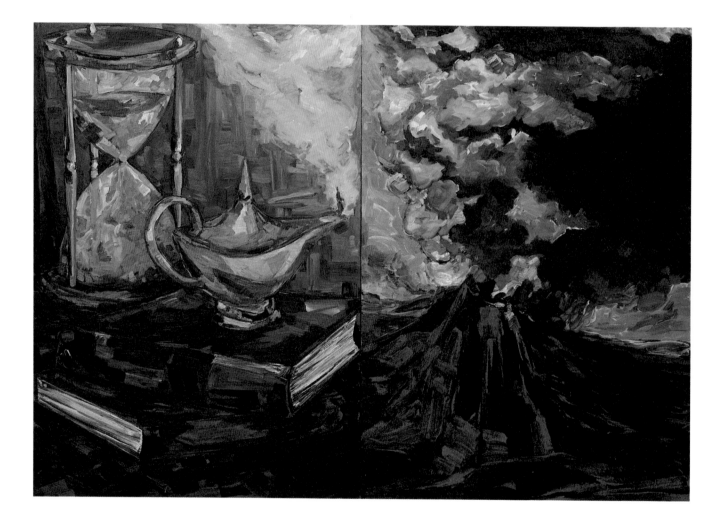

43

Armed Forces, 1985
Oil on canvas
84 x 120 in. (213.4 x 304.8 cm)
Charles Cowles Gallery, New York

BASUTOLAND

They are hardy, intelligent, and ... adopt modern ideas.

BATS

Mice which have lived to be very old sometimes grow tired of life in the dreariness of the fields. They see the birds and wish to fly. So they migrate through fissures and tunnels down into the bowels of the earth, the underworld. When they emerge years later, the finger bones of their front paws have lengthened to support long, thin, membranous wings. The metamorphosis, sadly, is not without its price. The enormous size of the wings necessary to lift the weight of their bodies prohibits the poor creatures from maneuvering on the ground, and even to rest they must hang inverted from the upper surfaces of the damp caverns in which they reside. More painful still, they are condemned to live in complete darkness as the long years spent in the absence of light have left them blind. Eventually the memory of their former existence drives them insane.

BATAAN

Basutoland, installation at Asher/Faure Gallery, Los Angeles, May 1986, and John Weber Gallery, New York, June 1986

44

Walking on Air, 1987
Text on wall with sculptural elements
Installation 204 x 180 in. (518.2 x 457.2 cm)
Lent by the artist
Courtesy Barbara Gladstone Gallery, New York
[Not illustrated]

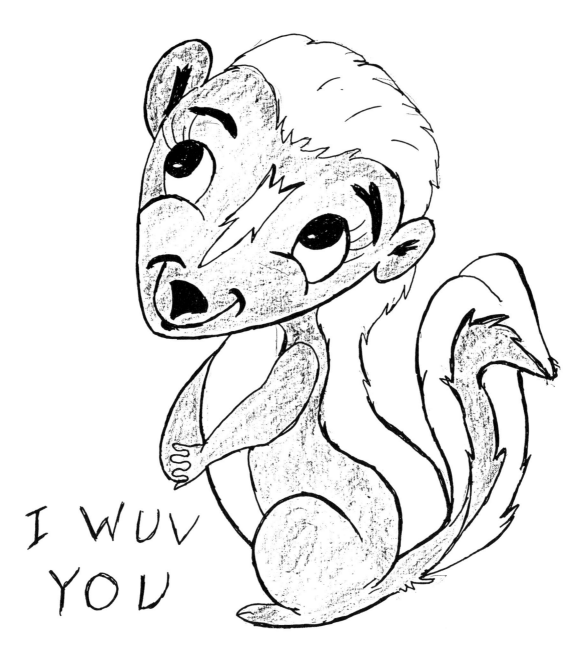

I WUV YOU

45

From My Institution to Yours, 1987
Mixed media
Installation 192 x 180 x 120 in. (487.7 x 457.2 x 304.8 cm)
Lent by the artist
Courtesy Rosamund Felsen Gallery, Los Angeles

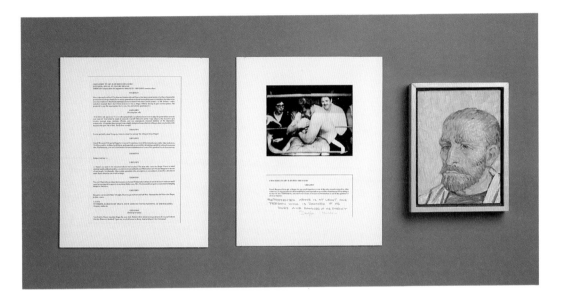

46

Crocodile Tears: Buried Treasure (Van Gogh), 1985
Oil on canvas, photograph, and text
Installation 14 x 39 in. (35.5 x 99 cm)
Kuhlenschmidt/Simon Gallery, Los Angeles, and Leo Castelli
Gallery, New York

47

Crocodile Tears: Buried Treasure II (De Chirico), 1985
Oil on canvas, photograph, and text
Installation 48 ¼ x 66 in. (122.6 x 167.6 cm)
Federal Reserve Bank of San Francisco, Los Angeles Branch
[Not illustrated]

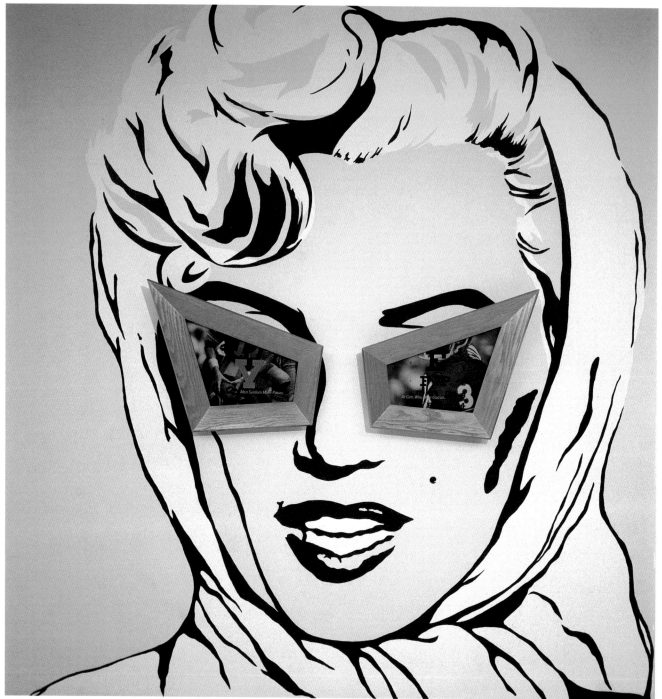

Installation at Walker Art Center, Minneapolis, 1986

48

Men Seldom Make Passes at Girls Who Wear Glasses, 1986, replicated 1987
Wall painting with two framed mixed media collages
Installation 144 x 180 in. (365.8 x 457.2 cm)
Lent by the artist
Courtesy Margo Leavin Gallery, Los Angeles

Abakanowicz

Abramović and Ulay

Golub

Allen

Nauman

Armajani

Paik

Holzer

Paolini

Poirier

Basquiat

Immendorff

Isermann and Segalove

Jenney

Bofill

Johnson

Kounellis

Kruger

Serrano

Coe

Lin

Lujan

Teraoka

Venturi, Rauch and Scott Brown

Moore

The contemporary avant-garde has witnessed the transition of the role of the artist from antagonist at society's periphery to committed participant in the continuance and interpretation of the culture. The classic avant-garde had viewed the artist as alienated from society, as the determined adversary of inherited culture. Not surprisingly, many of the most significant innovations of modern art represented a concerted effort to break from the conventions and values of established culture; some of the most advanced modern art pioneered in the creation of art forms that had little or no direct reference to the social and cultural milieu from which it had sprung, art forms that tended to stress private response and individual introspection. Many contemporary artists, persuaded less by the purposes of asserting their independence from the received culture than of assuring its continuing vitality, affirm an ethical responsibility of addressing the communal concerns and shared values of the body politic.

In *Unex Sign #1*, 1983, Jenny Holzer uses a public medium, an electronic message board, to examine the social and political attitudes implicit in clichés of thought and commonplace sayings. Barbara Kruger's photographs — such as *Roy Toy (Make my day)*, 1986, which juxtaposes a photograph of a wildcat eating prey with a photograph of McCarthyite Roy Cohn and the message "Make my day" — suggest a nasty connection between official political oppression and apparently harmless expressions of macho bravado. Similarly sexual politics is the subject of Bruce Nauman's recent animated neon tableaux.

Overtly political art had sometimes been associated with the avant-garde, and such ideological activism continues in the work of some contemporary artists. Leon Golub depicts the violence perpetrated by unidentified but politically repressive governments. And Hans Haacke's work, diagnosing the ways in which the activities of large corporations affect the physical, psychological, and cultural lives of all individuals in industrial societies, confronts the viewer with issues of social ethics.

But generally, politically and socially concerned artists such as Magdalena Abakanowicz, Sue Coe, Neil Jenney, and Terry Allen have assumed a less confrontational, more interpretive role, probing the personal involvement of artists and viewers alike in experiences as diverse as life under totalitarian regimes, survival in urban America, witnessing the piecemeal destruction of nature, or the psychological shock of veterans returning from Vietnam.

A renewed sense of social purpose is reflected in today's public art, especially in the United States where there has been a resurgence of art of commemorative or civic significance. For example, Maya Ying Lin's Vietnam Veterans Memorial and Venturi, Rauch and Scott Brown's Western Plaza — a public square in Washington, D.C., whose paving replicates Pierre L'Enfant's 1791 symbolic plan for the capital city — address events and concepts central to American experience. And Siah Armajani's *Meeting Garden*, a gathering place whose simple architecture was inspired by indigenous forms of American architecture, was conceived in a spirit of exercising such democratic values as freedom of assembly and freedom of speech.

Values and attitudes invested in popular culture are vital subjects in contemporary art. Ilene Segalove and Jim Isermann's collaborative work for this exhibition deals with 1960s American optimism about the future, particularly as reflected in its television programs. Nam June Paik's robot family pokes fun at television's influence on every aspect of living, including self-perception. Jazz, the streets, and urban energy are the sources of Jean-Michel Basquiat's paintings, while Gilbert Lujan and Masami Teraoka, respectively, explore the results of transposing traditional Mexican and Japanese cultures into contemporary societies.

The past, far from being a pernicious tyranny to be shunned, as it was for the classic avant-garde, offers conceptual and stylistic models that provide many contemporary artists with a point of departure. Major contemporary projects by architects Charles Moore, Philip Johnson, and Ricardo Bofill are imaginative reconsiderations of historical forms and precedents. Shared memory and mythologies of the classical past are invoked in the art of Anne and Patrick Poirier, Jannis Kounellis, and Giulio Paolini. The highly mannered works of these architects and sculptors are fictionalizations of historicized styles, which, transposed into the context of present culture, assume a provocative theatricality.

Clearly there has been a deep-rooted shift in attitudes among progressive artists about their role and the function of their art in the ongoing culture. Contemporary artists recognize that in the role of protagonist they must address the concerns of the audience in an accessible vocabulary that relates their art to the viewers' specific experiences and culture.

49

Uner Sign #1, selections from Survival series, 1983
Spectrocolor machine with moving graphics
30 ½ x 116 ½ x 11 ⅝ in. (77.5 x 295.9 x 29.5 cm)
Whitney Museum of American Art, New York
Purchase, with funds from the Louis and Bessie Adler Foundation,
Inc., Seymour M. Klein, President

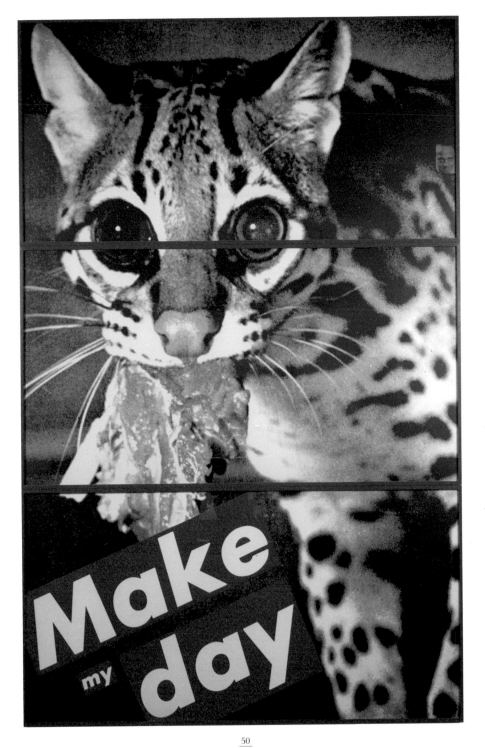

Roy Toy (Make my day), 1986
Photograph
138 ¼ x 90 ½ in. (351.1 x 229.9 cm)
The Eli Broad Family Foundation, Los Angeles

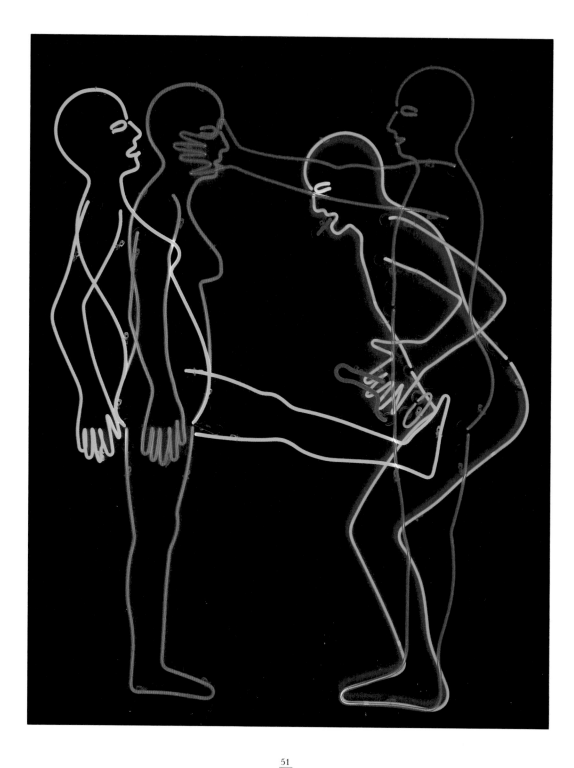

51

Punch and Judy: Kick in the Groin, Slap in the Face, 1985
Neon and glass tubing mounted on aluminum
77 x 61 x 14 in. (195.6 x 154.9 x 35.6 cm)
Leo Castelli Gallery, New York

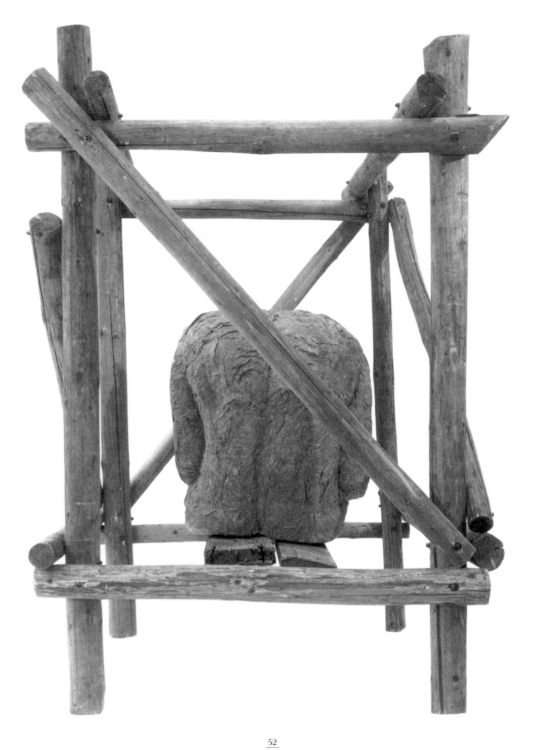

52

Cage, 1981
Burlap, glue, and wood
66 x 46 x 61 in. (167.6 x 116.8 x 154.9 cm)
Museum of Contemporary Art, Chicago
Gift of Ralph I. and Helyn D. Goldenberg

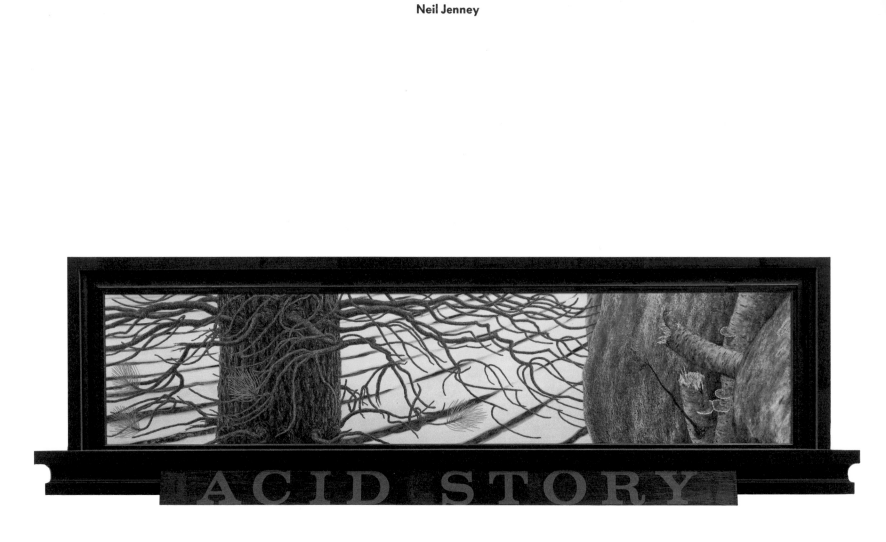

Acid Story, 1983–84
Oil on wood
34 ½ x 140 x 5 in. (87.6 x 355.6 x 12.7 cm)
Steve Martin
Promised gift to Los Angeles County Museum of Art

The Right to Life, 1979
Color photograph and silkscreen, edition of 2
50 ¼ x 40 ¼ in. (127.6 x 162.2 cm)
Allen Memorial Art Museum, Oberlin College, Ohio
R. T. Miller, Jr., Fund

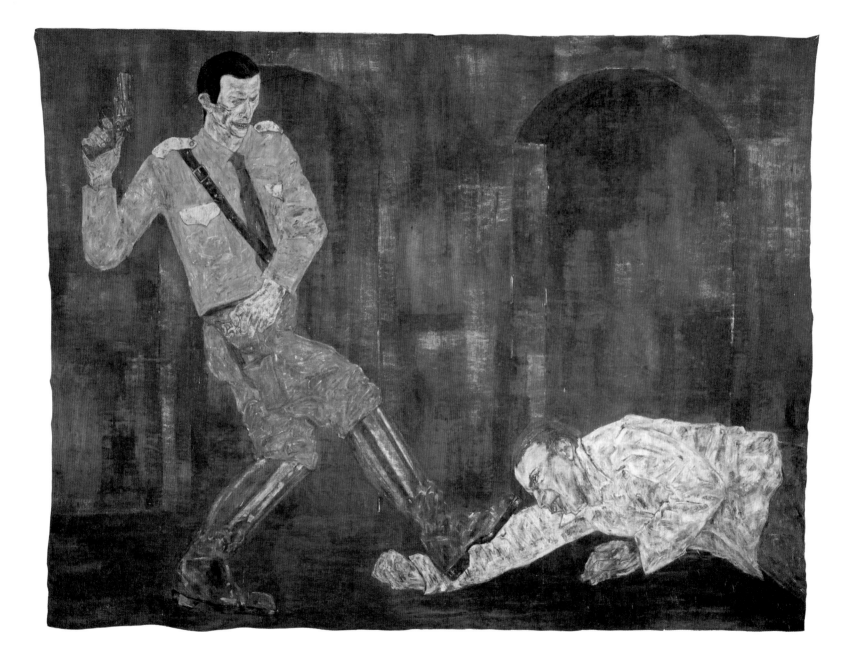

55

White Squad V, 1984
Acrylic on canvas
120 x 161 in. (304.8 x 408.9 cm)
The Eli Broad Family Foundation, Los Angeles

Sue Coe

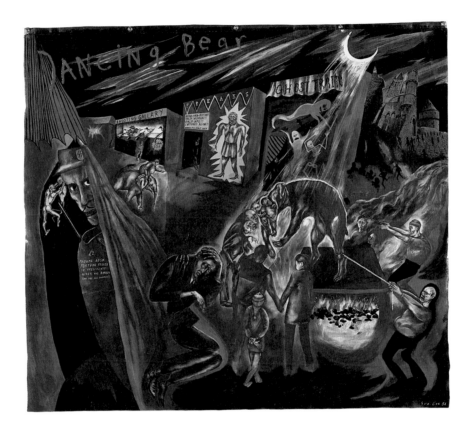

56

Dancing Bear, 1984
Mixed media
52 ⅝ x 59 ⅜ in. (133.7 x 150.8 cm)
San Francisco Museum of Modern Art
Albert M. Bender Collection, purchased
through a gift of Albert M. Bender

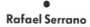

Rafael Serrano

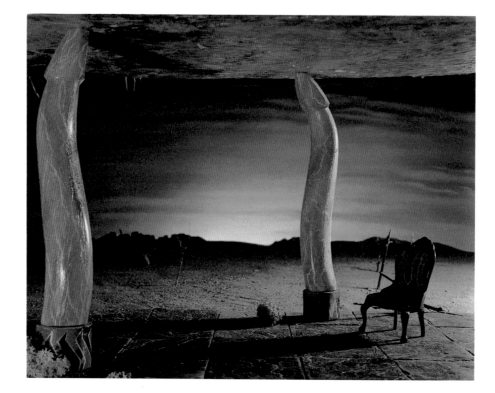



57

Panorama — Night, from Fertility of War series, 1986
Ektacolor photograph
30 x 40 in. (76.2 x 101.6 cm)
Lent by the artist





58

Untitled, from Fertility of War series, 1986
Ektacolor photograph
30 x 40 in. (76.2 x 101.6 cm)
Lent by the artist
[Not illustrated]



Terry Allen

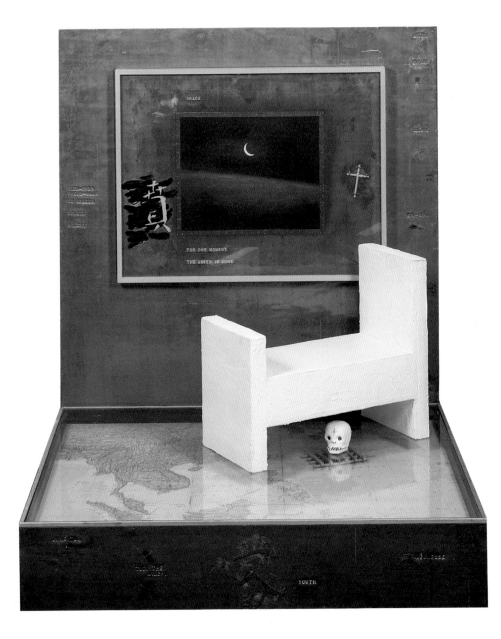

59

Grace, from Youth in Asia series, 1985
Mixed media
48 ¼ x 42 x 39 in. (122.5 x 106.7 x 99 cm)
Mr. and Mrs. Walter L. Weisman, Woodland Hills, California
Promised gift to Los Angeles County Museum of Art

Maya Ying Lin

Vietnam Veterans Memorial, Washington, D.C., 1981–82
[Represented in exhibition by model lent by Library of Congress,
Washington, D.C., and photodocumentation]

61

Western Plaza, Pennsylvania Avenue, Washington, D.C., 1977
[Represented in exhibition by photodocumentation]

Meeting Garden, Artpark, Lewiston, New York, 1980
[Represented in exhibition by model and photodocumentation lent
by the artist, courtesy Max Protetch Gallery, New York]

Family of Robot: Mother, 1986
Television cabinets and sets,
video cassette player, videotape
80 x 61 ½ x 21 in. (203.2 x 156.2 x 53.3 cm)
Carl Solway Gallery, Cincinnati

Family of Robot: Father, 1986
Television cabinets and sets,
video cassette player, videotape
89 x 54 ¾ x 20 ½ in. (226.1 x 139.1 x 52.1 cm)
Carl Solway Gallery, Cincinnati

Connection, 1986
Television cabinets and sets,
video cassette player, videotape
133 x 139 x 21 ¾ in. (337.8 x 353.1 x 55.2 cm)
Carl Solway Gallery, Cincinnati
[Not illustrated]

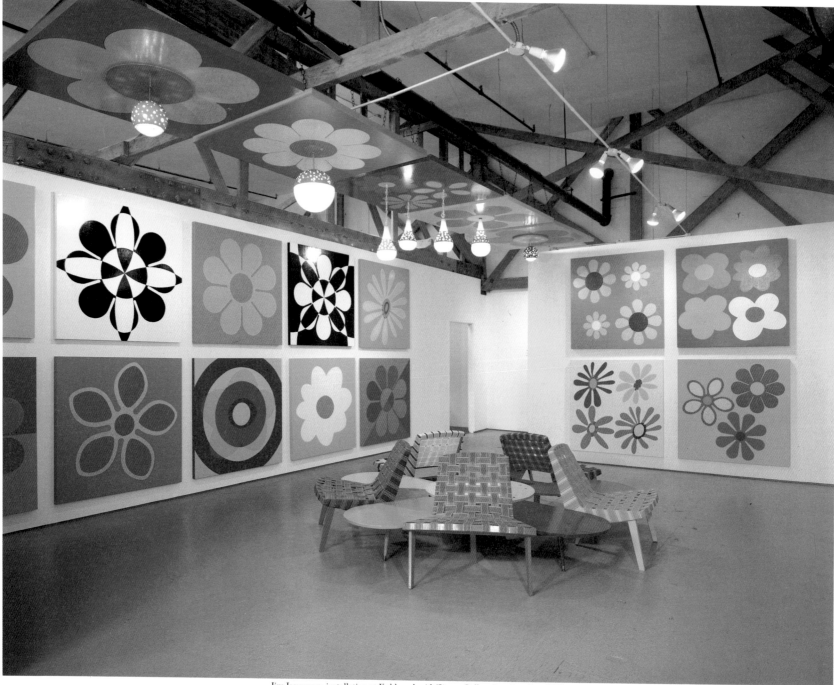

Jim Isermann, installation at Kuhlenschmidt/Simon Gallery, Los Angeles, 1986

Ilene Segalove, from *More TV Stories*, 1985, videotape

Futura, 1987
Furnished lounge and videotape
180 x 216 x 216 in. (457.2 x 548.6 x 548.6 cm)
Lent by the artists
[Not illustrated]

67	68	69	70	71
Tampon Series: Tabakobon, 1981	*Tampon Series: Figleaf and Kleenex*, 1981	*Tampon Series: Inro*, 1981	*Tampon Series: 12 Months' Supply*, 1982	*Tampon Series: Woman and Grasshoppers*, 1982
Watercolor	Watercolor	Watercolor	Watercolor	Watercolor
10 ½ x 6 ¾ in. (26.7 x 17.1 cm)	8 ½ x 11 ⅜ in. (21.6 x 28.9 cm)	11 ⅜ x 8 ½ in. (28.9 x 21.6 cm)	12 ¼ x 9 ⅛ in. (31.1 x 23.2 cm)	8 ½ x 11 ⅜ in. (21.6 x 28.9 cm)
Space Gallery, Los Angeles	Space Gallery, Los Angeles	Space Gallery, Los Angeles	Space Gallery, Los Angeles	Space Gallery, Los Angeles
	[Not illustrated]	[Not illustrated]	[Not illustrated]	[Not illustrated]

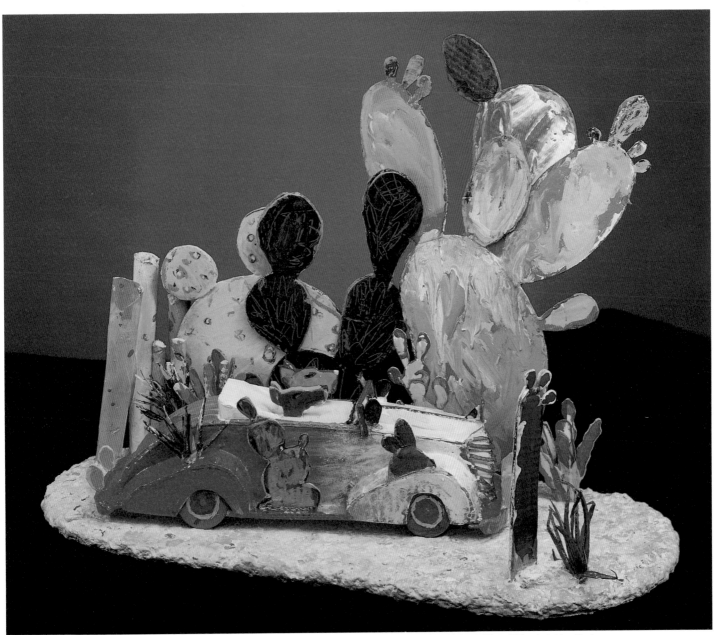

Cactus Parade, 1986, cardboard with acrylic/vinyl paint, 20 x 18 x 28 in. (50.8 x 45.7 x 71.1 cm), Mr. and Mrs. Aminidav Aloni

Procession, 1987
Enamel on corrugated board and wood
Installation 132 x 120 x 120 in. (335.3 x 304.8 x 304.8 cm)
Lent by the artist
[Not illustrated]

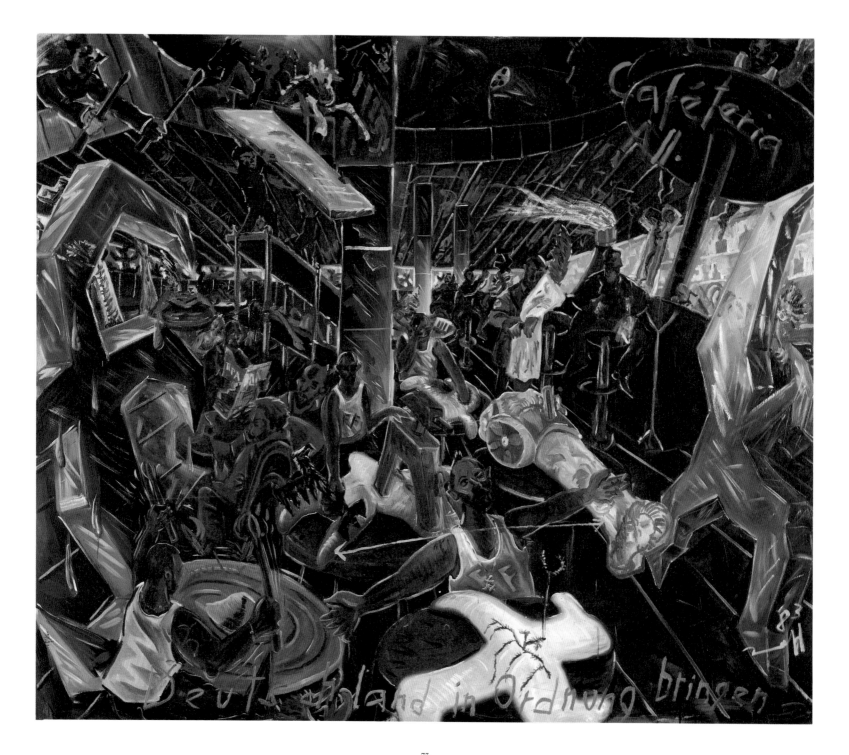

To Bring Germany to Order, 1983
Oil on canvas
111 x 130 in. (281.9 x 330.2 cm)
Norman and Irma Braman, Miami
Courtesy Mary Boone/Michael Werner Gallery, New York

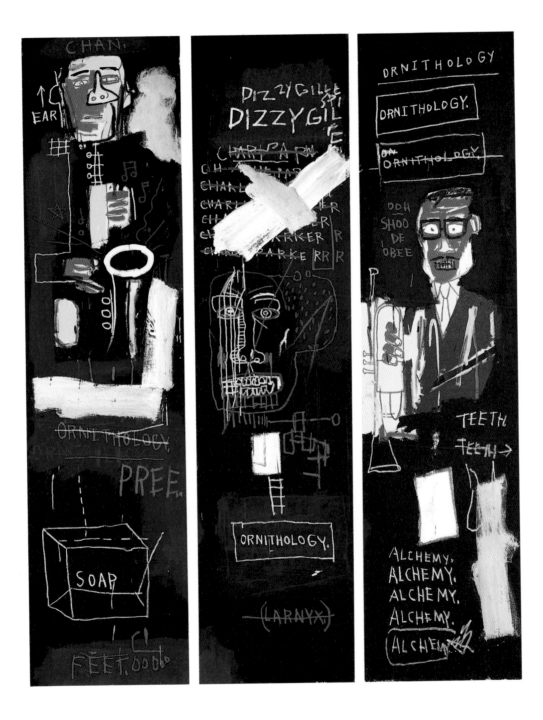

74

Horn Players, 1983
Acrylic and mixed media on canvas
96 x 75 in. (243.8 x 190.5 cm)
Eli and Edythe L. Broad, Los Angeles

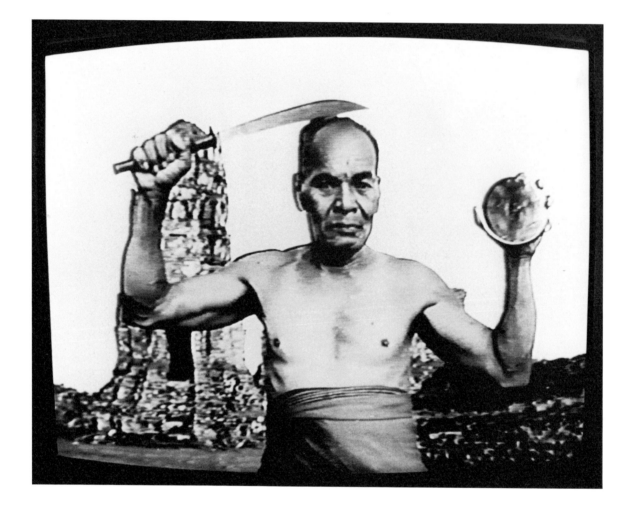

75

City of Angels, 1983
Videotape
20 minutes
Courtesy Electronic Arts Intermix, New York

76

Terra degli Dei Madre, 1984
Videotape
20 minutes
Courtesy Electronic Arts Intermix, New York
[Not illustrated]

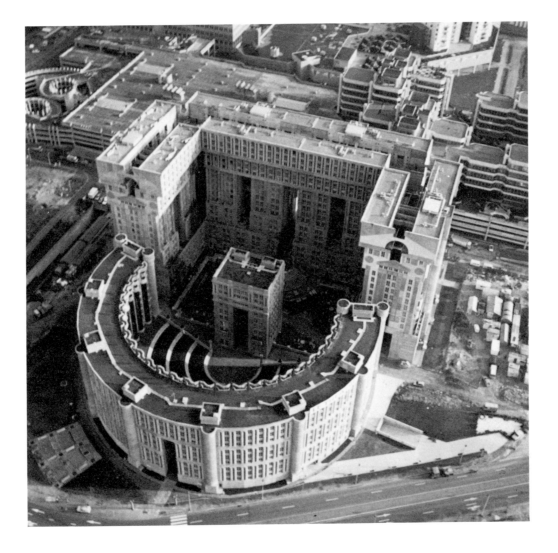

77

Les Espaces d'Abraxas, Marne-la-Vallée, France, 1978–83
[Represented in exhibition by photodocumentation
lent by the architect]

Philip Johnson

78

AT&T Corporate Headquarters, New York, 1978–85
[Represented in exhibition by model lent by AT&T,
New York, and photodocumentation]

79

Piazza d'Italia, New Orleans, 1974–78
[Represented in exhibition by photodocumentation]

Jannis Kounellis

Untitled, 1981
Wash paint on canvas, plaster casts, iron shelves, and soot
94 x 115 in. (238.8 x 292.1 cm)
Private collection
Courtesy Sonnabend Gallery, New York

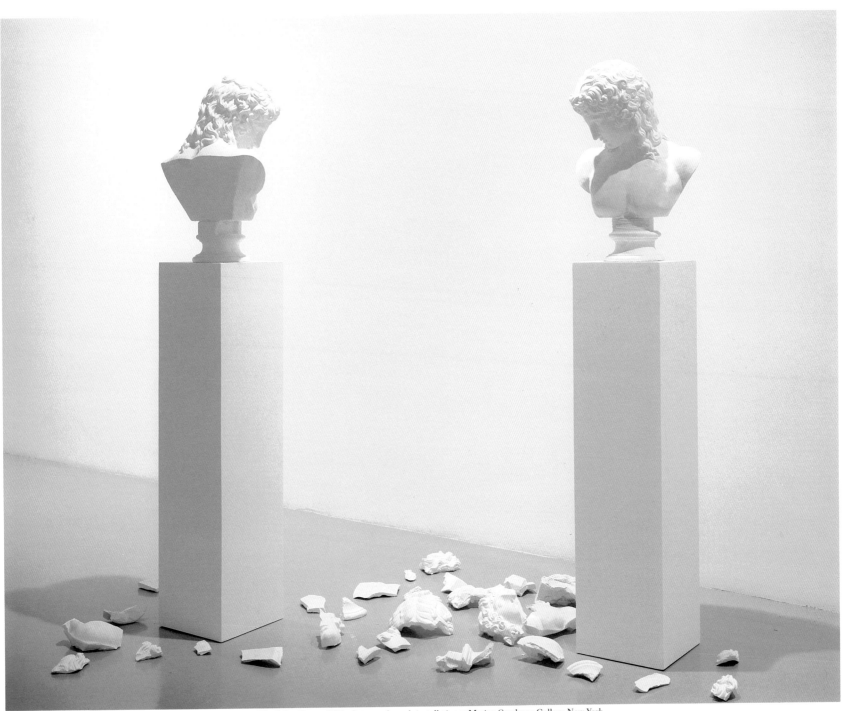

The Other Figure, 1986, plaster and wood, installation at Marian Goodman Gallery, New York

81

The Other Figure, 1983
Plaster and wood
Installation 70 x 42 x 20 in. (177.8 x 106.7 x 50.8 cm)
Marian Goodman Gallery, New York
[Not illustrated]

Anne and Patrick Poirier

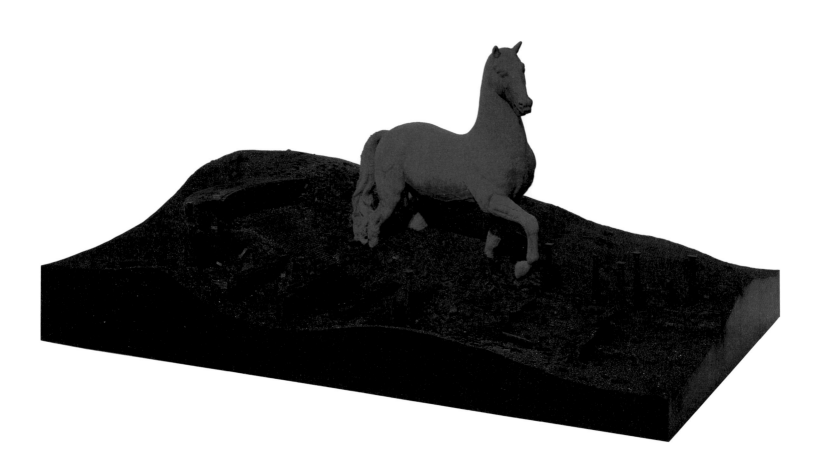

Pegasus, 1984
Charcoal, plaster, wood, and pigment
42 x 92 x 61 ½ in. (106.7 x 233.7 x 156.2 cm)
Marc and Livia Straus, Chappaqua, New York

Abakanowicz

Abramović and Ulay

Alberola

Albert

Allen

Anderson

Armajani

Aycock

Baldessari

Barni

Basquiat

Bender

Bidlo

Bofill

Bohatsch

Borofsky

Braunteich

Campbell

Caporael

Chevalier

Clegg and Guttman

Clemente

Cobo

Coe

Cucchi

Cutrone

Dahn

Diao

di Stasio

Dokoupil

Drake

Durham

Fischl

Fisher

Frailey

Frame

Garouste

Gober

Golub

Gormley

Haacke

Halley

Haring

Herman

Holzer

Huebler

Immendorff

Isermann and Segalove

Jenney

Johnson

Ketley

Kiefer

Keene

Kounellis

Kruger

Laddin

Le Brun

Lere

Levine

Levinthal

Lim

Longo

Lojan

Lüpertz

Maggiotto

Majore

Mariani

McCollum

McKenna

Mendieta

Moore

Morphesis

Morris

Müller

Mullican

Nauman

Nerdrum

Ott

Paik

Paladino

Paolini

Poirier

Polke

Raaum

Rainer

Reiss

G. Richter

S. Richter

Rothenberg

Salle

Schindler

Serrano

Shelton

Sherman

Smith

Solien

Steinbach

Sarlo

Saron

Tansey

Jacobin

Uklos

Venturi Rauch and Scott Brown

Viola

Yamaguchi

A common idea about avant-garde art, as it came to be understood in the 1960s and the early 1970s, was that advanced artists took aesthetic risks in order to challenge the definition of art and expand its limits. Yet it is possible to anaylze the history of modern art as a progressive delimiting of artistic concerns. This reductivist tendency, well-noted in modern art, culminated in the 1960s and early 1970s with advanced art's exclusionary emphasis on form, material, and process. The logical evolution of modernist ideas about art led many modern artists to regard the art object as an independent unit: self-referential, purified of extraneous subject matter, and resistant to viewers' literary interpretations.

Many contemporary artists, while acknowledging that the exploration of the limits of art is an area of primary interest to all artists, have subsumed the modernist exploration of the material and formal limits of visual art to an expanded notion of the content and purpose of visual art. Their intent is to provoke the viewer's interpretation as an integral part of the experience of art, and they approach their art with a belief in its capacity to express something akin to a philosophy of existence. Much contemporary art, related to nineteenth-century symbolist and romantic traditions, stresses symbol, metaphor, and allegory: forms that present one reality in terms of another and lend themselves to the expression of psychological, mythical, and spiritual aspects of human existence.

Artists such as Carlo Maria Mariani, Stefano di Stasio, Odd Nerdrum, Stephen McKenna, Gérard Garouste, and Jean-Michel Alberola, working in styles that seem to come from earlier periods of art history, draw upon biblical and mythological themes. Their idealized and mannered imaging of human subjects and events are aggrandized beyond the ordinary. Underlying such art is an impulse to center art not within the material limits of the object but in the very activity of conceptualization. A similar sense of heightened reality is conveyed in the use of such archetypes as the journey, the search, and the return, which are prevalent in the narrative forms that have emerged in recent years as primary expressive modes for such artists as Thomas Schindler, Hermann Albert, Peter Chevalier, and Steven Campbell.

A distinctly psychological expressionism is the inspiration for artists as diverse as Suzanne Caporael, Eric Fischl, Francesco Clemente, Peter Drake, Jonathan Borofsky, T. L. Solien, Keith Haring, Roland Reiss, Komar and Melamid, Cindy Sherman, and Susan Rothenberg. Their evocations of personal reveries, remembrances, dream images, and fantasy, reflect a pervasive interest in the search for identity and an inquiry into the nature of human psychology.

Josef Felix Müller's wood carving, the six-breasted *Mother*, 1985, expresses a vision of mankind's primordial condition as an animal in nature. Bill Viola, Peter Shelton, Yuriko Yamaguchi, and Mark Lere also probe this primal identification with the natural world. Antony Gormley's *The Beginning, the Middle, the End*, 1983–84, suggests a cycle to man's mortal, corporeal existence, while Ana Mendieta's wood carvings from her Totem Grove series evoke ancestral spirits.

Often, spiritual values in modern avant-garde art were expressed through abstract forms; but in contemporary art spiritual, religious, and philosophical content are more likely to draw upon representational styles and iconographic traditions. The human figure, sometimes depicted with elements of traditional Christian iconography, is a primary aspect of the art of Brad Durham, John Frame, and Jim Morphesis, in whose art the themes of anxiety and struggle are prominent. The allegorical depictions of Jiři Georg Dokoupil, Roberto Barni, and Markus Lüpertz reveal humanity as subject to its own limitations in a universe governed by forces beyond its control. The art of Chema Cobo, William Raaum, Erwin Bohatsch, Arnulf Rainer, Robert Morris, and Robert Longo is suffused with visions of angst

and apocalypse. An undefinable yet patently tragic tone prevails in their work, perhaps deriving from the artists' attempts to suggest humanity's culpability in its own fate.

A visionary cosmology informs the work of some artists. In the art of Mimmo Paladino people and animals cohabit a realm with the spirits of other people and animals. The horse in Christopher Le Brun's *Prow*, 1983, emerging with a mighty and heroic energy as if from a wave, is a metaphor for an unstoppable life force. The spiraling flames in Enzo Cucchi's *A Painting of Precious Fires*, 1983, symbolize the artist's existential vision: the triumph of vitality in an indifferent universe. The impossible and unwieldy machines of Alice Aycock are metaphors for the unending intelligence and force that informs all creation. Matt Mullican's massive charts and schematic designs reveal order and function in the physical creation. And Anselm Kiefer's art, mythic in its import, raises the possibility — through knowledge, transmitted culture, and belief — of human transcendence over the elements, history, and death.

The most ambitious contemporary art aspires to an ever more comprehensive vision of existence in an attempt to reveal mankind's involvement with the surrounding infinitude. The art of the contemporary avant-garde is an art of expansion, of inclusion, of synthesis, through which contemporary artists have undertaken the ethical mission to search for the significance of human existence and express the beliefs by which mankind lives.

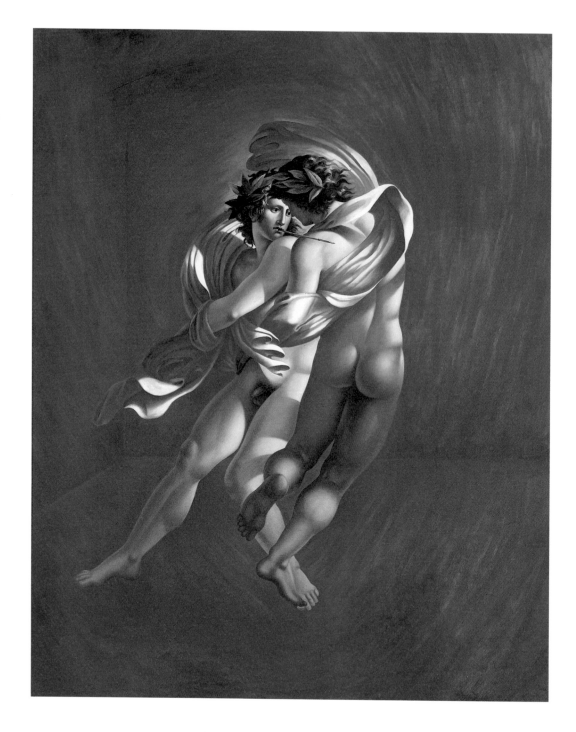

83

Looking into a Celestial Mirror, 1984
Oil on canvas
98 ⅜ x 78 ¾ in. (250 x 200 cm)
Mr. and Mrs. Stewart Resnick, Beverly Hills
Promised gift to Los Angeles County Museum of Art

Stefano di Stasio

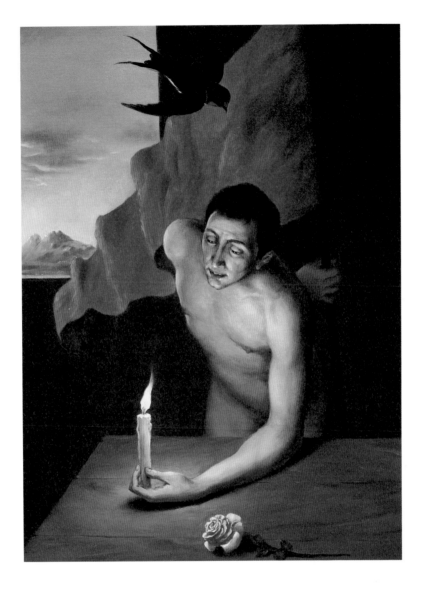

84

Evening, 1986
Oil on canvas
43 x 31 in. (109.2 x 78.7 cm)
Lent by the artist

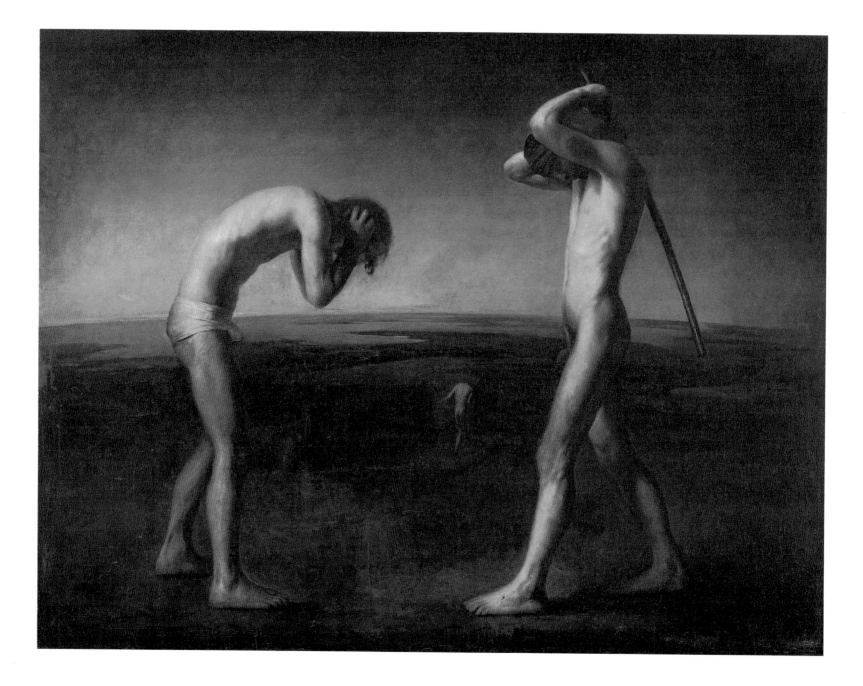

Iron Law, 1983–84
Oil on canvas
82 x 114 in. (208.3 x 289.6 cm)
Martina Hamilton Gallery, New York

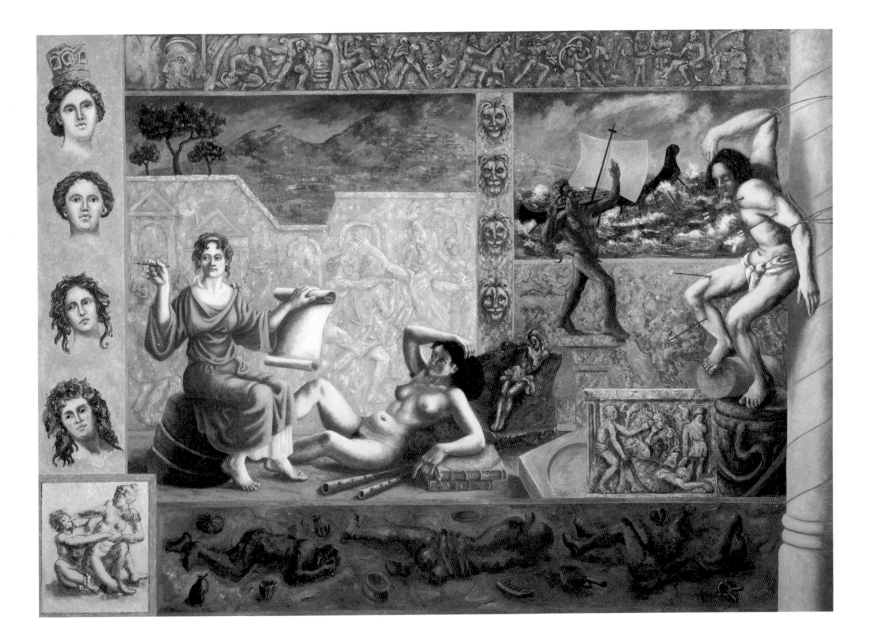

86
Clio Observing the Fifth Style, 1985
Oil on canvas
78 x 110 in. (198.1 x 279.4 cm)
Lent by the artist
Courtesy Edward Totah Gallery, London

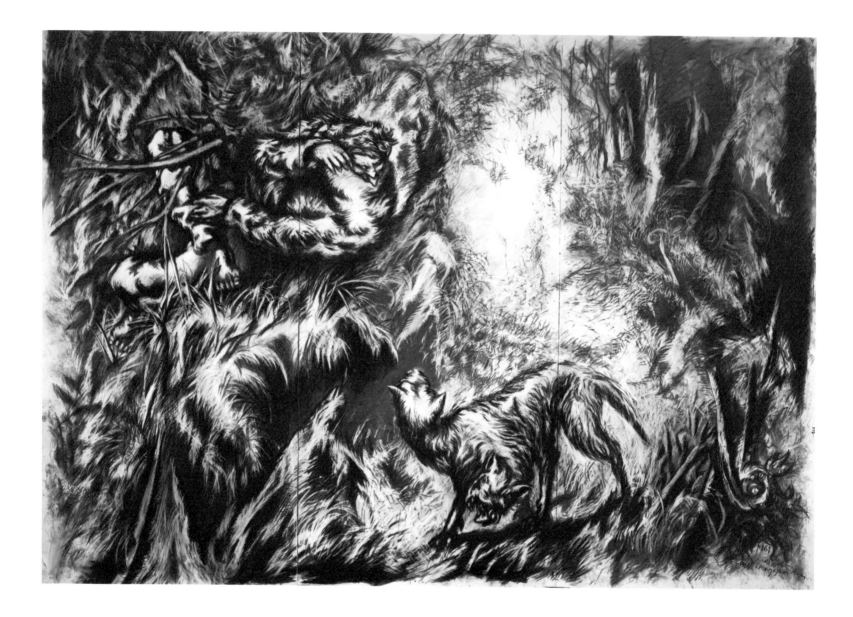

Study for Orthios and Orion, 1982
Pastel and conte crayon on paper
116 ½ x 159 ½ in. (295.9 x 405.1 cm)
Leo Castelli Gallery, New York

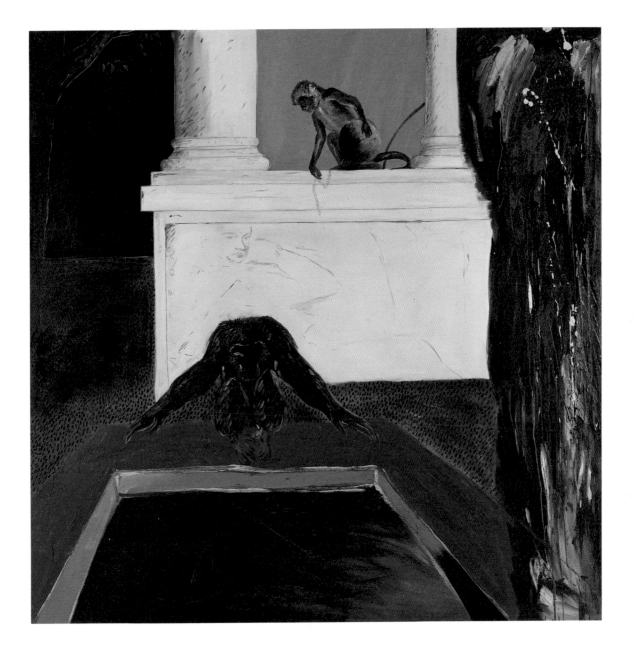

88

Suzanna and the Elders: The Idea Received, 1983
Oil on canvas
78 ¾ x 78 ¾ in. (200 x 200 cm)
Mr. Fredrik Roos, London

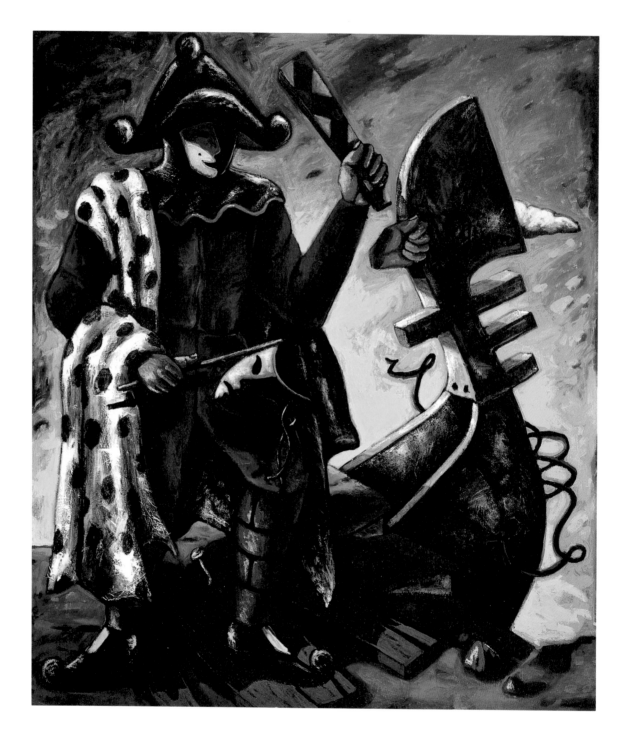

89

Arrival, 1985
Oil on canvas
88 x 76 in. (223.5 x 193 cm)
Chip and Laurie Tom, Chicago

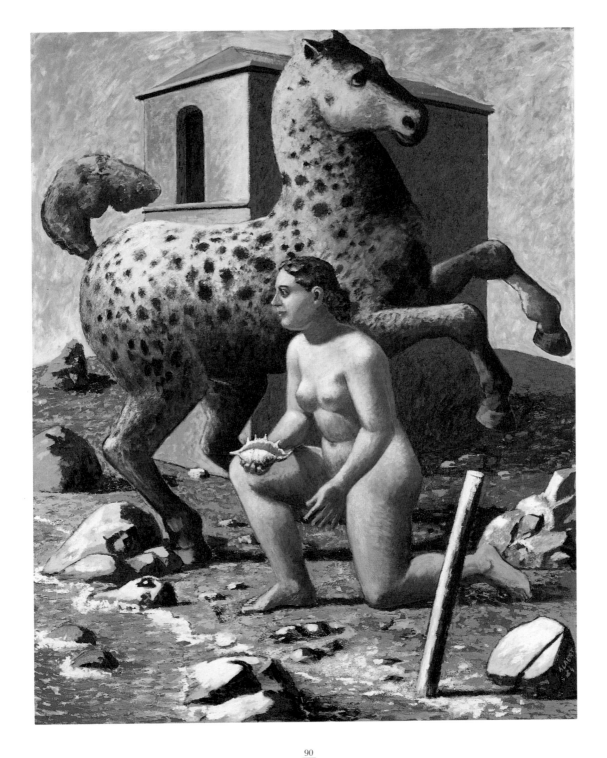

90

Horse and Nude by the Sea (Evening), 1984
Tempera on canvas
96 x 78 in. (243.8 x 198.1 cm)
Byron Meyer, San Francisco

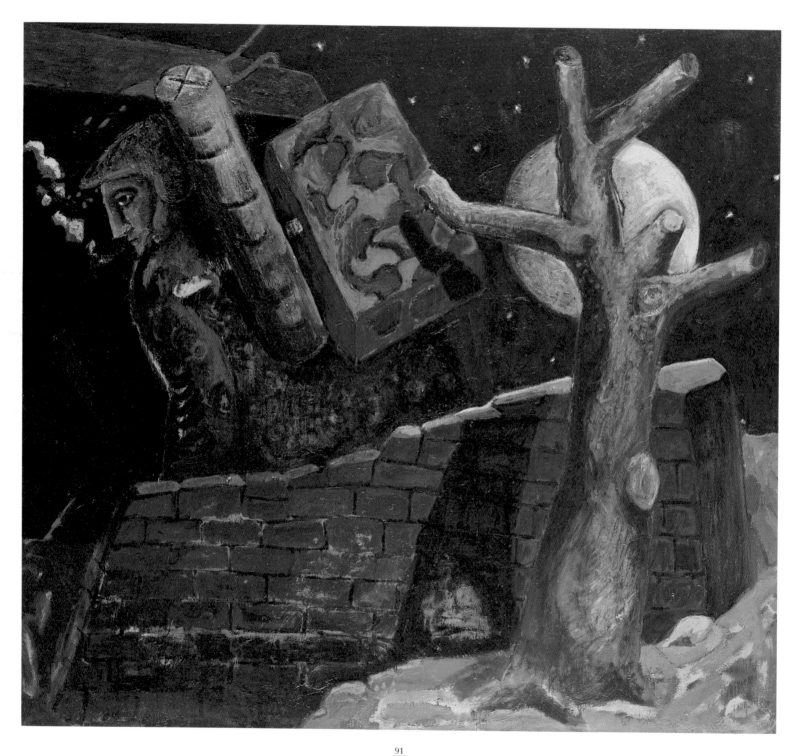

<u>91</u>
The Wanderer V, 1982–83
Oil on canvas
78 ¾ x 86 ½ in. (200 x 220 cm)
Raab Galerie, West Berlin

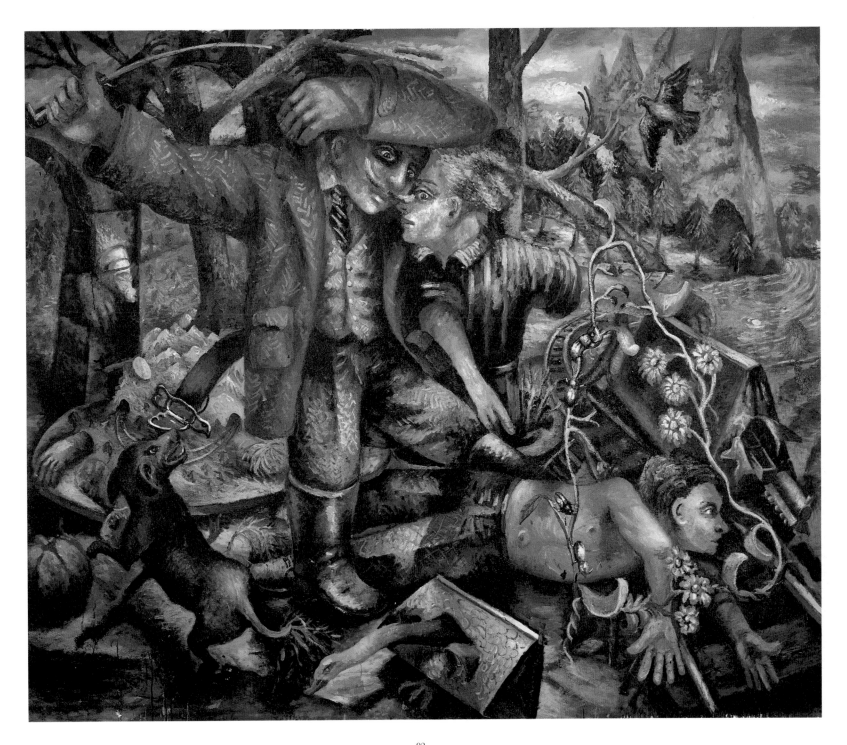

Men Insulting Nature and the Notion of Travel, 1986
Oil on canvas
83 x 99 in. (210.8 x 251.5 cm)
Nan and Gene Corman, Beverly Hills

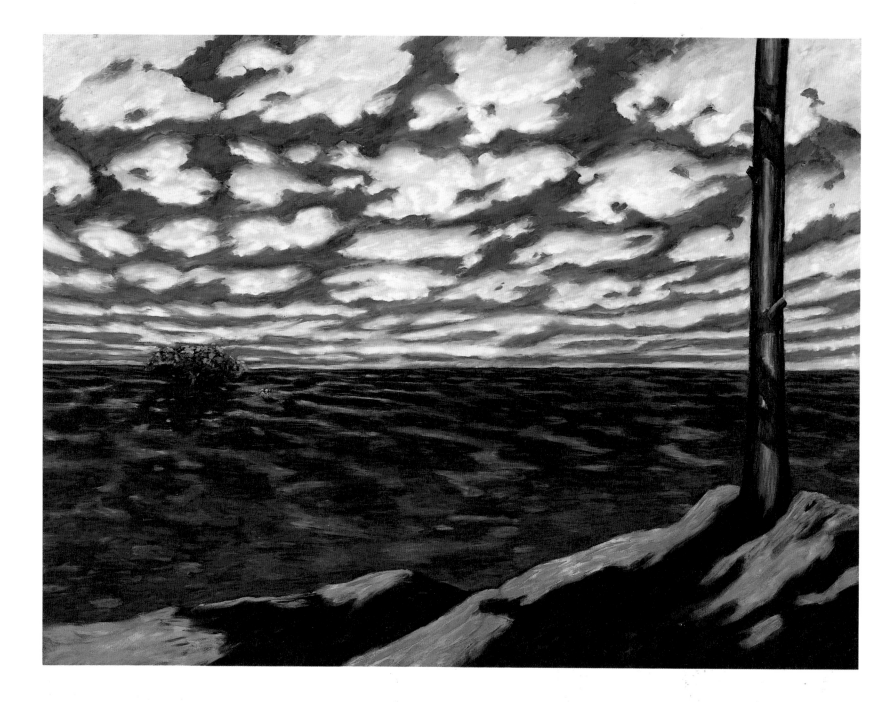

93

Absence Becomes You, 1986
Oil on canvas
72 x 96 in. (182.9 x 243.8 cm)
Lent by the artist
Courtesy Krygier/Landau Contemporary Art, Los Angeles

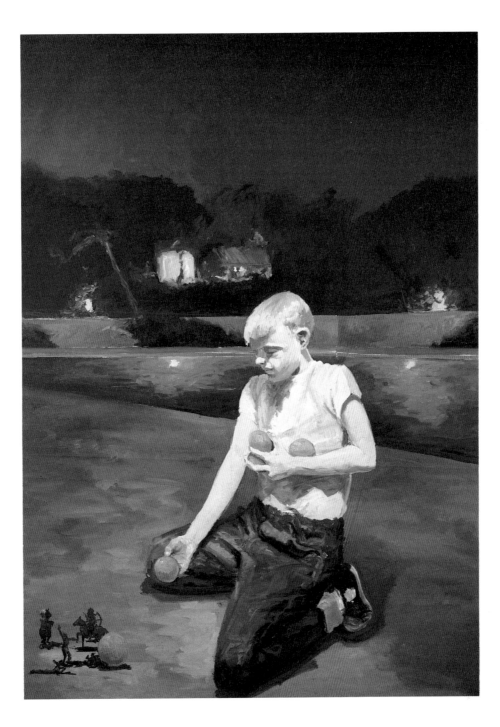

94

Best Western, 1983
Oil on canvas
107 ⅞ x 77 ½ in. (274 x 197 cm)
Speyer Family Collection, New York
Courtesy Mary Boone/Michael Werner Gallery, New York

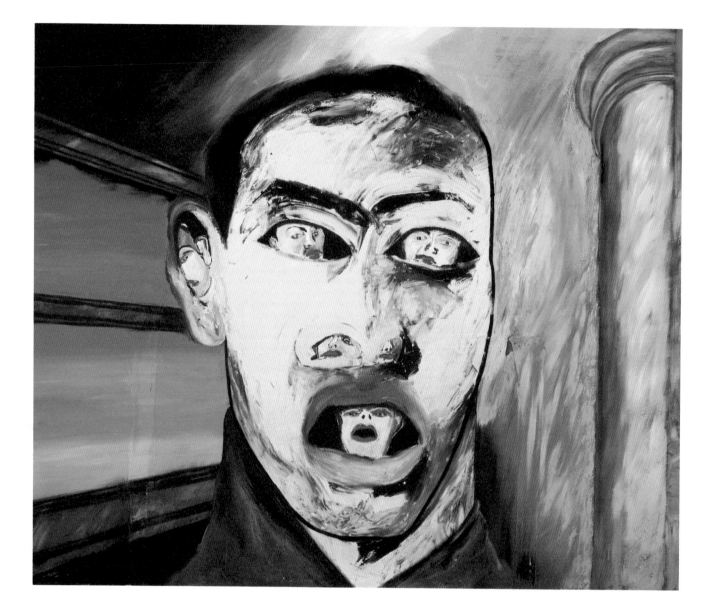

95

Untitled, 1983
Oil on canvas
78 x 93 in. (198.1 x 236.2 cm)
Thomas Ammann, Zurich

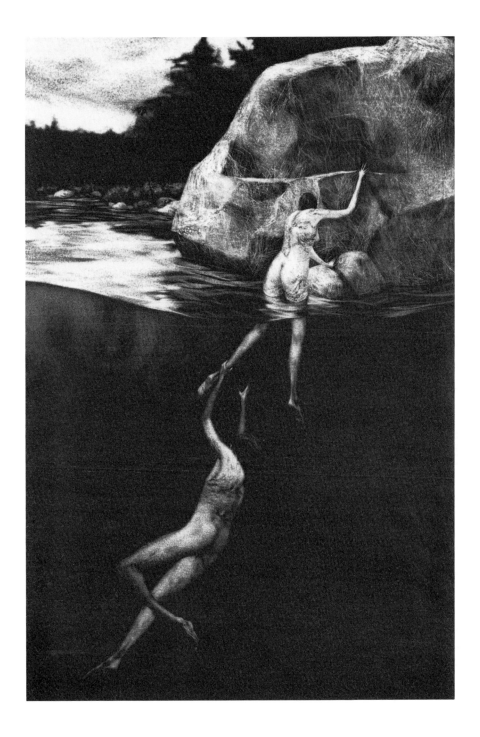

96

Ankle, 1986
Ink on paper, sanded
92 x 62 ½ in. (243.8 x 158.7 cm)
Robert Harshorn Shimshak, Berkeley, California
Courtesy Curt Marcus Gallery, New York

Jonathan Borofsky

I Dreamed a Dog Was Walking a Tightrope at 2,715,346, mixed media and video gallery installation at Los Angeles County Museum of Art, 1981

On-site project, 1987
Mixed media
Lent by the artist
[Not illustrated]

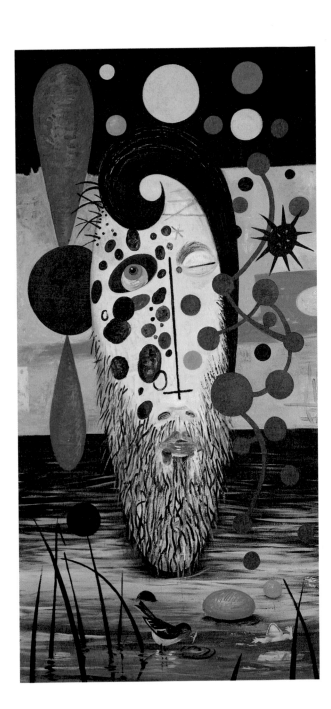

98

The Gaze of the Astronomer: A Stare into Space, 1985
Oil and enamel on canvas
96 x 48 in. (243.8 x 121.9 cm)
Boake and Marian Sells, Wayzata, Minnesota
Courtesy John C. Stoller & Co., Minneapolis

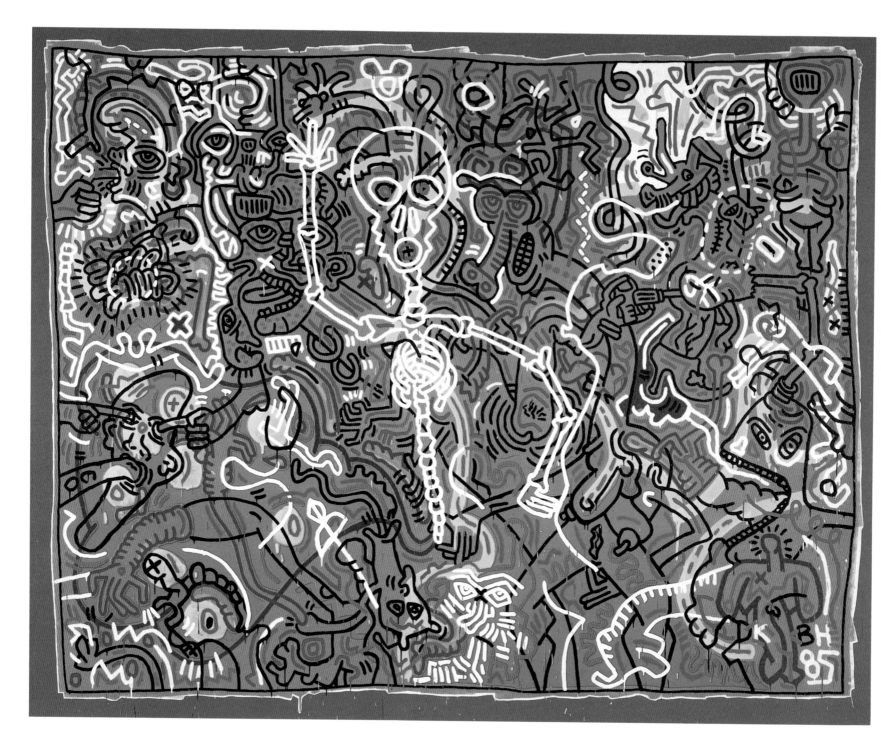

99

Untitled, 1983
Acrylic on canvas
120 x 144 in. (305 x 366 cm)
Elliott and Adrienne Horwitch, Beverly Hills

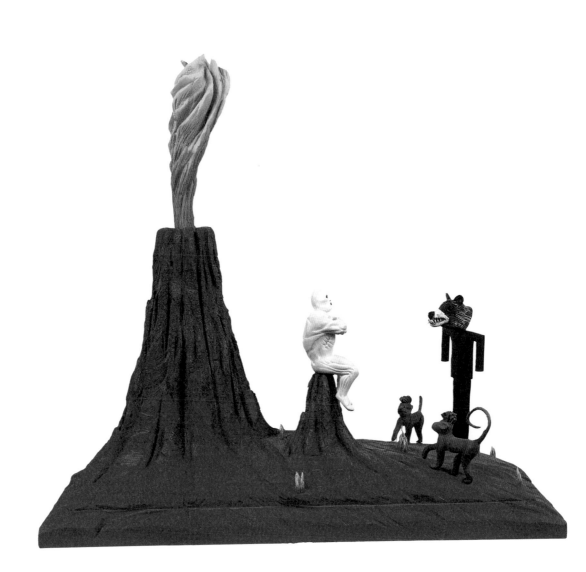

100

Keeper of the Fire, 1986
Polychromed wood
16 x 31 x 28 in. (40.6 x 78.7 x 71.1 cm)
Flow Ace Gallery, Los Angeles

101

Smooth Sailing, 1985–86
Mixed media
157 x 80 in. (398.8 x 203.2 cm)
Ronald Feldman Fine Arts, New York

102

No. 140, 1985
Color photograph
48 x 72 in. (121.9 x 182.9 cm)
Metro Pictures, New York

103

No. 147, 1985
Color photograph
48 x 72 in. (121.9 x 182.9 cm)
Gerald S. Elliott Collection, Chicago

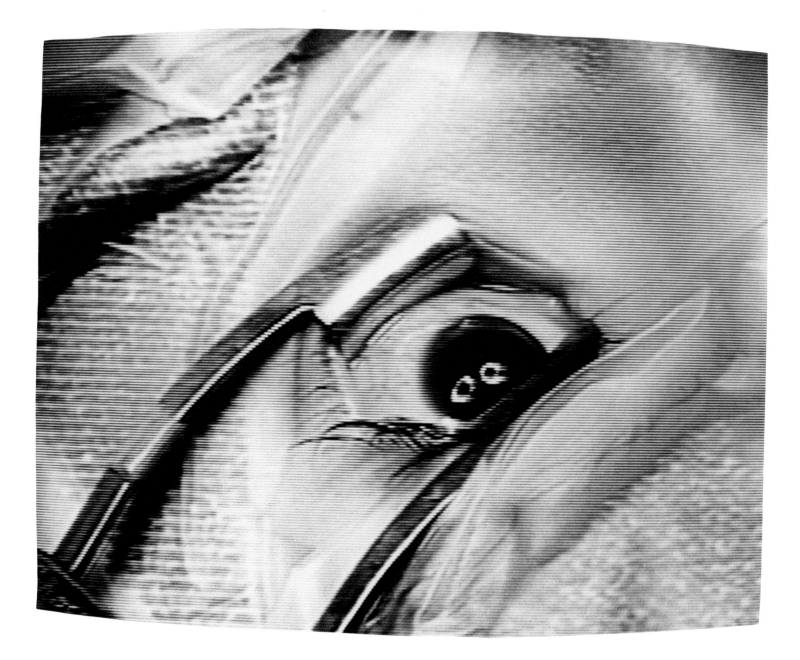

104

Anthem, 1983
Color videotape with stereo sound
11 minutes 30 seconds
Courtesy Electronic Arts Intermix, New York

Susan Rothenberg

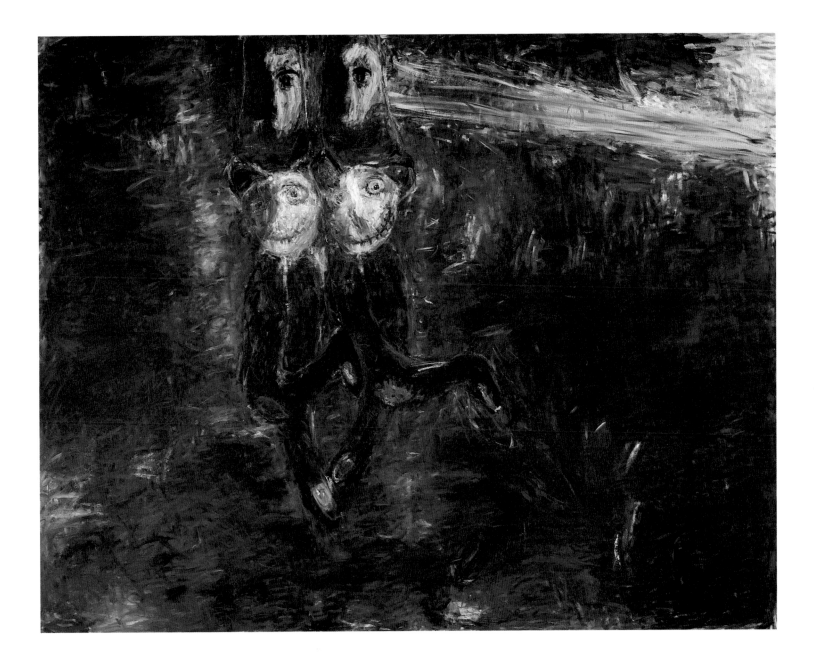

Green Ray, 1984
Oil on canvas
84 x 107 in. (213.7 x 271.8 cm)
The Edward R. Broida Trust, Los Angeles

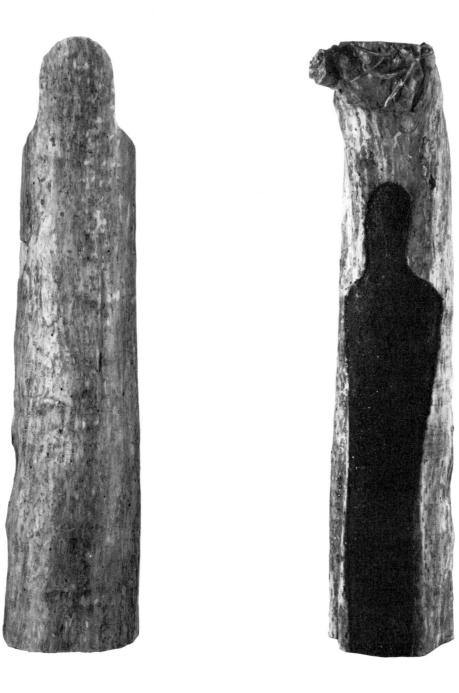

106

Untitled I and II, from Totem Grove series, 1985
Carved and burned tree trunks
Installation 180 x 120 x 120 in. (457.2 x 304.8 x 304.8 cm)
Estate of the artist

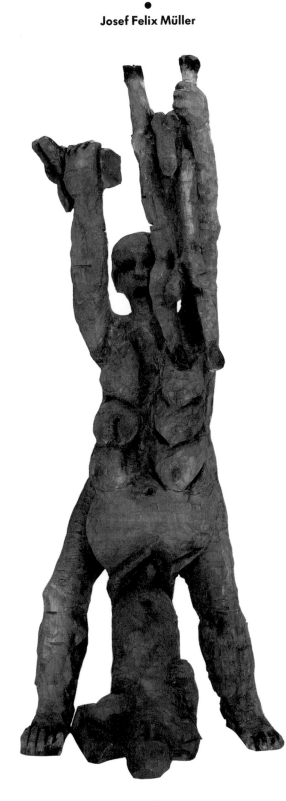

107

Mother, 1985
Painted wood
96 ½ x 38 ³/₁₆ x 33 ¹/₁₆ in. (245 x 97 x 84 cm)
Lent by the artist

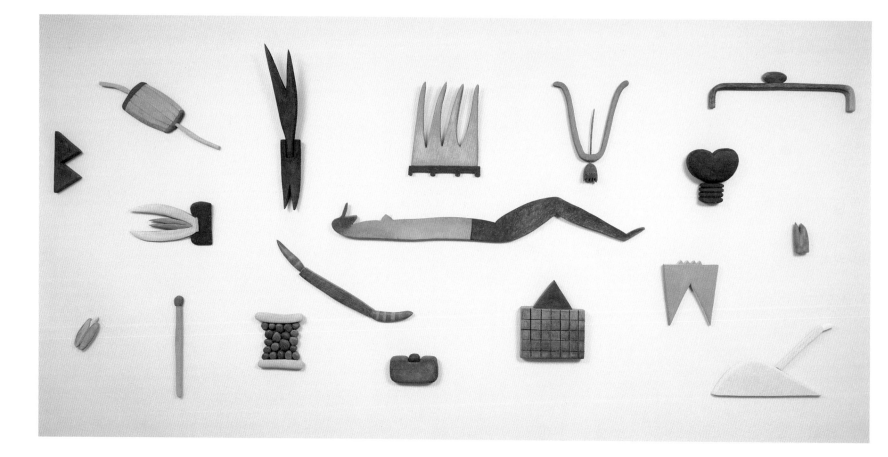

108

The Earth and Woman, 1984
Painted wood
Installation 48 x 120 in. (121.9 x 304.8 cm)
Scott H. Lang, Chicago

Mark Lere

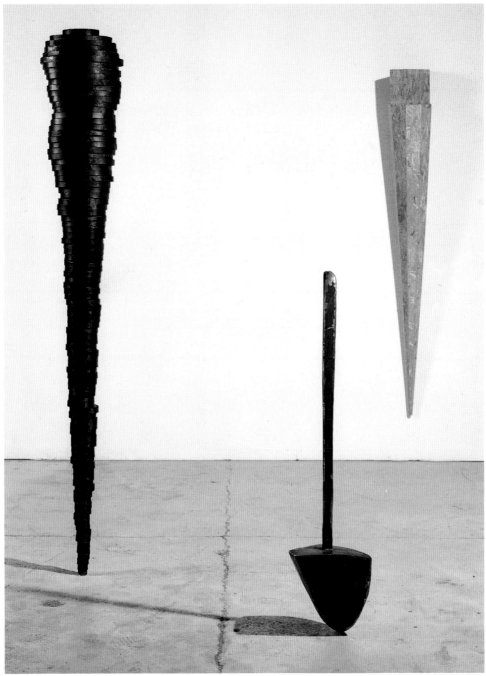

Installation view of *Strata*, 1986, *Axil*, 1986, and *Split*, 1985, at Margo Leavin Gallery, Los Angeles, 1986

<u>109</u>

Extremities, 1986–87
Mixed media
Installation 204 x 96 x 120 in. (518.2 x 243.8 x 304.8 cm)
Lent by the artist
Courtesy Margo Leavin Gallery, Los Angeles
[Not illustrated]

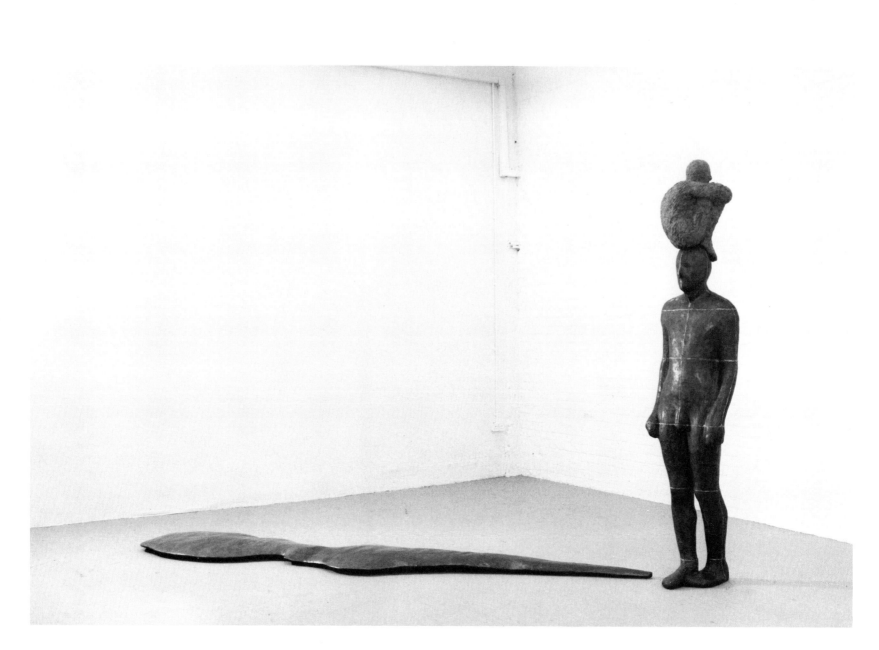

The Beginning, the Middle, the End, 1983–84
Terracotta, lead, fiberglass, plaster, air
92 ½ x 118 ⅛ x 29 ½ in. (235 x 300 x 75 cm)
Salvatore Ala Gallery, Milan/New York

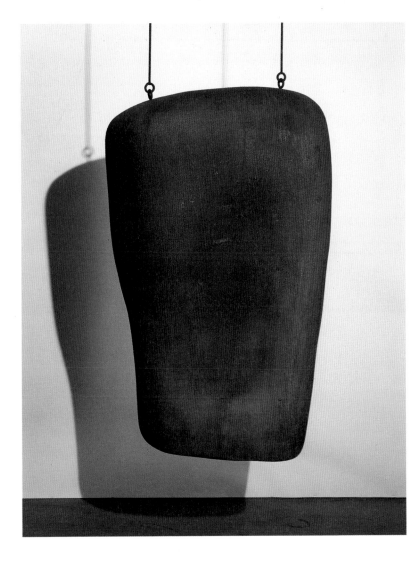

<u>111</u>

Ump, 1984–86
Iron
43 x 26 x 13 in. (109.2 x 66 x 33 cm)
Lent by the artist
Courtesy L.A. Louver Gallery, Venice, California

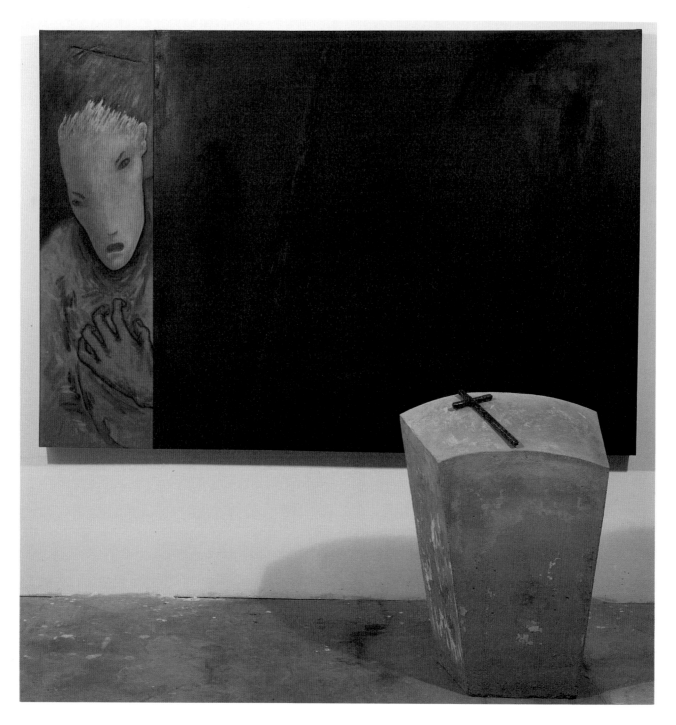

112

The Transformation of St. Francis, 1985
Oil on canvas, cast stone, wrought iron
Canvas: 62 x 91 in. (157.5 x 231.1 cm);
stone and iron: 35 x 26 x 12 ½ in. (88.9 x 66 x 31.7 cm)
Lent by the artist

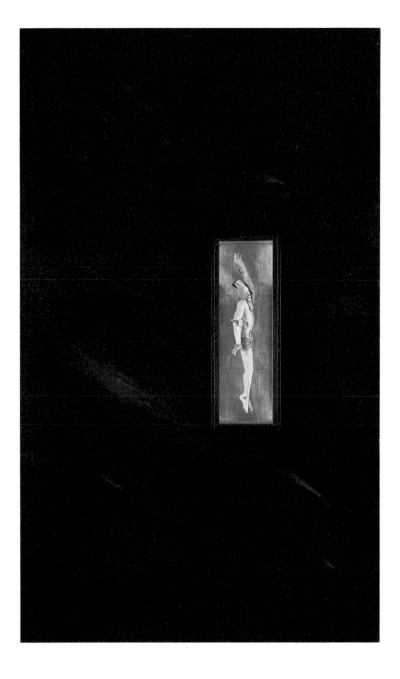

113

Memento Mori . . . My Sweet Paraleipsis, 1986
Wood, pigment, and gold leaf set in oil on panel
60 x 36 x 5 ½ in. (152.4 x 91.4 x 13.9 cm)
Kurt and Rosalie Meyer, Los Angeles
Courtesy Jan Turner Gallery, Los Angeles

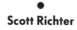

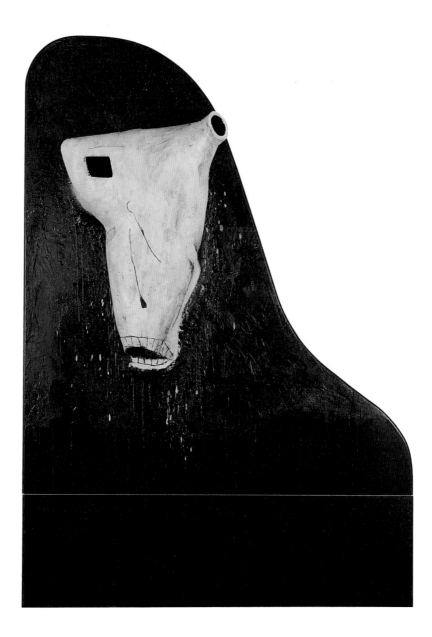

114

Death and Shape, 1986
Beeswax, wood, paint, foam
80 x 57 x 11 in. (203.2 x 144.8 x 27.9 cm)
Mr. and Mrs. Earl Millard, Belleville, Illinois

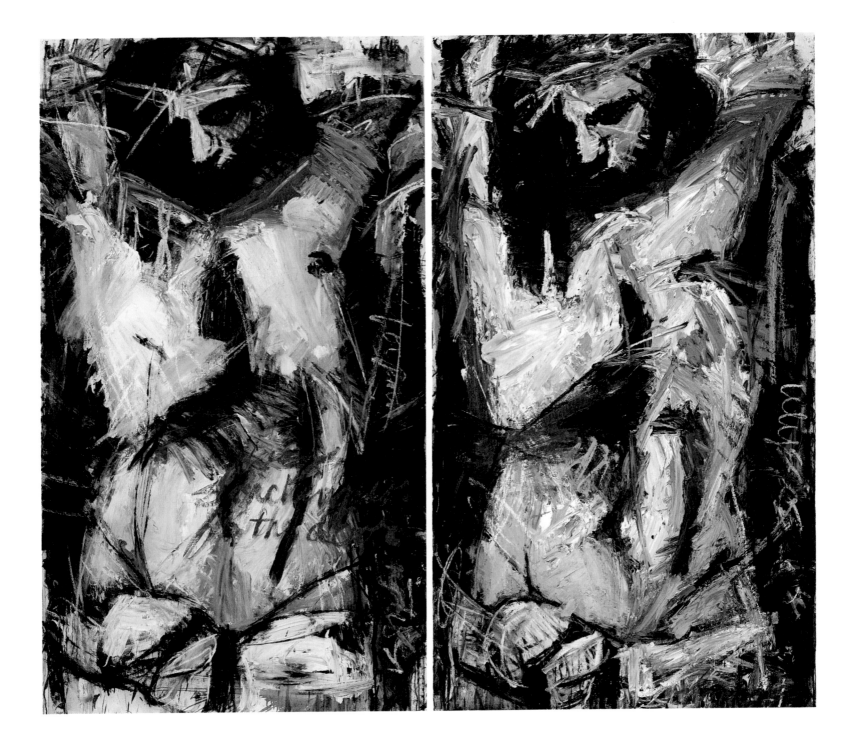

Tales of Ulysses, 1985
Oil, magna, pastel, and charcoal on paper, diptych
76 x 90 in. (193 x 228.6 cm)
Los Angeles County Museum of Art
Modern and Contemporary Art Council,
Young Talent Purchase Award

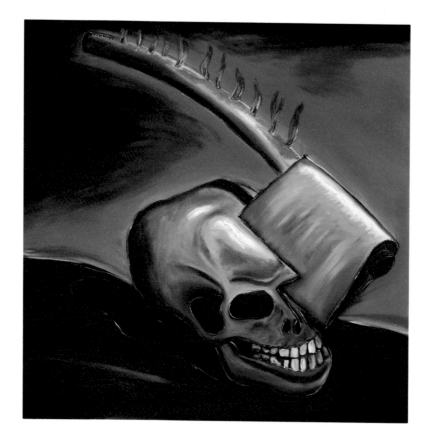

116

Portrait of a Dead Young Scientist, 1982
Dispersion on canvas
78 ¾ x 78 ¾ in. (200 x 200 cm)
Galerie Paul Maenz, Cologne

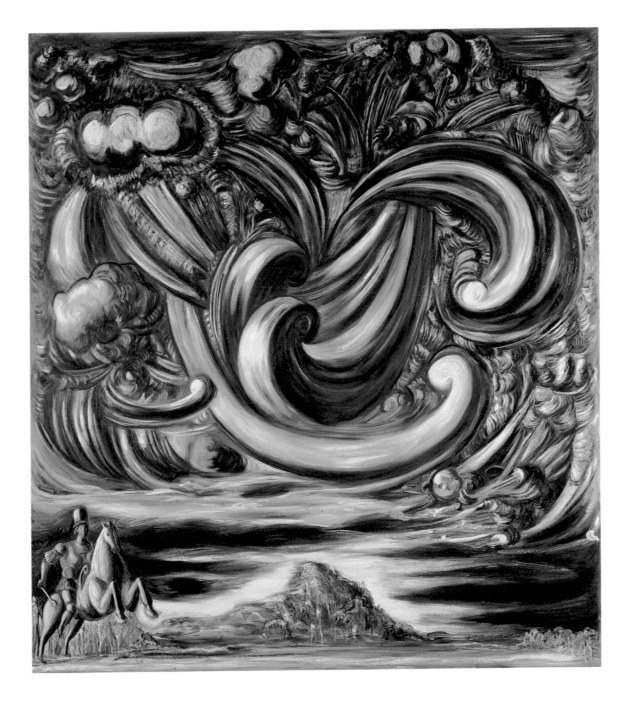

Roberto Barni

Rider in the Vortex, 1983
Oil on canvas
113 x 102 ⅜ in. (287 x 260 cm)
DiLaurenti Gallery, New York

Markus Lüpertz

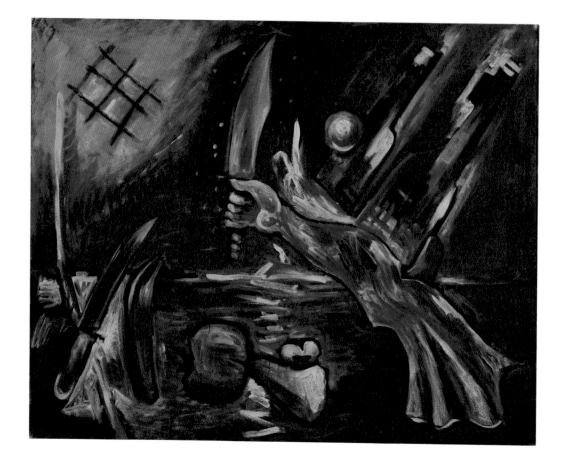

118

The Expulsion from Paradise or the Archangel Hacks
at the Table II, 1982
Oil on canvas
51 ⅛ x 63 ¾ in. (130 x 162 cm)
Galerie Michael Werner, Cologne, and
Mary Boone/Michael Werner Gallery, New York

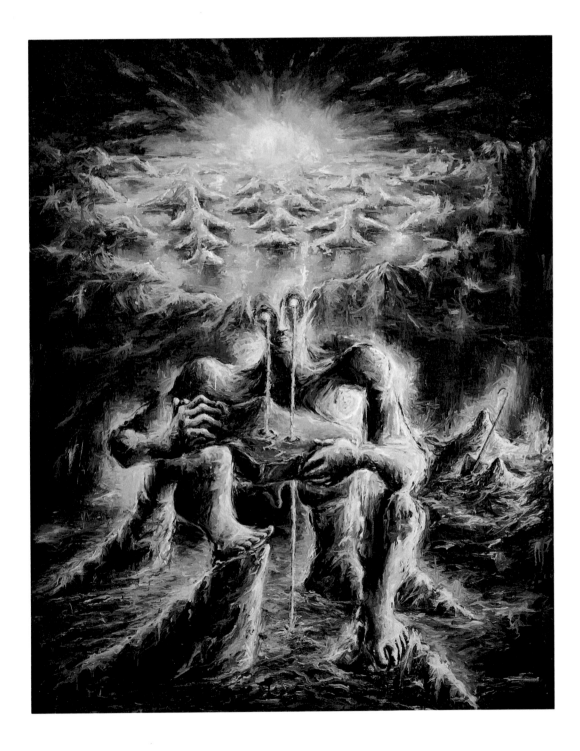

119

John of the Cross I, 1985–86
Oil on canvas
97 x 78 ¼ in. (246.4 x 198.8 cm)
Roberta and Richard Lieberman
Courtesy Zolla/Lieberman Gallery, Chicago

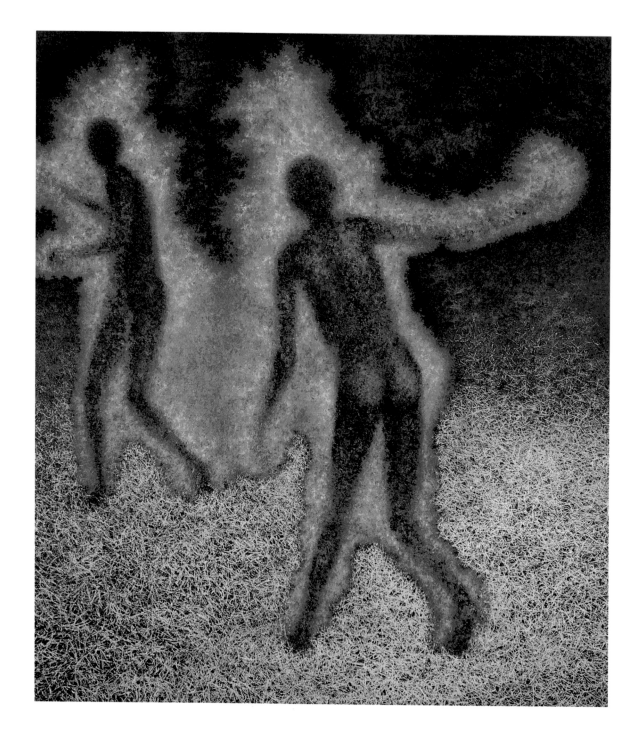

<u>120</u>

Field of Straw (Heart of Fire), 1986
Oil on canvas
66 x 58 in. (167.6 x 147.3 cm)
Lent by the artist

Erwin Bohatsch

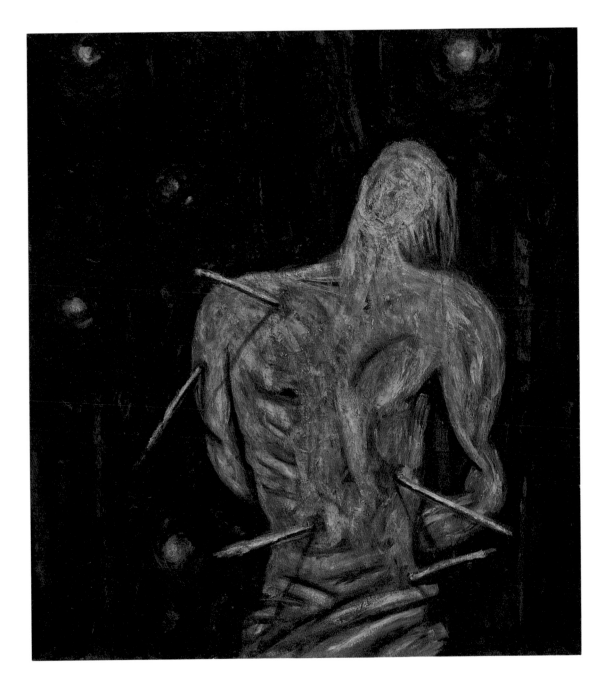

121

Sebastian, 1984
Oil on canvas
63 x 55 in. (160 x 140 cm)
Morat-Institut, Freiburg im Breisgau, West Germany

Arnulf Rainer

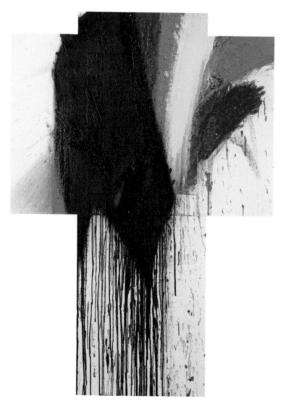

Cross, 1980–85
Oil on wood
74 ½ x 52 ½ in. (171 x 121 cm)
Galerie Ulysses, Vienna

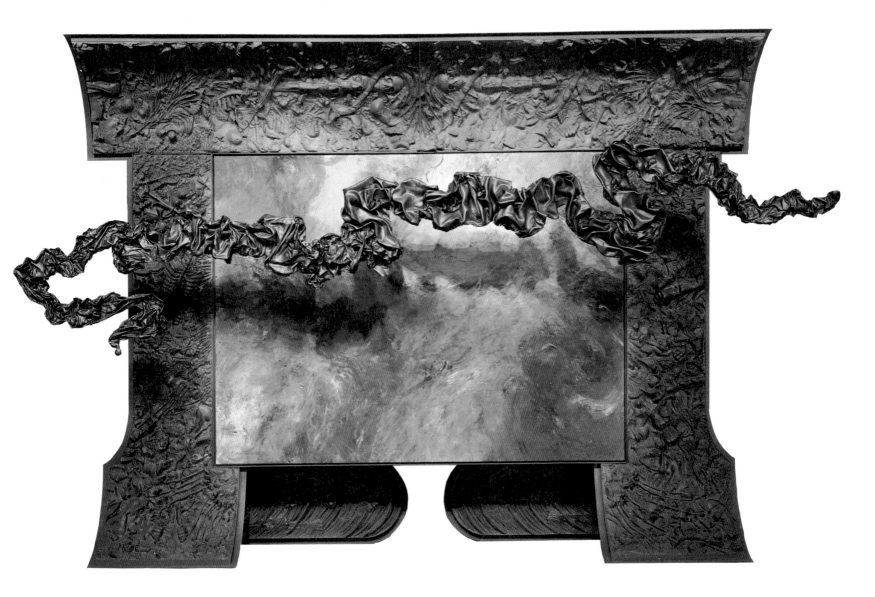

Order, from Burning Planet series, 1985
Painted cast hydrocal plaster, oil on canvas, and fiberglass
112 x 147 x 24 in. (284.5 x 373.4 x 61 cm)
Los Angeles County Museum of Art
Purchased with funds provided by the Collectors Committee, 1986

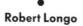

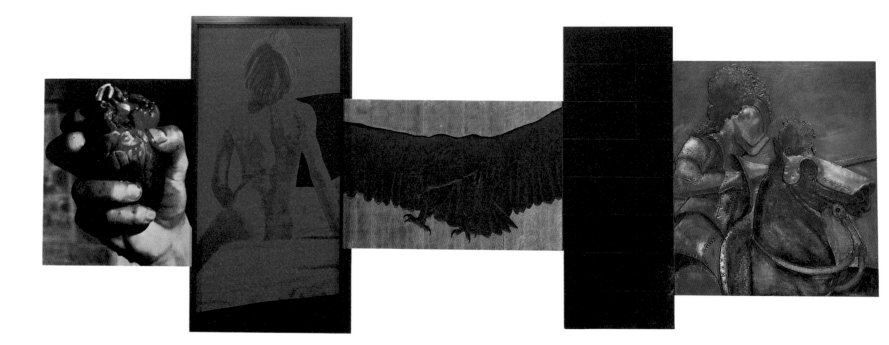

124

Still, 1984
Mixed media
96 x 288 in. (243.8 x 731.5 cm)
The Edward R. Broida Trust, Los Angeles

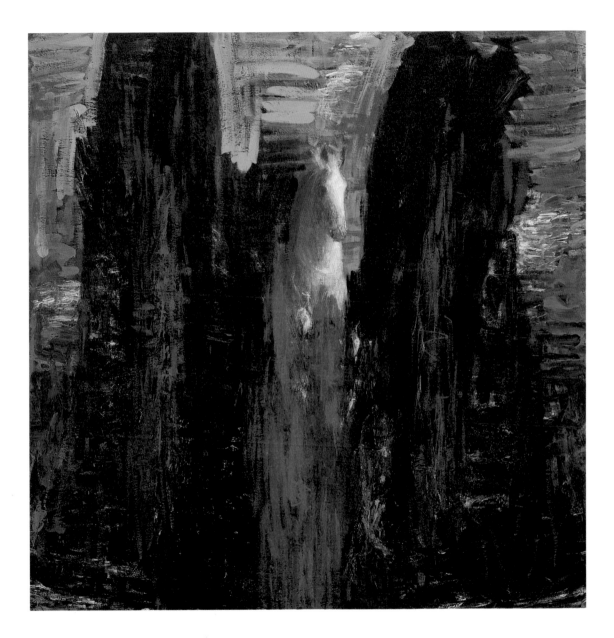

Prow, 1983
Oil on canvas
102 x 102 in. (259.1 x 259.1 cm)
PaineWebber Group Inc. Collection, New York

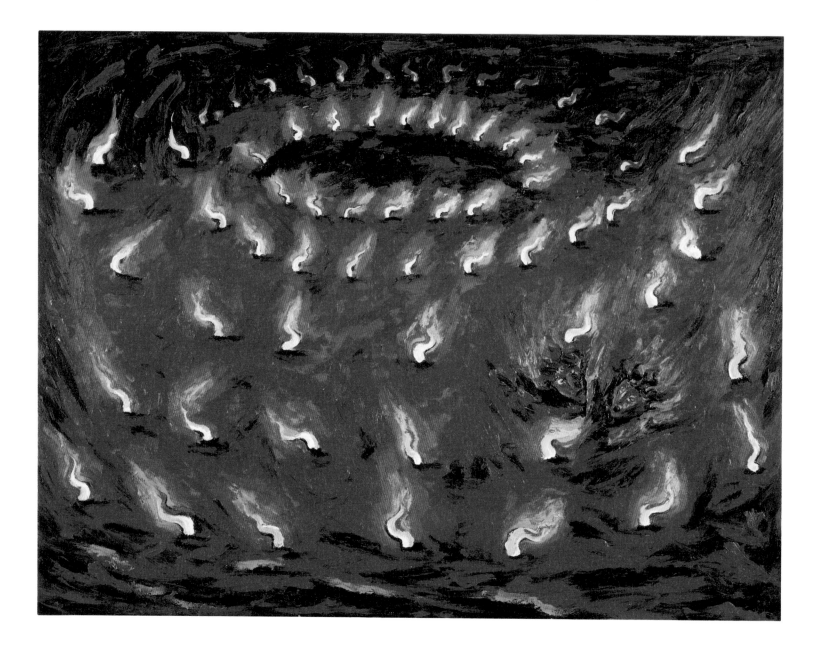

126

A Painting of Precious Fires, 1983
Oil on canvas
117 ⅜ x 153 ½ in. (298.1 x 389.9 cm)
Gerald S. Elliott Collection, Chicago

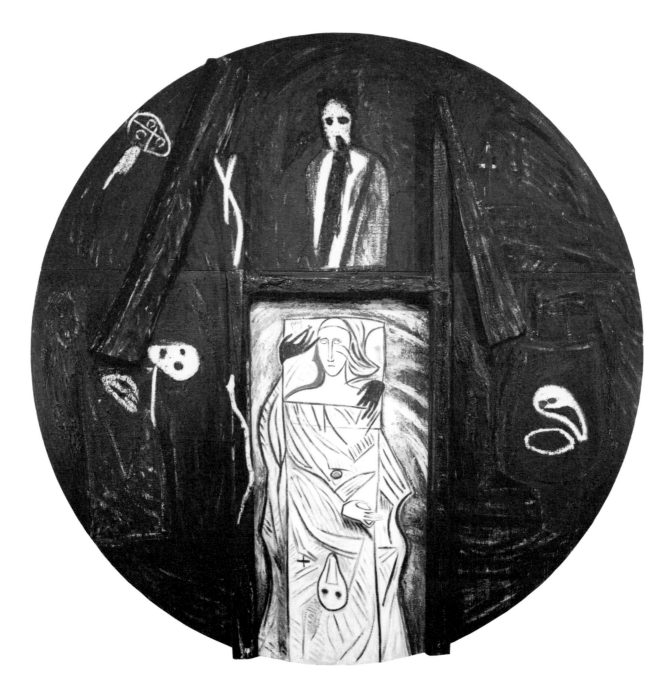

127

Sonata, 1985
Oil and collage on wood
Diameter 125 in. (317.5 cm)
Los Angeles County Museum of Art
Purchased with funds provided by Mary Lou and George Boone,
Mr. and Mrs. Donald Stein, William Keller, Jo Ann and Julian Ganz, Jr.,
Stanley and Elyse Grinstein, and Anita and Julius L. Zelman

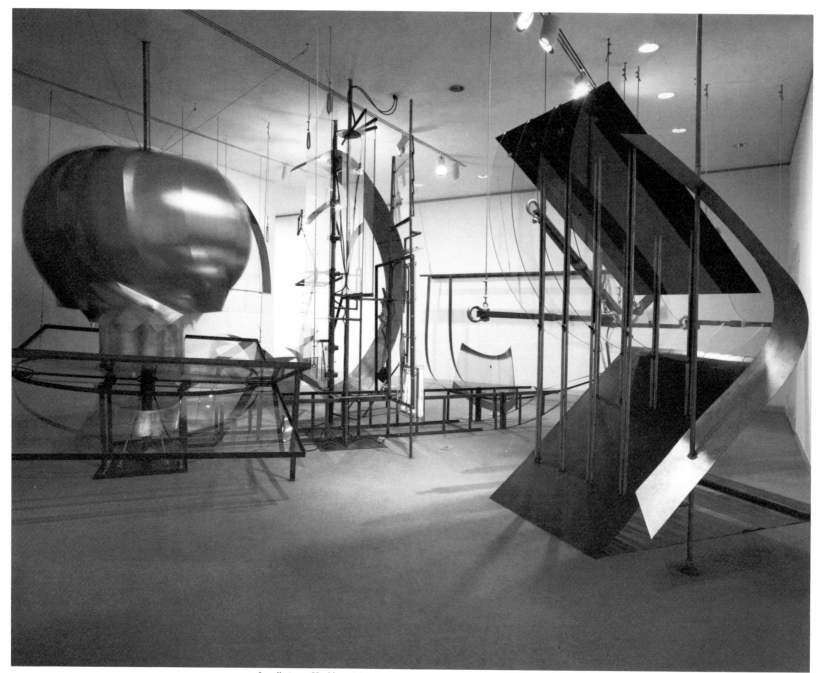

Installation at Hirshhorn Museum and Sculpture Garden, Washington, D.C., 1981

Hoodo (Laura). From the Series Entitled "How to Catch and Manufacture Ghosts."
Vertical and Horizontal Cross-Sections of the Ether Wind, 1981, refabricated 1987
Mixed media
Installation 336 x 420 x 156 in. (853.4 x 1066.8 x 396.2 cm)
Los Angeles County Museum of Art
Purchased with funds provided by the Collectors Committee, 1986

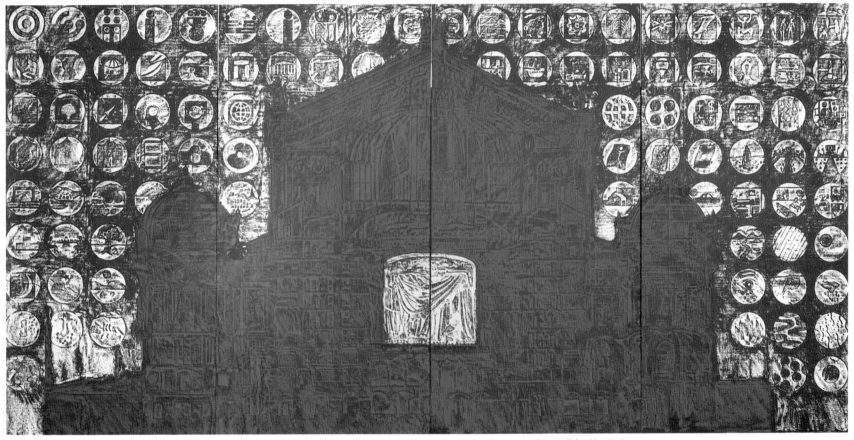

Untitled [Paris Opera], 1986, 120 x 240 in. (304.8 x 609.6 cm), oil stick on canvas, Martin Sklar, New York

129

Untitled, 1986–87
Black granite, five panels
Each 96 x 60 x ¾ in. (243.8 x 152.4 x 1.9 cm)
Lent by the artist
Courtesy Michael Klein, Inc., New York, and
Kuhlenschmidt/Simon Gallery, Los Angeles
[Not illustrated]

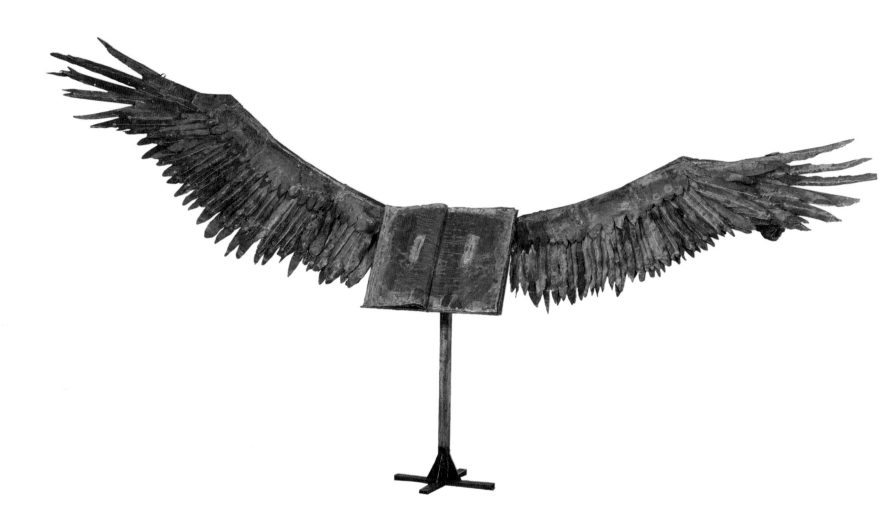

The Book, 1985
Lead, steel, and tin
114 x 213 ½ x 34 in. (289.6 x 542.3 x 86.4 cm)
Los Angeles County Museum of Art
Purchased with funds provided by the Modern and Contemporary
Art Council and Louise and Harold Held

Artists' Exhibitions and Bibliographies

Compiled by Rosalinde L. Leader
with the assistance of Debbe Goldstein

Magdalena Abakanowicz

1930
Born in Falenty, Poland

1955
Receives M.A. from Academy of Fine Arts, Warsaw

Lives in Warsaw

Selected Solo Exhibitions

1980
Polish Pavilion, Venice Biennale

1981
Galerie Alice Pauli, Lausanne

1982
ARC, Musée d'Art Moderne de la Ville de Paris

Galerie Jeanne Bucher, Paris

Walter Phillips Gallery, Banff Centre and Glenbow-Alberta Institute, Calgary, Canada

1982–84
Museum of Contemporary Art, Chicago, and tour; exh. cat., *Magdalena Abakanowicz*

1985
Xavier Fourcade Gallery, New York; exh. cat., *Magdalena Abakanowicz: About Men, Sculpture 1974–1985*

Selected Group Exhibitions

1980
Sculptures Polonaises Contemporaines, Musée d'Art Moderne de la Ville de Paris

Selected Bibliography

Drohojowska, Hunter. "Magical Mystery Tours." *Art News* 84 (September 1985): 108–13.

Levin, Kim. "Art: Bodies Politic." *Village Voice*, 8 October 1985.

Prévost, Jean Marc. "Magdalena Abakanowicz: Galerie Jeanne Bucher/Paris." *Flash Art* 107 (May 1982): 56.

Schmitt, Anne E. "An Abakanowicz Retrospective." *Artweek* 15 (18 February 1984): 4.

Stavitsky, Gail. "Magdalena Abakanowicz: Xavier Fourcade." *Arts Magazine* 60 (December 1985): 120.

Upshaw, Reagan. "Magdalena Abakanowicz at Fourcade." *Art in America* 73 (December 1985): 125–26.

Marina Abramović and Ulay

Marina Abramović

1946
Born in Belgrade

Lives in Amsterdam

Ulay

1943
Born in Solingen, West Germany

1963–68
Studies photography

Lives in Amsterdam

Selected Solo Exhibitions

1985
Stedelijk Van Abbemuseum, Eindhoven, Netherlands; exh. cat., *Ulay and Marina Abramović, Modus Vivendi, 1980–1985*

1986
Atholl McBean Gallery, San Francisco Art Institute

Burnett Miller Gallery, Los Angeles

Reference Gallery, Massachusetts Institute of Technology, Cambridge

Selected Group Exhibitions

1981
Bienal de São Paulo

New Art Practice, Gallery of Students, Cultural Centre, Belgrade

1982
Contemporary Art from the Netherlands, Museum of Contemporary Art, Chicago

Documenta 7, Kassel, West Germany

1984
Content: A Contemporary Focus, 1974–1984, Hirshhorn Museum and Sculpture Garden, Washington, D.C.; exh. cat., essays by Howard N. Fox, Miranda McClintic, and Phyllis Rosenzweig

National Video Festival, American Film Institute, Los Angeles

Venice Biennale

1985
By the 3/Varrella Virran 3: International Photography Today, Pori Art Museum, Finland

Selected Bibliography

Flood, Richard. "Marina Abramović/Ulay, Ulay/Marina Abramović." *Artforum* 21 (October 1982): 85.

Glueck, Grace. "Artists' Artists." *Art News* 81 (November 1982): 90.

Laurence, Michael. "Ulay and Marina Abramović: Burnett Miller Gallery." *West Hollywood Paper*, 20–27 March 1986.

Pholen, Annelie. "Marina Abramović and Ulay: Kölnischer Kunstverein." Translated by Leslie Strickland. *Artforum* 24 (January 1986): 101.

Ratcliff, Carter. "Report from Chicago: The Anti-hierarchical Dutch." *Art in America* 70 (September 1982): 45–49.

Jean-Michel Alberola

1953
Born in Saida, Algeria

Lives in Le Havre, France

Selected Solo Exhibitions

1982
Bonlow Gallery, New York

Galerie Daniel Templon, Paris; exh. cat., *Jean-Michel Alberola*, interview by Catherine Strasser

1983
Raab Galerie, West Berlin

1986
Städtische Kunsthalle Düsseldorf; exh. cat., *Jean-Michel Alberola: Die Malerei, die Geschichte, die Geographie und . . .*, essays by Jacques Sato and Marie Luise Syring

Selected Group Exhibitions

1981
Ateliers 81/82, ARC, Musée d'Art Moderne de la Ville de Paris

1982
Venice Biennale

1983
Bonjour Monsieur Manet, Musée National d'Art Moderne, Centre Georges Pompidou, Paris

1984
French Spirit Today, La Jolla Museum of Contemporary Art, California

An International Survey of Recent Painting and Sculpture, Museum of Modern Art, New York; exh. cat.

Venice Biennale

Selected Bibliography

Arnolfini Gallery. *To Kill Two Birds with One Stone*. Exh. cat. Interview by Jerôme Sans. Bristol, 1985.

Bohm-Duchen, Monica. "Jean-Michel Alberola: Arnolfini, Bristol." *Flash Art* 122 (April/May 1985): 42–43.

Bouisset, Maïten. "Cronica de Paris." *Goya* 167/168 (May/June 1982): 329–33.

De Loisy, Jean. "New French Painting." *Flash Art* 110 (January, 1983): 44–48.

Duret-Robert, François. "Figurations libre, chic, et autre . . . à marche!" *Connaissance des Arts* 374 (April 1983): 34–35.

Francblin, Catherine. "Free French." *Art in America* 70 (September 1982): 128–31.

Hayot, Monelle. "Le Xe Anniversaire de la Fiac: Le renouveau du dessin." *L'Oeil* 338 (September 1983): 50–57.

Indiana, Gary. "Report from Paris." *Art in America* 72 (May 1984): 33–41.

Poinsot, Jean-Marc. "New Painting in France." *Flash Art* 108 (Summer 1982): 40–44.

Hermann Albert

1937
Born in Ansbach, West Germany

1972–76
Attends Hochschule für Bildende Künste, Brunswick, West Germany

Lives in Ribbesbüttel, West Germany, and Ronzano, Italy

Selected Solo Exhibitions

1981
Schloss Charlottenburg, West Berlin

1982
Galerie Hermeyer, Munich

1983
Raab Galerie, West Berlin

1985
Edward Totah Gallery, London

Raab Galerie; exh. cat., *Hermann Albert: Bilder 1983–1984*, interview by Klaus Thiele-Dohrmann

Sander Gallery, New York

Selected Group Exhibitions

1986
Second Sight, San Francisco Museum of Modern Art Biennial; exh. cat., essay by Graham Beal

Selected Bibliography

Prinz, Ursula. "Hermann Albert: Galerie Poll." *Flash Art* 25 (March 1979): 10.

Vattese, Angela. "Europe and America: Two Aspects of the New Surreal." *Flash Art* 122 (April/May 1985): 20–25.

● Terry Allen

1943
Born in Wichita, Kansas

1966
Receives B.F.A. from Chouinard Art Institute, Los Angeles

Lives in Fresno, California

Selected Solo Exhibitions

1971–72
Museum of Contemporary Art, Chicago

1975
Houston Museum; exh. cat., *Juarez Series: Terry Allen*, introduction by James Harithas, essays by Dave Hickey, Paul G. Shimmel, and Michael Walls

1981
Baxter Art Gallery, California Institute of Technology, Pasadena; exh. cat., *Terry Allen (Part of and Some in Betweens)*, essay by Michael Smith

Nelson Gallery of Art, Atkins Museum of Fine Arts, Kansas City, Missouri; exh. cat., *Ring: Terry Allen*, essays by Sherry Cromwell-Lacy and Marcia Tucker

1983
La Jolla Museum of Contemporary Art, California; exh. cat., *Rooms and Stories by Terry Allen*, essays by

Lynda Forsha, James Harithas, and Robert MacDonald

1984
Barbara Gladstone Gallery, New York

Espace Lyonnais d'Art Contemporain, Lyons; exh. cat., *Sprawl/Prowl/Growl: A Geographical Survey of Works by Terry Allen*, essay by Marcia Tucker

1985
Alberta College of Art, Calgary, Canada; exh. cat., *Terry Allen: Visual and Aural Mythologies*, essay by Ron Gleason

Paule Anglim Gallery, San Francisco

1986
Florida State University Fine Arts Gallery, Tallahassee; exh. cat., *China Night: Terry Allen*, by Craig Adcock

John Weber Gallery, New York

Selected Group Exhibitions

1982
Awards in the Visual Arts, National Gallery of Art, Washington, D.C.

Sydney Biennale, Art Gallery of New South Wales

1984
Content: A Contemporary Focus, 1974–1984, Hirshhorn Museum and Sculpture Garden, Washington, D.C.; exh. cat., essays by Howard N. Fox, Miranda McClintic, and Phyllis Rosenzweig

1985
Bienal de São Paulo

Selected Bibliography

Adcock, Craig. "Terry Allen's Youth in Asia Series." *Arts Magazine* 60 (April 1986): 50–59.

Berkson, Bill. "Terry Allen: Gallery Paule Anglim." *Artforum* 24 (Summer 1986): 131–32.

Tucker, Marcia. "Terry Allen (On Everything)." *Artforum* 19 (October 1980): 42–49.

● Laurie Anderson

1947
Born in Chicago

1969
Receives B.A. from Barnard College, New York

1972
Receives M.F.A. from Columbia University, New York

Lives in New York

Selected Solo Exhibitions

1979
San Francisco Art Institute

1980
Holly Solomon Gallery, New York

1981
Holly Solomon Gallery

1983
Institute of Contemporary Art, University of Pennsylvania, Philadelphia; exh. cat., *Laurie Anderson: Works from 1969–1983*, essays by Janet Kardon, Ben Lifson, Craig Owens, and John Rockwell

1984
Frederick S. Wight Art Gallery, University of California, Los Angeles

Selected Group Exhibitions

1985
Technics and Civilization, Thomas Segal Gallery, Boston

Selected Bibliography

Berger, Maurice. "Mythology of Ritual: Reflections on Laurie Anderson." *Arts Magazine* 57 (June 1983): 120–21.

Flood, Richard. "Soundings: Neuberger Museum, State University of New York, Purchase." *Artforum* 20 (May 1982): 88.

Greene, Alexis. "Caught in the Act: Video Performance Is Making Strange Bedfellows of Robert Altman, Shirley Clarke and Laurie Anderson." *American Film* 7 (June 1982): 66–70.

Hartney, M. "Laurie Anderson's United States." *Studio International* 196 (April/May 1983): 51.

Howell, John. "United States Parts I–IV: Brooklyn Academy of Music, New York; Performance." *Artforum* 21 (Summer 1983): 79-80.

Jarmusch, Ann. "Laurie Anderson: Institute of Contemporary Arts, Philadelphia." *Art News* 83 (May 1984): 128–31.

McEvilley, Thomas. "Laurie Anderson: Institute of Contemporary Art, Boston." *Artforum* 22 (March 1984): 100.

Mendini, Alessandro. "Colloquio con Laurie Anderson." *Domus* 646 (January 1984): 1.

Smith, Philip. "Laurie Anderson Story: Interview." *Arts Magazine* 57 (January 1983): 60–61.

● Siah Armajani

1939
Born in Teheran

1963
Receives B.A. from Macalester College, Saint Paul, Minnesota

Lives in Minneapolis

Selected Projects

1983
NOAA Bridges, National Oceanic and Atmospheric Administration, Seattle

1985
Garden, University of Maryland, College Park

Selected Solo Exhibitions

1980
Artpark, Lewiston, New York

Joslyn Art Museum, Omaha, Nebraska; exh. cat., *I-80 Series: Siah Armajani: Reading Garden #2*, by Holliday T. Day

1981
Hudson River Museum, Yonkers, New York; exh. cat., *Siah Armajani*, by Julie Brown

Max Protetch Gallery, New York

1983
Max Protetch Gallery

1984
Max Protetch Gallery

1985
Institute of Contemporary Art, University of Pennsylvania, Philadelphia; exh. cat., *Siah Armajani*

Selected Group Exhibitions

1984
Content: A Contemporary Focus, 1974–1984, Hirshhorn Museum and Sculpture Garden, Washington, D.C.; exh. cat., essays by Howard N. Fox, Miranda McClintic, and Phyllis Rosenzweig

1985
The Artist as Social Designer: Aspects of Public Urban Art Today, Los Angeles County Museum of Art

Selected Bibliography

Berkson, Bill. "Seattle Sites: Part I." *Art in America* 74 (July 1986): 68–81, 133–35.

Berlind, Robert. "Armajani's Open-Ended Structures," *Art in America* 67 (October 1979): 82–85.

Geibel, Victoria. "The Act of Engagement." *Metropolis* 6 (July/August 1986): 32–36.

Koshalek, Richard. "A New Idiom of Public Art." *Landscape Architecture* (July 1971): 313–16.

Phillips, Patricia C. "Siah Armajani's Constitution." *Artforum* 24 (December 1985): 70–75.

Princenthal, Nancy. "Master Builder." *Art in America* 74 (March 1986): 126–32.

Russell, John. "Art View: Where City Meets Sea to Become Art." *New York Times*, 11 December 1983.

● Alice Aycock

1946
Born in Harrisburg, Pennsylvania

1968
Receives B.A. from Douglas College, New Brunswick, New Jersey

1971
Receives M.A from Hunter College, New York

Lives in New York

Selected Solo Exhibitions

1980
Institute for Art and Urban Resources, P.S. 1, Long Island City, New York

The Large Scale Dis/Integration of Microelectronic Memories (A Newly Revised Shanty Town), Battery Park City Landfill, New York

Washington Project for the Arts, Washington, D.C.

1981
John Weber Gallery, New York

University of South Florida, Tampa; exh. cat., *Alice Aycock Projects, 1979–1981*, essay by Edward F. Fry

1982
John Weber Gallery

1983
Museum of Contemporary Art, Chicago

Protetch-McNeil, New York

1984
Kunstmuseum, Lucerne

1985
Serpentine Gallery, London

Selected Group Exhibitions

1980
Aycock, Holste, Singer, Fort Worth Art Museum, Texas; exh. cat. by David Ryan.

1981
Biennial Exhibition, Whitney Museum of American Art, New York; exh. cat.

Machineworks: Vito Acconici, Alice Aycock, Dennis Oppenheim, Institute of Contemporary Art, University of Pennsylvania, Philadelphia; exh. cat.

Metaphor: New Projects by Contemporary Sculptors, Hirshhorn Museum and Sculpture Garden, Washington, D.C.; exh. cat. by Howard N. Fox

1984
Content: A Contemporary Focus, 1974–1984, Hirshhorn Museum and Sculpture Garden; exh. cat., essays by Howard N. Fox, Miranda McClintic, and Phyllis Rosenzweig

1986
Sitings, La Jolla Museum of Contemporary Art, California; exh. cat. by Hugh Davies, Ronald T. Onorato, and Sally Yard

Selected Bibliography

Albright, Thomas. "Alice Aycock's Personal Flight of Fancy." *San Francisco Chronicle*, 29 August 1979.

Kuspit, Donald B. "Aycock's Dream of Homes." *Art in America* 68 (September 1980): 84–87.

Lobell, John. "Myth in Architecture: The Work of Alice Aycock." *Skyline* 3 (April 1980): 6.

Morgan, Stuart, and Alice Aycock. "Alice Aycock: 'A Certain Image of Something I Like Very Much.'" *Arts Magazine* 52 (March 1978): 118–19.

● John Baldessari

1931
Born in National City, California

1953
Receives B.A. from San Diego State College

1955
Attends University of California, Berkeley

1957
Receives M.A. from San Diego State College

1957–59
Attends Otis Art Institute, Los Angeles

Lives in Santa Monica, California

Selected Solo Exhibitions

1980
Stedelijk Van Abbemuseum, Eindhoven, Netherlands

1981
Albright-Knox Art Gallery, Buffalo, New York

Museum Folkwang, Essen

New Museum, New York, and tour

1982
Contemporary Arts Museum, Houston

1985
Sonnabend Gallery, New York

1986
Margo Leavin Gallery, Los Angeles

University Art Museum, University of California, Berkeley

Selected Group Exhibitions

1981
Art in Los Angeles, The Museum as Site: Sixteen Projects, Los Angeles County Museum of Art; exh. cat. by Stephanie Barron

1985
Carnegie International, Museum of Art, Carnegie Institute, Pittsburgh; exh. cat., edited by Saskia Bos and John R. Lane

1986
TV Generations, LACE (Los Angeles Contemporary Exhibitions); exh. cat., essays by John Baldessari, Peter D'Agostino, John G. Hanhardt, and Bruce Yonemoto

Selected Bibliography

Baldessari, John. "Learn to Read, Learn to Write." *Art Journal* 42 (Summer 1982): 134–36.

Drohojowska, Hunter. "No More Boring Art." *Art News* 85 (January 1986): 62–69.

Fisher, Jean. "John Baldessari: Sonnabend Gallery." *Artforum* 23 (November 1985): 99–100.

Foster, Hal. "John Baldessari's 'Blasted Allegories.'" *Artforum* 18 (October 1979): 52–55.

Morgan, Robert C. "Conceptual Art and Photographic Installations: The Recent Outlook." *Afterimage* 9 (December 1981): 8–9.

Owens, Craig. "Telling Stories: A Recent Collocation of John Baldessari's Narrative Art." *Art in America* 69 (May 1981): 129–35.

Perrone, Jeff. "Words When Art Takes a Rest." *Artforum* 15 (Summer 1977): 36–37.

Singerman, Howard. "Art in Los Angeles: Los Angeles County Museum of Art." *Artforum* 20 (March 1982): 76.

Winer, Helene. "Scenarios/Documents/Images 1." *Art in America* 61 (March–April 1973): 42.

● Roberto Barni

1939
Born in Pistoia, Italy

Lives in Florence

Selected Solo Exhibitions

1982
Palazzo Comunale, Festival dei Due Mondi, Spoleto

1983
Casa di Masaccio, Organizzazione Carini, San Giovanni Valdarno

Galleria Monti, Rome

1985
Due Ci, Rome

Sharpe Gallery, New York

1986
Galleria Carini, Florence

Selected Group Exhibitions

1980
Arte allo specchio, Venice Biennale and tour

Cronografie, Venice Biennale and tour

1985
Affinità elettive, Triennale di Milano

Selected Bibliography

Balmas, Paolo. "Anachron'isms' of Art." *Flash Art* 113 (Summer 1983): 32–38.

Heartney, Eleanor. "Apocalyptic Visions, Arcadian Dreams." *Art News* 85 (January 1986): 86–93.

Yau, John. *Roberto Barni: Ferite Solitarie*. Edizioni Carini, 1986.

● Jean-Michel Basquiat

1960
Born in New York

Lives in New York

Selected Solo Exhibitions

1981
Annina Nosei Gallery, New York

1985
Institute of Contemporary Arts, London

1986
Larry Gagosian Gallery, Los Angeles

Selected Group Exhibitions

1981
New York, New Wave, Institute for Art and Urban Resources, P.S. 1, Long Island City, New York

1982
Documenta 7, Kassel, West Germany

The Expressionist Image: From Pollock to Today, Sidney Janis Gallery, New York

1984
Content: A Contemporary Focus, 1974–1984, Hirshhorn Museum and Sculpture Garden, Washington, D.C.; exh. cat., essays by Howard N. Fox, Miranda McClintic, and Phyllis Rosenzweig

Figuration Libre, Musée d'Art Moderne de la Ville de Paris

1985
Matrix, University Art Museum, University of California, Berkeley

Selected Bibliography

Cohen, Ronny H. "Jumbo Prints: Artists Who Paint Big Want to Print Big." *Art News* 83 (October 1984): 86.

Gablik, Suzi. "Report from New York: The Graffiti Question." *Art in America* 70 (October 1982): 33–39.

Galligan, Gregory. "Jean-Michel Basquiat: The New Painting." *Arts Magazine* 59 (May 1985): 140–41.

Komac, Dennis. "An Aggressive Energy." *Artweek* 16 (1 June 1985): 5.

Linker, Kate. "Jean-Michel Basquiat: Mary Boone Gallery." *Artforum* 23 (October 1984): 91.

McGuigan, Cathleen. "New Art, New Money: The Marketing of an American Artist." *New York Times Magazine*, 10 February 1985.

Nilson, Lisbet. "Making It Neo [Younger Generation Has Taken Center Stage]." *Art News* 82 (September 1983): 65.

Ricard, Rene. "The Radiant Child." *Artforum* 20 (December 1981): 35–43.

Wechsler, Max. "Collaborations." *Artforum* 23 (February 1985): 99.

● Gretchen Bender

1951
Born in Seaford, Delaware

1972
Receives B.F.A. from University of North Carolina at Chapel Hill

Lives in New York

Selected Solo Exhibitions

1983
Gallery Nature Morte, New York

1984
Dumping Core, Kitchen Center for Video, Music, Dance, Performance, and Film, New York

Selected Group Exhibitions

1982
[(" " ")] Frames of Reference, Downtown Branch, Whitney Museum of American Art, New York

1984
The East Village Scene, Insititute of Contemporary Art, University of Pennsylvania, Philadelphia; exh. cat. by Janet Kardon

Limbo, Institute for Art and Urban Resources, P.S. 1, Long Island City, New York

Neo York: Report on a Phenomenon, University Art Museum, University of California, Santa Barbara; exh. cat. by Phyllis Plous

1985
Infotainment (18 Artists from New York), Gallery Nature Morte and tour; exh. cat., essays by Thomas Lawson and George W. S. Trow

Smart Art, Carpenter Center for the Visual Arts, Harvard University, Cambridge, Massachusetts

1986
A Brokerage of Desire, Otis Art Institute of Parsons School of Design; exh. cat., essays by Howard Halle and Walter Hopps

Paravision, Margo Leavin Gallery, Los Angeles

Television's Impact on Contemporary Art, Queens Museum, Flushing, New York

TV Generations, LACE (Los Angeles Contemporary Exhibitions); exh. cat., essays by John Baldessari, Peter D'Agostino, John G. Hanhardt, and Bruce Yonemoto

Selected Bibliography

Cameron, Dan. "Pretty as a Product." *Arts Magazine* 60 (May 1986): 22–25.

Crary, Jonathan. "Gretchen Bender at Nature Morte." *Art in America* 72 (April 1984): 189–90.

Fisher, Jean. "Gretchen Bender: Nature Morte." *Artforum* 22 (April 1984): 189.

Jones, Ronald. "Six Artists at the End of the Line: Gretchen Bender, Ashley Bickerton, Peter Halley, Louise Lawler, Allen McCollum and Peter Nagy." *Arts Magazine* 60 (May 1986): 49–51.

Wallis, Brian, ed. *Art After Modernism: Rethinking Representation*. New York: New Museum of Contemporary Art, 1985.

● Mike Bidlo

1953
Born in Chicago

1973
Attends University of Illinois, Chicago

1975
Attends Southern Illinois University at Carbondale

1978
Attends Columbia University, New York

Lives in New York

Selected Solo Exhibitions

1983
Windows on White, New York

1984
Larry Gagosian Gallery, Los Angeles

1986
Massimo Audiello Gallery, New York

Piezo Electric, Venice, California

Selected Group Exhibitions

1980
Times Square Show, New York

1985
A Brave New World, A New Generation: 40 New York Artists, Charlottenborg, Copenhagen; exh. cat., essays by Mogens Breyen, Carlo McCormick, and Thomas B. Solomon

1986
Supermannerism, Davies Long Gallery, Los Angeles

Selected Bibliography

Goldstein, Richard. "The Politics of Culture." *Village Voice,* 17 May 1983.

Kuspit, Donald. "New York Review: Climbing." *Artforum* 22 (March 1984): 73.

Lawson, Thomas. "Forum: Generation in Vitro." *Artforum* 23 (September 1984): 99.

Levin, Kim. "Mike Bidlo: Jack the Dripper at Peg's Place." *Village Voice,* 17 May 1983.

Masheck, Joseph. "Tendering Rendering: Nine Notes Apropos Still Lifes by Giorgio Morandi by Mike Bidlo." *Arts Magazine* 60 (March 1986): 81–83.

McCormick, Carlo. "Steal This Painting!: Mike Bidlo's Artistic Kleptomania." *East Village Eye* 7 (October 1985): 27.

McEvilly, Thomas. "On the Manner of Addressing Clouds." *Artforum* 22 (Summer 1984): 70.

Panicelli, Ida. "Mike Bidlo: Wessel O'Connor Gallery." *Artforum* 24 (April 1986): 117.

Prial, Frank. "Protest over Pollock." *New York Times,* 11 August 1983.

● Ricardo Bofill

1939
Born in Barcelona

Lives in Barcelona

Selected Projects

1982
Les Espaces d'Abraxas: Le Théâtre, L'Arc, Marne-la-Vallée, France

1983
Le Lac: Les Arcades du Lac, Le Viaduc, Les Temples du Lac, Saint-Quentin-en-Yvelines, France

1984
Antigone: La Place du Nombre d'Or, Montpelier, France

1985
The Green Crescent, Cergy-Pontoise, France

Selected Solo Exhibitions

1986
Max Protetch Gallery, New York

Selected Group Exhibitions

1985
Ricardo Bofill and Leon Krier: Architecture, Urbanism, and History, Museum of Modern Art, New York; exh. cat., essay by Arthur Drexler

Selected Bibliography

Curtis, W. J. R. "Principle Versus Pastiche: Perspectives on Some Recent Classicisms." *Architectural Review* 176 (August 1984): 17–18.

Futagawa, Yukio. *Ricardo Bofill: Taller de Arquitectura.* Introduction by Christian Norberg-Schultz. New York: Rizzoli, 1985.

Glancey, J. "Ricardo Bofill." *Architectural Review* 171 (June 1982): 22–35.

Jodidio, Philip. "Michel-Ange, Gaudi et moi: Interview." *Connaissance des Arts* 373 (March 1983): 54–63.

Kimball, Roger. "In Search of the Ideal City: The Architecture of Ricardo Bofill and Leon Krier." *Architectural Record* 173 (August 1985): 77.

Krier, Leon. "The Reconstruction of Vernacular Building and Classical Architecture." *Architectural Journal* 180 (12 September 1984): 73.

Mangin, David. "L'homme de marbre (dix années de réalisations en France)." *Architecture aujourd'hui* 236 (December 1984): VII–XIV.

● Erwin Bohatsch

1951
Born in Mürzzuschlag, Austria

1966–70
Attends Graz School of Arts, Austria

1971–76
Attends Vienna Academy of Fine Arts

Lives in Beistein bei Fehring, Austria

Selected Solo Exhibitions

1981
Galerie Ariadne, Vienna

1982
Arte Viva, Basel

1983
Neue Galerie, Graz, Austria

1985
daadgalerie, West Berlin; exh. cat., *Erwin Bohatsch,* essays by Helmut Draxler, Wieland Schmied, and Jiri Svestka

Galerie Folker Skulima, West Berlin

Selected Group Exhibitions

1982
Junge Künstler aus Österreich, Kunstmuseum, Lucerne

Zeitgeist, Martin-Gropius-Bau, West Berlin

1984
An International Survey of Recent Painting and Sculpture, Museum of Modern Art, New York; exh. cat.

Märchen, Mythen, Monster, Neue Galerie

1985
Visitors 1, Municipal Art Gallery, Los Angeles; exh. cat., essays by Helmut Draxler and Wilfried Skreiner

Selected Bibliography

Draxler, Helmut. "Pomp and Punishment." *Flash Art* 119 (November 1984): 23–27.

Skreiner, Wilfried. "Austrian Trans-Avantgarde." *Flash Art* 106 (February/March 1982): 55.

Zellweger, Harry. "Junge Künstler aus Österreich: Kunstmuseum Luzern." *Kunstwerk* 35 (August 1982): 61.

● Jonathan Borofsky

1942
Born in Boston

1964
Receives B.F.A. from Carnegie Mellon University, Pittsburgh

1966
Receives M.F.A. from Yale University, New Haven, Connecticut

Lives in Venice, California

Selected Solo Exhibitions

1980
Paula Cooper Gallery, New York

1981
Contemporary Arts Museum, Houston

Kunsthalle Basel

1982
Museum Boymans-van Beuningen, Rotterdam

1983

Paula Cooper Gallery and tour

1984

Philadelphia Museum of Art and tour; exh. cat., *Jonathan Borofsky*, essays by Richard Marshall and Mark Rosenthal

1986

Paula Cooper Gallery

Selected Group Exhibitions

1981

Art in Los Angeles, The Museum as Site: Sixteen Projects, Los Angeles County Museum of Art; exh. cat. by Stephanie Barron

1982

Zeitgeist, Martin-Gropius-Bau, West Berlin

1984

Content: A Contemporary Focus, 1974–1984, Hirshhorn Museum and Sculpture Garden, Washington, D.C.; exh. cat., essays by Howard N. Fox, Miranda McClintic, and Phyllis Rosenzweig

Selected Bibliographies

Knight, Christopher. "The Invisible Man." *Flash Art* 121 (March 1985): 20–22.

Kontova, Helena. "From Performance to Painting." *Flash Art* 106 (February/March 1982): 16–21.

Kuspit, Donald B. "The Night Mind." *Artforum* 21 (September 1982): 64–67.

Larson, Kay. "Jonathan Borofsky, Counting to a Billion." *Art News* 80 (May 1981): 75–76.

Moufarrege, Nicolas A. "Intoxication: April 9, 1983." *Arts Magazine* 57 (April 1983): 70–76

Rosenthal, Mark. "The Ascendance of Subject Matter and a 1960's Sensibility." *Arts Magazine* 56 (June 1982): 92–94.

Simon, Joan. "An Interview with Jonathan Borofsky." *Art in America* 69 (November 1981): 156–57.

Soldaini, Antonella, and Vincent Todoli. "Borofsky." *Flash Art* 121 (March 1985): 18–19.

Zelevansky, Lynn. "Jonathan Borofsky's Dream Machine." *Art News* 83 (May 1984): 108–15.

● Troy Brauntuch

1954

Born in Jersey City, New Jersey

1975

Receives B.F.A. from California Institute of the Arts, Valencia

Lives in New York

Selected Solo Exhibitions

1981

Metro Pictures, New York

1985

Mary Boone Gallery, New York

1986

Larry Gagosian Gallery, Los Angeles

Selected Group Exhibitions

1982

Documenta 7, Kassel, West Germany

Venice Biennale

1984

Drawings After Photography, Allen Memorial Art Museum, Oberlin, Ohio

1985

Art of Memory, Loss of History, New Museum of Contemporary Art, New York

Selected Bibliographies

Becker, Robert. "Troy Brauntuch." *Interview* 13 (February 1983): 72–73.

Blau, Douglas. "Troy Brauntuch." *Flash Art* 104 (October–November 1981): 53.

Gibson, Eric. "American Still Life." *New Criterion* 3 (October 1984): 70–75.

Owens, Craig. "Back in the Studio." *Art in America* 70 (January 1982): 99–107.

Salle, David. "New Image Painting." *Flash Art* 88–89 (March/April 1979): 40–41.

Silverthorne, Jeanne. "Troy Brauntuch at Mary Boone." *Artforum* 21 (September 1982): 76.

Simon, Joan. "Double Takes." *Art in America* 68 (October 1980): 113–17.

● Steven Campbell

1954

Born in Glasgow

1982

Receives B.A. from Glasgow School of Art

Lives in New York and Glasgow

Selected Solo Exhibitions

1983

Barbara Toll Fine Arts, New York

1984

Rhona Hoffman Gallery, Chicago

1985

Fruitmarket Gallery, Edinburgh

Walker Art Center, Minneapolis; exh. cat., *Viewpoints: Steven Campbell*

Selected Group Exhibitions

1984

The British Art Show, City Museum and Art Gallery and Ikon Gallery, Birmingham, and tour

The Human Condition, San Francisco Museum of Modern Art Biennial

Selected Bibliographies

Adams, Brooks. "Steven Campbell at Barbara Toll and John Weber." *Art in America* 72 (May 1984): 163–64.

Liebmann, Lisa. "Steven Campbell: Barbara Toll Gallery and John Weber Gallery." *Artforum* 22 (April 1984): 75–76.

Moufarrege, Nicolas A. "The Mutant International, VII: Time and Timing, Shelter and Storm." *Arts Magazine* 58 (March 1984): 62–64.

Yourgrau, Barry. "Steven Campbell." *Arts Magazine* 58 (January 1984): 10.

● Suzanne Caporael

1949

Born in New York

1977

Receives B.F.A. from Otis Art Institute, Los Angeles

1979

Receives M.F.A. from Otis Art Institute

Lives in Los Angeles

Selected Solo Exhibitions

1984

Newport Harbor Art Museum, Newport Beach, California

1985

Irit Krygier Contemporary Art, Los Angeles

1986

Irit Krygier Contemporary Art

Santa Barbara Museum of Art, California; exh. cat., *Suzanne Caporael: California Viewpoints*, essay by Howard N. Fox

Selected Group Exhibitions

1985

Summer 1985, Museum of Contemporary Art, Los Angeles; exh. cat., interview by Julia Brown and Jacqueline Crist

Selected Bibliographies

Barnes, Lucinda. "Visions of Psychic Energy." *Artweek* 16 (19 January 1985): 5.

Muchnic, Suzanne. "Caporael Mysteries at Newport." *Los Angeles Times*, 16 January 1985.

Parker, Douglas M. "Paintings by Suzanne Caporael at Newport Harbor Art Museum." *L.A. Weekly*, 18–24 January 1985.

● Peter Chevalier

1953

Born in Karlsruhe, West Germany

1976–80

Attends Hochschule der Kunst, Brunswick, West Germany

Lives in West Berlin

Selected Solo Exhibitions

1985

Kunstverein, Freiburg, West Germany

Luhring, Augustine & Hodes Gallery, New York

1986

Raab Galerie, West Berlin; exh. cat., *Ideal Landscape City by the Sea*

Rena Bransten Gallery, San Francisco

Selected Group Exhibitions

1982

Biennale des Jeunes, Musée d'Art Moderne de la Ville de Paris

1984

Ursprung und Vision: Neue Deutsche Malerei, Museo de Arte Moderna, Mexico City

1985

Metaphor and/or Symbol: A Perspective on Contemporary Art, National Museum of Modern Art, Tokyo, and tour

Selected Bibliographies

Heartney, Eleanor. "Peter Chevalier: Luhring, Augustine, & Hodes." *Flash Art* 124 (October/November 1985): 50–51.

Jensen, Birgit. "Peter Chevalier." *Flash Art* 118 (Summer 1984): 41–43.

Kuspit, Donald B. "Peter Chevalier at Luhring, Augustine, & Hodes." *Art in America* 73 (October 1985): 152.

Simmen, Jeannot L. "New Painting in Germany." *Flash Art* 109 (November 1982): 54–58.

Winter, Peter. "Peter Chevalier: Bilder, Gouachen, Zeichnungen." *Kunstwerk* 35 (June 1982): 62–63.

● Michael Clegg and Martin Guttmann

1957

Born in Israel

Live in New York

Selected Solo Exhibitions

1981

Annina Nosei Gallery, New York

1984

Cable Gallery, New York

1985

Galerie Löhrl am Abteiberg, Mönchengladbach, West Germany; exh. cat., *Clegg & Guttman: Einzel-, Doppel- und Gruppenporträts*, essay by Arielle Pelenc

Selected Group Exhibitions

1985

Infotainment (18 Artists from New York), Gallery Nature Morte, New York, and tour; exh. cat., essays by Thomas Lawson and George W. S. Trow

1986

The Real Big Picture, Queens Museum, Flushing, New York

Selected Bibliographies

Indiana, Gary. "Signs of Empire." *Village Voice*, 31 December 1985.

Marzorati, Gerald. "Old Master Prints: Clegg & Guttman's Double Takes." *Vanity Fair* 49 (June 1986): 108.

● Francesco Clemente

1953

Born in Naples

Lives in Rome and Madras

Selected Solo Exhibitions

1981

University Art Museum, University of California, Berkeley, and tour

1983

Whitechapel Art Gallery, London, and tour

1984

Kunsthalle Basel

Nationalgalerie, West Berlin, and tour

1985

Leo Castelli Gallery, New York

Mary Boone Gallery, New York

Sperone Westwater Gallery, New York

1985–86

John and Mabel Ringling Museum of Art, Sarasota, Florida; exh. cat., *Francesco Clemente*, by Michael Auping

1986

Anthony d'Offay Gallery, London

Selected Group Exhibitions

1982

New Works on Paper 2: Borofsky, Clemente, Merz, Penck, Penone, Museum of Modern Art, New York

Zeitgeist, Martin-Gropius-Bau, West Berlin

1984

Images and Impressions: Painters Who Print, Walker Art Center, Minneapolis

1985

New Art of Italy, Joslyn Art Museum, Omaha, Nebraska, and tour; exh. cat. by Holliday T. Day

Selected Bibliographies

Castle, Ted. "A Bouquet of Mistakes." *Flash Art* 108 (Summer 1982): 54–55.

Deak, Edit, and Diego Cortez. "Baby Talk." *Flash Art* 107 (May 1982): 34–38.

Frackman, Noel, and Ruth Kaufmann. "Documenta 7: The Dialogue and a Few Asides." *Arts Magazine* 75 (October 1982): 91–97.

Groot, Paul. "Alchemy and the Rediscovery of the Human Figure in Recent Art." *Flash Art* 126 (February–March 1986): 42–43.

Hawthorne, Don. "Prints from the Alchemist's Laboratory." *Art News* 85 (February 1986): 89–95.

Oliva, Achille Bonito. "The Bewildered Image." *Flash Art* 96–97 (March/April 1980): 32–41.

Ottman, Klaus. "Painting in an Age of Anxiety." *Flash Art* 118 (Summer 1984): 32–35.

Politi, Giancarlo. "Francesco Clemente." *Flash Art* 117 (April/May 1984): 12–21.

Ratcliff, Carter. "On Iconography and Some Italians." *Art in America* 70 (September 1982): 152–59.

● Chema Cobo

1952

Born in Tarifa, Spain

1970–74

Attends University of Madrid

Lives in Tarifa

Selected Solo Exhibitions

1983

Zolla/Lieberman Gallery, Chicago

1985

Museo de Arte Contemporaneo, Seville

Zolla/Lieberman Gallery; exh. cat., *Chema Cobo: New Work*

1986

Kunstmuseum, Bern; exh. cat., *Chema Cobo*, essays by Jürgen Glaesemer and Juan Muñoz

Selected Group Exhibitions

1982

Carnegie International, Museum of Art, Carnegie Institute, Pittsburgh

Studio International, Institute for Art and Urban Resources, P.S. 1, Long Island City, New York

1983

Recent European Painting, Solomon R. Guggenheim Museum, New York

1984

The Human Condition, San Francisco Museum of Modern Art Biennial

1985

States of War, Seattle Art Museum; exh. cat. by Bruce Guenther

Selected Bibliographies

Bonesteel, Michael. "Chema Cobo: Zolla/Lieberman Gallery." *Artforum* 22 (November 1983): 84.

Cameron, Dan. "Report from Spain." *Art in America* 73 (February 1985): 25–34.

Forgey, Benjamin. "How Universal Is the 'International'?" *Art News* 82 (March 1983): 99.

Glowen, Ron. "The Carnegie International: Venerating the Past." *Artweek* 14 (12 March 1983): 1.

Moser, Charlotte. "Chema Cobo: Zolla/Lieberman." *Art News* 85 (February 1986): 108–9.

Serraller, Francisco Carvo. "The New Figurativists." *Flash Art* 107 (May 1982): 43–46.

● Sue Coe

1951
Born in London

1970–73
Attends Royal College of Art, London

Lives in New York

Selected Solo Exhibitions

1982
Moira Kelly Fine Art, London

1983
P.P.O.W. Gallery, New York

1985
Contemporary Art Center, New Orleans

Institute for Art and Urban Resourses, P.S. 1, Long Island City, New York

Phyllis Kind Gallery, Chicago

P.P.O.W. Gallery

Selected Group Exhibitions

1984
Art as Social Conscience, Avery Arts Center, Bard College, Annandale-on-Hudson, New York

The Human Condition, San Francisco Museum of Modern Art Biennial

1985
57th between A and D, Holly Solomon Gallery, New York

1986
Law and Order Show, John Weber Gallery, Leo Castelli Gallery, and Barbara Gladstone Gallery, New York

Selected Bibliographies

Cotter, Holland. "Sue Coe: Witness." *Arts Magazine* 59 (April 1985): 124–25.

Jan, Alfred. "The Shapes of Narrative." *Artweek* 15 (25 August, 1984): 3.

Mason, Robert. "Why Drawing Needs Daring." *Design* 421 (January 1984): 56–58.

O'Brien, Glenn. "Sue Coe: P.P.O.W. Gallery." *Artforum* 22 (February 1984): 75.

Robinson, Walter, and Carlo McCormick. "Slouching toward Avenue D." *Art in America* 72 (Summer 1984): 135–60.

Stein, Donna, and Stuart Greenspan. "The Broad View." *Art & Auction* 8 (October 1985): 179–83.

Yau, John. "Sue Coe." *Flash Art* 128 (May/June 1986): 46–47.

● Enzo Cucchi

1950
Born in Ancona, Italy

Lives in Ancona

Selected Solo Exhibitions

1980
Galerie Paul Maenz, Cologne

1981
Galerie Bruno Bischofberger, Zurich

Gian Enzo Sperone, Rome

Sperone Westwater Fischer Gallery, New York

1982
Kunsthaus Zurich and tour

1983
Sperone Westwater Gallery, New York; exh. cat., *Album La Scimmia*, by Enzo Cucchi

1984
Anthony d'Offay Gallery, London

Institute of Contemporary Art, Boston

Mary Boone Gallery, New York

Stedelijk Museum, Amsterdam; exh. cat., *Enzo Cucchi: Giulio Cesare Roma*, by Enzo Cucchi

1985
Galerie Daniel Templon, Paris; exh. cat., *Enzo Cucchi: Arthur Rimbaud au Harrar*, by Enzo Cucchi

1986
Solomon R. Guggenheim Museum, New York; exh. cat., *Enzo Cucchi*, by Diane Waldman

Selected Group Exhibitions

1980
Sandro Chia, Francesco Clemente, Enzo Cucchi, Sperone Westwater Fischer Gallery

1981
Biennale de Paris, Musée d'Art Moderne de la Ville de Paris

1982
Documenta 7, Kassel, West Germany

Italian Art Now: An American Perspective, Solomon R. Guggenheim Museum; exh. cat. by Diane Waldman

The Pressure to Paint, Marlborough Gallery, New York

Transavanguardia: Italia/America, Galleria Civica del Comune di Modena, Italy

Zeitgeist, Martin-Gropius-Bau, West Berlin

1983
Recent European Painting, Solomon R. Guggenheim Museum

Sandro Chia, Francesco Clemente, Enzo Cucchi, Kunsthalle, Bielefeld, West Germany; exh. cat. by Heiner Bastian and Wolfgang Max Faust

1984
An International Survey of Recent Painting and Sculpture, Museum of Modern Art, New York; exh. cat.

1985
New Art of Italy, Joslyn Art Museum, Omaha, Nebraska, and tour; exh. cat. by Holliday T. Day

A New Romanticism: Sixteen Artists from Italy, Hirshhorn Museum and Sculpture Garden, Washington, D.C., and tour; exh. cat. by Howard N. Fox with essay by Carl Brandon Strehlke

Selected Bibliographies

Ammann, Jean-Christophe. "Enzo Cucchi: When the Tiger Goes Cock-a-Doodle-Doo, and the Fish Boldly Becomes an Axe." *Flash Art* 103 (Summer 1981): 37.

———. "A Talk: Joseph Beuys, Jannis Kounellis, Anselm Kiefer, Enzo Cucchi." *Flash Art* 128 (May/June 1986): 36–39.

Berger, Danny. "Enzo Cucchi: An Interview." *Print Collector's Newsletter* 13 (September–October 1982): 118–20.

Cucchi, Enzo. "Lettera di un disegno dal fronte." *Domus* 615 (March 1981): 52.

———. "Letter from Enzo Cucchi." *Artscribe* 46 (May–June 1984): 39.

Kachur, Lewis. "Enzo Cucchi." *Arts Magazine* 55 (April 1981): 13.

Politi, Giancarlo, Helena Kontova. "Interview with Enzo Cucchi." *Flash Art* 114 (November 1983): 12–21.

● Ronnie Cutrone

1948
Born in New York

1966–70
Attends School of Visual Arts, New York

Lives in New York

Selected Solo Exhibitions

1982
Tony Shafrazi Gallery, New York

1983
Rotterdam Arts Council, Galerie T'Venster

1984
Salvatore Ala Gallery, Milan

Salvatore Ala Gallery, New York

1985
Tony Shafrazi Gallery

Selected Group Exhibitions

1981
New York/New Wave, Institute for Art and Urban Resources, P.S. 1, Long Island City, New York

1983
The Comic Art Show, Downtown Branch, Whitney Museum of American Art, New York

1984
Aperto '84, Venice Biennale

Terrae Motus, Institute of Contemporary Art, Naples

Visions of Childhood: A Contemporary Iconography, Downtown Branch, Whitney Museum of American Art

Selected Bibliographies

Cotter, Holland. "Double Vision." *Arts Magazine* 59 (April 1985): 41.

Ferrari, Carlo Rocco. "Gli Americani a Milano Ottobre 1983." *Domus* 646 (January 1984): 69.

Larson, Kay. "Garbage Chic." *New York* 18 (1 April 1985): 77–78.

Liebmann, Lisa. "Tangled Nets: 41st Venice Biennale." *Artforum* 23 (September 1984): 108–9.

Mahoney, Robert. "Ronnie Cutrone: Tony Shafrazi." *Arts Magazine* 60 (Summer 1986): 126.

Panicelli, Ida. "Latitudine Napoli New York: Galleria Lucio Amelio, Naples." *Artforum* 22 (February 1984): 87–88.

Parmesani, Loredana. "Significant Celebrations: Haring, Cutrone, Scharf, Brown at Salvatore Ala Gallery, Milan." *Flash Art* 116 (March 1984): 32.

Silverthorne, Jeanne. "Ronnie Cutrone: Tony Shafrazi Gallery." *Artforum* 21 (March 1983): 76–77.

Trini, T. "Ronnie Cutrone: Interview." *Flash Art* 117 (April/May 1984): 62–63.

Zelevansky, Lynn. "Ronnie Cutrone: Tony Shafrazi Gallery." *Flash Art* 112 (May 1983): 66.

● Walter Dahn

1954
Born in Krefeld, West Germany

Lives in Cologne

Selected Solo Exhibitions

1982
Galerie Paul Maenz, Cologne

1983
Mary Boone Gallery, New York

1985
Asher/Faure Gallery, Los Angeles
Städtisches Kunstmuseum Bonn, West Germany

1986
Museum Folkwang, Essen
Kunsthalle Steinenberg, Basel
Stedelijk Van Abbemuseum, Eindhoven, Netherlands

Selected Group Exhibitions

1981
Bildwechsel-Neue Malerei Aus Deutschland, Akademie der Künste, West Berlin

1982
Documenta 7, Kassel, West Germany
Zeitgeist, Martin-Gropius-Bau, West Berlin

1983
Expressionisten-Neue Wilde, Museum am Ostwall, Dortmund, West Germany

An International Survey of Recent Painting and Sculpture, Museum of Modern Art, New York; exh. cat.

New Art, Tate Gallery, London

Walter Dahn, Rene Daniels, Isa Genzken, Jenny Holzer, Robert Longo, Henk Visch, Stedelijk Van Abbemuseum

Selected Bibliographies

Faust, Wolfgang Max. "Du hast Keine Chance, Nutze sie! With It and Against It: Tendencies in Recent German Art." *Artforum* 20 (September 1981): 33–39.

Frackman, Noel, and Ruth Kaufmann. "Documenta 7: The Dialogue and a Few Asides." *Arts Magazine* 57 (October 1982): 91–97.

Iden, Peter. "Die hochgemuten Nichtskönner." *Kunstwerk* 34 (June 1981): 3–5, 23.

Kuspit, Donald. "Walter Dahn/Jiři Georg Dokoupil: Mary Boone Gallery." *Artforum* 22 (November 1983): 82–83.

Pohlen, Annelie. "Walter Dahn: Rheinisches Landesmuseum." *Artforum* 24 (February 1986): 116.

Schmidt-Wulffen, Stephan. "Walter Dahn: Rheinisches Landesmuseum, Bonn." *Flash Art* 124 (October/November 1985): 58.

Taylor, Paul. "Café Deutschland." *Art News* 85 (April 1986): 68–76.

Von Kageneck, Christian. "Mühlheimer Freiheit, Kunstverein Freiburg." *Kunstwerk* 34 (May 1981): 91.

Zellweger, Harry. "12 Künstler aus Deutschland." *Kunstwerk* 35 (June 1982): 58–59.

● David Diao

1943
Born in Chengdu, Sichuan, China

Lives in New York

Selected Solo Exhibitions

1980
Rosa Esman Gallery, New York

1985
Postmasters Gallery, New York

Selected Group Exhibitions

1981
Geometric Abstraction: A New Generation, Institute of Contemporary Art, Boston

1986
Paravision, Margo Leavin Gallery, Los Angeles

Selected Bibliographies

Lawson, Thomas. "David Diao: Spring Street Gallery." *Art in America* 67 (January/February 1979): 144.

Westfall, Stephen. "Diaorama." *Art in America* 74 (March 1986): 134–37.

● Stefano di Stasio

1948
Born in Naples

Lives in Rome

Selected Solo Exhibitions

1980
La Tartaruga, Rome

1982
Casa del Mantegna, Mantua, Italy

1983
Galleria Monti, Macerata, Italy
La Tartaruga

1985
Galleria Monti, Rome; exh. cat., *Stefano di Stasio,* by Maurizio Calvesi

1986
Galleria Artra, Milan

Selected Group Exhibitions

1980
Sei Pittori, Galeria de'Foscherari, Bologna; exh. cat. by Maurizio Calvesi

1982
Anacronismo, La Tartaruga
Aperto '82, Venice Biennale
Stefano di Stasio, Concello Pozzati, Casa del Mantegna

1983
Gli anacronisti o pittori della memoria, Galleria Vigato, Alessandria, Italy, and tour
Il tempo dell'immagine, Villa Fidelia, Spello, and Palazzo Trinci, Foligno, Italy
Pittori della memoria, Galleria Vigato

1984
Anacronismo, ipermanierismo, Monte Frumentario, Anagni, Italy; exh. cat. by Maurizio Calvesi and Italo Tomassoni
Arte allo specchio, Venice Biennale
La persistenza del mito nella pittura e nella scultura degli anni ottanta, Centro Communale di Cultura, Valenza, Italy

1985
A New Romanticism: Sixteen Artists from Italy, Hirshhorn Museum and Sculpture Garden, Washington, D.C., and tour; exh. cat. by Howard N. Fox with essay by Carl Brandon Strehlke
Ubaldo Bartolini, Stefano di Stasio, Galleria Monti, Rome

Selected Bibliographies

Balmas, Paolo. "Stefano di Stasio, La Tartaruga." *Flash Art* 114 (June 1983): 64.

Calvesi, Maurizio. "Il Tempo dell'immagine." *Flash Art* 114 (June 1983): 8–13.

Maestri, Barbara. "Spello: 'il tempo dell'immagine,' Villa Fidelia." *Artforum* 22 (December 1983): 91.

Martin, Henry. "Inside Europe: Italy." *Art News* 84 (February 1985): 60–62.

Parmesani, Loredana. "Io sono tutti i nomi della storia." *Flash Art* 121 (June 1984): 21–24.

Vidali, Roberto. "La presenza del passato, colloquio con Stefano di Stasio." *La Tartaruga* 1 (January 1984): 18–19.

● Jiři Georg Dokoupil

1954
Born in Krnov, Czechoslovakia

1976–78
Studies fine arts in Cologne, Frankfurt am Main, and New York

1983–84
Tutorship at State Academy of Arts, Düsseldorf

Lives in Cologne, New York, and Tenerife

Selected Solo Exhibitions

1982
Galerie Paul Maenz, Cologne

1983
Mary Boone Gallery, New York

1984
Museum Folkwang, Essen

1985
Asher/Faure Gallery, Los Angeles

Selected Group Exhibitions

1980
Mühlheimer Freiheit und interessante Bilder aus Deutschland, Galerie Paul Maenz

1982
Documenta 7, Kassel, West Germany

Venice Biennale

Zeitgeist, Martin-Gropius-Bau, West Berlin

1983
New Art, Tate Gallery, London

1984
An International Survey of Recent Painting and Sculpture, Museum of Modern Art, New York; exh. cat.

Selected Bibliographies

Crone, Rainer. "Jiři Georg Dokoupil: The Imprisoned Brain." *Artforum* 21 (March 1983): 50–55.

Faust, Wolfgang Max. "Du hast keine Chance, Nutze sie! With It and Against It: Tendencies in Recent German Art." *Artforum* 20 (September 1981): 33–39.

————. "The Appearance of the Zeitgeist." *Artforum* 21 (January 1983): 86–93.

Grasskamp, Walter. "Disgusting Techniques." *Flash Art* 125 (December 1985/January 1986): 27–29.

"Interview with Paul Maenz." *Flash Art* 117 (April/May 1984): 44–45.

Kuspit, Donald B. "Report from Berlin Bildwechsel: Taking Liberties." *Art in America* 70 (February 1982): 43–49.

Maenz, Paul. "Conversation between Dokoupil and Maenz." *Flash Art* 127 (April 1986): 45–67.

Owens, Craig. "Bayreuth '82." *Art in America* 70 (September 1982): 132–39, 191.

Simmen, Jeannot L. "New Painting in Germany." *Flash Art* 109 (November 1982): 54–58.

Wildermuth, Armin. "The Crisis of Interpretation." *Flash Art* 116 (March 1984): 8–18.

● Peter Drake

1957
Born in New York

1979
Receives B.F.A. from Pratt Institute, Brooklyn, New York

Lives in New York

Selected Solo Exhibitions

1984
Sharpe Gallery, New York

1985
Sharpe Gallery

1986
Michael Kohn Gallery, Los Angeles

Selected Group Exhibitions

1984
Neo York, University Art Museum, University of California, Santa Barbara

1985
A Brave New World, A New Generation: 40 New York Artists, Charlottenborg, Copenhagen; exh. cat., essays by Mogens Breyen, Carlo McCormick, and Thomas B. Solomon

57th Between A and D, Holly Solomon Gallery, New York

New York/Seattle, Seattle Center of Contemporary Art

Selected Bibliographies

Brennan, Mark. "Political Topics in Art at Borgenicht." *Manhattan Arts* (June 1984): 11.

Cone, Michele. "Peter Drake." *Flash Art* 127 (April 1986): 66–67.

Cotter, Holland. "57th between A and D." *Arts Magazine* 59 (April 1985): 13.

Kohn, Michael. "Romantic Vision." *Flash Art* 120 (January 1985): 56–60.

Robinson, Walter, and Carlo McCormick. "Slouching toward Avenue D." *Art in America* 72 (Summer 1984): 134–63.

Volmer, Suzanne. "Drawings and Prints: As the Twain Meet." *Arts Magazine* 57 (February 1983): 84–85.

● Brad Durham

1952
Born in San Francisco

1972
Attends Art Center College of Design, Los Angeles

1973–74, 1978
Attends Humboldt State University, Arcadia, California

1980–81
Attends San Diego State University

Lives in Los Angeles

Selected Solo Exhibitions

1983
Maple Gallery, San Diego

Selected Group Exhibitions

1983
Art Auction, Los Angeles Municipal Art Gallery

1985
Artists Guild, San Diego Museum of Art

Hot, Simard/Halm Gallery, Los Angeles

1986
All California Exhibition, Laguna Art Museum, Laguna Beach, California

Group Show, Karl Bornstein Gallery, Santa Monica, California

● Eric Fischl

1948
Born in New York

1972
Receives B.F.A. from California Institute of the Arts, Valencia

Lives in New York

Selected Solo Exhibitions

1980
Edward Thorp Gallery, New York

1983
Larry Gagosian Gallery, Los Angeles

1984
Mary Boone Gallery, New York

1985–86
Mendel Art Gallery, Saskatoon, Canada, and tour; exh. cat., *Eric Fischl: Paintings*, essays by Jean-Christopher Ammann, Bruce W. Ferguson, and Donald B. Kuspit

1986
Daniel Weinberg Gallery, Los Angeles

Larry Gagosian Gallery

Mary Boone Gallery

Selected Group Exhibitions

1982
The Expressionist Image: From Pollock to Today, Sidney Janis Gallery, New York

Focus on the Figure: Twenty Years, Whitney Museum of American Art, New York

1984

Content: A Contemporary Focus, 1974–1984, Hirshhorn Museum and Sculpture Garden, Washington, D.C.; exh. cat., essays by Howard N. Fox, Miranda McClintic, and Phyllis Rosenzweig

Paradise Lost: Paradise Regained, American Pavilion, Venice Biennale

Selected Bibliographies

Berman, Avis. "Artist's Dialogue: Eric Fischl, Trouble in Paradise." *Architectural Digest* 42 (December 1985): 72–79.

Liebmann, Lisa. "Eric Fischl's Year of the Drowned Dog: Eight Characters in Search of an Autumn." *Artforum* 22 (March 1984): 67–69.

Linker, Kate. "Eric Fischl: Involuted Narratives." *Flash Art* 115 (January 1984): 54–56.

Owens, Craig. "Back to the Studio." *Art in America* 70 (January 1982): 99–107.

Ratcliff, Carter. "Contemporary American Art." *Flash Art* 108 (Summer 1982): 32–35.

———. "Expressionism Today: An Artist's Symposium." *Art in America* 70 (December 1982): 58–75.

Russell, John. "Art: At the Whitney, 28 Eric Fischl Paintings." *New York Times*, 21 February 1986.

Storr, Robert. "Desperate Pleasures." *Art in America* 72 (November 1984): 124–31.

Tatransky, Valentin. "Fischl, Lawson, Robinson, and Zwack: They Make Pictures." *Arts Magazine* 55 (June 1981): 147–49.

Tomkins, Calvin. "The Art World: Real and Unreal." *New Yorker* 62 (12 May 1986): 99–101.

Yau, John. "How We Live: The Paintings of Robert Birmelin, Eric Fischl, and Ed Paschke." *Artforum* 21 (April 1983): 60–67.

● Vernon Fisher

1943
Born in Fort Worth, Texas

1967
Receives B.A. from Hardin-Simmons University, Abilene, Texas

1969
Receives M.F.A. from University of Illinois, Champaign-Urbana

Lives in Fort Worth

Selected Solo Exhibitions

1980
Contemporary Arts Museum, Houston; exh. cat., *Vernon Fisher: Story Paintings and Drawings*, essay by Marti Mayo

1981
Barbara Gladstone Gallery, New York

Franklin Furnace, New York

1982
Rotterdam Arts Foundation

1984
Barbara Gladstone Gallery

1986
Asher/Faure Gallery, Los Angeles

Selected Group Exhibitions

1980
Investigations: Probe-Structure-Analysis, New Museum of Contemporary Art, New York

1981
Biennial Exhibition, Whitney Museum of American Art, New York; exh. cat.

Directions 1981, Hirshhorn Museum and Sculpture Garden, Washington, D.C.

19 Artists, Emergent Americans: 1981 Exxon National Exhibition, Solomon R. Guggenheim Museum, New York

The Southern Voice: Terry Allen, Vernon Fisher, Ed McGowin, Fort Worth Art Museum

1982
Indian Triennial, New Delhi

Mediums of Language, Hayden Gallery, Massachusetts Institute of Technology, Cambridge

Painting and Sculpture Today, Indianapolis Museum of Art

1983
The Comic Art Show, Downtown Branch, Whitney Museum of American Art

Language, Drama, Source and Vision, New Museum of Contemporary Art

1984
Content: A Contemporary Focus, 1974–1984, Hirshhorn Museum and Sculpture Garden; exh. cat., essays by Howard N. Fox, Miranda McClintic, and Phyllis Rosenzweig

Narrative Forms, Museo Rufino Tamayo, Mexico City

1986
Memento Mori, Centro Cultural de Arte Contemporaneo, Mexico City

75th American Exhibition, Art Institute of Chicago; exh. cat., essays by Neal Benezra and A. James Speyer

Wall Works, John Weber Gallery, New York

Selected Bibliographies

Freudenheim, Susan. "Vernon Fisher at Delahunty." *Art in America* 71 (March 1983): 164–65.

———. "Vernon Fisher: At Home on the Ranges." *Artforum* 24 (October 1985): 93–96.

Gardner, Colin. "The Unpredictable and the Deconstructive." *Artweek* 17 (14 June 1986): 1.

Indiana, Gary. "Vernon Fisher at Barbara Gladstone." *Art in America* 72 (December 1984): 166–67.

Kalil, Susie. "Vernon Fisher at Contemporary Arts

Museum." *Art in America* 69 (April 1981): 151.

Platt, Susan. "Vernon Fisher: Delahunty, Dallas." *Arts Magazine* 54 (February 1980): 13.

Westfall, Stephen. "Vernon Fisher: Barbara Gladstone Gallery." *Arts Magazine* 56 (January 1982): 20.

Yard, Sally. "The Shadow of the Bomb." *Arts Magazine* 58 (April 1984): 73.

● Stephen Frailey

1957
Born in Evanston, Illinois

1978
Attends San Francisco Art Institute

1979
Receives B.A. from Bennington College, Vermont

Lives in New York

Selected Solo Exhibitions

1982
New England School of Photography, Boston

1984
New Museum of Contemporary Art, New York

1986
303 Gallery, New York

Selected Group Exhibitions

1982
Sports, Museum of Modern Art, New York

1984
A Decade of New Art, Artists Space, New York

1986
Stephen Frailey and Larry Johnson, New Strategies, Los Angeles

Selected Bibliographies

Grundberg, Andy. "At Photo Shows, a Kaleidoscope of Visual Delights." *New York Times*, 16 May 1986.

Pincus-Witten, Robert. "Entries: Myth in Formation." *Arts Magazine* 58 (November 1983): 97–99.

Zimmer, William. "Photographers Explore Artifice." *New York Times*, 27 April 1986.

● John Frame

1950
Born in Colton, California

1975
Receives B.A. from San Diego State University

1980
Receives M.F.A. from Claremont Graduate School, California

Lives in Los Angeles

Selected Solo Exhibitions

1982
Janus Gallery, Los Angeles

1984
Janus Gallery

Selected Group Exhibitions

1981
Newcomers 1981, Los Angeles Municipal Art Gallery

1984
Return of the Narrative, Palm Springs Desert Museum, California

Three Sculptors: John Frame, Sam Hernandez, Gary Martin, ARCO Center for Visual Art, Los Angeles

Selected Bibliographies

Donohue, Marlena. "John Frame: Janus Gallery." *Los Angeles Times*, 27 July 1984.

Hugo, Joan. "The Enduring Object: From Anecdote to Myth." *Artweek* 15 (26 May 1984): 1.

Komac, Dennis. "An Artful Dilemma." *Artweek* 14 (18 June 1983): 20.

Menzies, Neal. "Evolving from the Primitive." *Artweek* 12 (3 October 1981): 16.

Muchnic, Suzanne. "Language: A Message of Futility." *Los Angeles Times*, 29 March 1982.

———. "Wood Sculptors Find a Niche." *Los Angeles Times*, 30 January 1984.

———. "2 Sculptors Earn Young Talent Prize." *Los Angeles Times*, 24 June 1985.

Pincus, Robert L. "Galleries." *Los Angeles Times*, 13 August 1982.

● Gérard Garouste

1946
Born in Paris

Lives in Paris

Selected Solo Exhibitions

1981
Palazzo Ducezio, Noto, Italy

1982
Museo Civico d'Arte Contemporanea, Gibellina, Italy

1983
Leo Castelli Gallery and Sperone Westwater, New York

1985
Leo Castelli Gallery

Selected Group Exhibitions

1982
Twelve Contemporary French Artists, Albright-Knox Art Gallery, Buffalo, New York

Zeitgeist, Martin-Gropius-Bau, West Berlin

1983
Image Innovations: The Europeans, Virginia Museum of Fine Arts, Richmond

1985
The Classic Tradition in Recent Painting and Sculpture,

Aldrich Museum, Ridgefield, Connecticut

Selected Bibliography

Adams, Brooks. "Gérard Garouste at Castelli and Sperone Westwater." *Art in America* 71 (May 1983): 162–63.

Blistene, Bernard. "Gérard Garouste: Galerie Durand-Desset." *Flash Art* 100 (November 1980): 48–49.

Hahn, Otto. "Made in France." *Connaissance des Arts* 360 (February 1982): 50–55.

———. "Théâtre Sans Parole." *Connaissance des Arts* 372 (February 1983): 42–47.

Harris, Susan A. "Gérard Garouste: Sperone Westwater." *Arts Magazine* 57 (April 1983): 41–42.

Heartney, Eleanor. "Gérard Garouste." *Arts Magazine* 57 (April 1983): 4.

Kohn, Michael. "Gérard Garouste: Sperone Westwater and Castelli." *Flash Art* 112 (May 1983): 60.

Liebmann, Lisa. "Gérard Garouste: Leo Castelli Gallery." *Artforum* 21 (May 1983): 95–96.

San, Jerome. "The Other Face of Banality: Gérard Garouste." *Artscribe International* 55 (December–January 1985–86): 48–50.

Sofer, Ken. "Gérard Garouste: Sperone Westwater/Leo Castelli." *Art News* 82 (May 1983): 151–52.

● Robert Gober

1954
Born in Wallingford, Connecticut

1976
Receives B.A. from Middlebury College, Connecticut

Lives in New York

Selected Solo Exhibitions

1984
Paula Cooper Gallery, New York

1985
Daniel Weinberg Gallery, Los Angeles

Paula Cooper Gallery

1986
Daniel Weinberg Gallery

Selected Group Exhibitions

1983
New York Work, Studio 10, Chur, Switzerland

1986
Objects from the Modern World, Daniel Weinberg Gallery

Selected Bibliography

Lichtenstein, Therese. "Group Show: Paula Cooper." *Arts Magazine* 59 (November 1984): 37.

Rinder, Larry. "Kevin Larmon and Robert Gober: Nature Morte." *Flash Art* 128 (May/June 1986): 56–57.

Russell, John. "Robert Gober: Paula Cooper Gallery." *New York Times*, 4 October 1985.

● Leon Golub

1922
Born in Chicago

1942
Receives B.A. from University of Chicago

1950
Receives M.F.A. from Art Institute of Chicago

Lives in New York

Selected Solo Exhibitions

1983
Sarah Campbell Blaffer Gallery, University of Houston, and tour

University Art Museum, University of California, Berkeley

1984
New Museum of Contemporary Art, New York, and tour; exh cat., *Golub*, essays by Lynn Gumpert and Ned Rifkin

1985
Institute of Contemporary Art, Boston

1986
Barbara Gladstone Gallery, New York

Selected Group Exhibitions

1983
Brave New Works: Recent American Painting and Drawing, Museum of Fine Arts, Boston

1984
Content: A Contemporary Focus, 1974–1984, Hirshhorn Museum and Sculpture Garden, Washington, D.C.; exh. cat., essays by Howard N. Fox, Miranda McClintic, and Phyllis Rosenzweig

The Human Condition, San Francisco Museum of Modern Art Biennial

Selected Bibliography

Baigell, Matthew. "'The Mercenaries': An Interview with Leon Golub." *Arts Mazagine* 55 (May 1981): 167–69.

Barnes, Lucinda. "A Commitment to Politics." *Artweek* 16 (12 January 1985): 5.

Cameron, Dan. "Content in Content: The Retrospective of Leon Golub and George McNeil." *Arts Magazine* 59 (March 1985): 115–17.

Kuspit, Donald. *Leon Golub, Existentially Activist Painter*. New Brunswick, N.J.: Rutgers University Press, 1985.

Marzorati, Gerald. "Leon Golub's Mean Streets." *Art News* 85 (February 1985): 74–87.

Perl, Jed. "Hayter's Line and Golub's Message." *New Criterion* 4 (March 1986): 45–53.

Pincus-Witten, Robert. "Entries: The View from the Golub Heights." *Arts Magazine* 60 (March 1986): 44–45.

Ratcliff, Carter. "Theatre of Power." *Art in America* 72 (January 1984): 74–82.

Robins, Corinne. "Leon Golub in the Realm of Power." *Arts Magazine* 55 (May 1981): 170–73.

Siegel, Jeanne. "Leon Golub/Hans Haacke: What Makes Art Political?" *Arts Magazine* 58 (April 1984): 107–13.

Smith, Paul. "Election Issues: A Timely Artistic Response." *Arts Magazine* 59 (November 1984): 126–27.

● Antony Gormley

1950
Born in London

Lives in London

Selected Solo Exhibitions

1981
Whitechapel Art Gallery, London

1985
Städtisches Galerie Regensberg and Frankfurter Kunstverein, West Germany; exh. cat., *Antony Gormley*, essays by Veit Loers and Sandy Nairne

1986
Salvatore Ala, New York

Selected Group Exhibitions

1981
British Sculpture in the 20th Century, Whitechapel Art Gallery

1982
Hayward Annual: British Drawing, Hayward Gallery, London

1983
New Art, Tate Gallery, London

1984
An International Survey of Recent Painting and Sculpture, Museum of Modern Art, New York; exh. cat.

1985
Three British Sculptors, Neuberger Museum, State University of New York, Purchase

Selected Bibliography

Archer, Michael. "Antony Gormley." *Studio International* 196, no. 1004 (1984): 44.

Castle, Frederick Ted. "Antony Gormley at Salvatore Ala." *Art in America* 72 (October 1984): 195.

Dimitrijevic, Nena. "Antony Gormley: Coracle Press." *Flash Art* 115 (January 1984): 40.

Fisher, Jean. "Antony Gormley: Salvatore Ala." *Artforum* 24 (January 1986): 86.

Moorman, Margaret. "Antony Gormley: Salvatore Ala." *Art News* 83 (September 1984): 149–50.

● Hans Haacke

1936
Born in Cologne

1960
Receives M.F.A. from State Academy of Fine Art, Kassel, West Germany

Lives in New York

Selected Solo Exhibitions

1979
Stedelijk Van Abbemuseum, Eindhoven, Netherlands

1981
John Weber Gallery, New York

1984
Neue Gesellschaft für Bildende Kunst, West Berlin; exh. cat., *Hans Haacke: Nach allen Regeln der Kunst*, essays by Ulrich Giersch, Hans Haacke, and Barbara Straka, interview by Jeanne Siegel

Tate Gallery, London

1985
Kunsthalle, Bern

Selected Group Exhibitions

1981
Art Allemand Aujour'hui, ARC, Musée d'Art Moderne de la Ville de Paris

1982
Documenta 7, Kassel

1984
Content: A Contemporary Focus, 1974–1984, Hirshhorn Museum and Sculpture Garden, Washington, D.C.; exh. cat., essays by Howard N. Fox, Miranda McClintic, and Phyllis Rosenzweig

Selected Bibliography

Archer, Michael. "Hans Haacke on the Inside." *Studio International* 197, no. 1005 (1984): 42–43.

Buchloh, Benjamin H. D. "Allegorical Procedures, Appropriation and Montage in Contemporary Art." *Artforum* 21 (September 1982): 43–56.

Frohne, Ursula. "Hans Haacke: Kunstlerhaus Bethanien." *Flash Art* 120 (January 1985): 49–50.

Haacke, Hans. "On Social Grease." *Art Journal* 42 (Summer 1982): 137–43.

———. "Issues and Commentary: Museums, Managers of Consciousness." *Art in America* 72 (February 1984): 9–17.

Lichtenstein, Therese. "Hans Haacke: John Weber." *Flash Art* 124 (October/November 1985): 52.

Morgan, Robert C. "Hans Haacke: Working from the Inside Out." *Arts Magazine* 60 (October 1985): 24–25.

Siegel, Jeanne. "Leon Golub/Hans Haacke: What Makes Art Political?" *Arts Magazine* 58 (April 1984): 107–13.

Taylor, Paul. "Interview with Hans Haacke." *Flash Art* 126 (February–March 1986): 39–41.

● Peter Halley

1953
Born in New York

1975
Receives B.A. from Yale University, New Haven, Connecticut

1978
Receives M.F.A. from University of New Orleans

Lives in New York

Selected Solo Exhibitions

1978
Contemporary Arts Center, New Orleans

1985
International with Monument, New York

1986
Galerie Daniel Templon, Paris; exh. cat., *Peter Halley*, by Peter Halley

Selected Group Exhibitions

1983
Tradition, Transition, New Vision, Addison Gallery of American Art, Andover, Massachusetts

1985
A Brave New World, A New Generation: 40 New York Artists, Charlottenborg, Copenhagen; exh. cat., essays by Mogens Breyen, Carlo McCormick, and Thomas B. Solomon

Infotainment (18 Artists from New York), Gallery Nature Morte, New York, and tour; exh. cat., essays by Thomas Lawson and George W. S. Trow

Postmasters Gallery, New York

1986
Europe America, Ludwig Museum, Cologne

Painting and Sculpture Today: 1986, Indianapolis Museum of Art

Paravision, Margo Leavin Gallery, Los Angeles

Post Pop, Michael Kohn Gallery, Los Angeles

Selected Bibliography

Cone, Michele. "Peter Halley." *Flash Art* 126 (February–March 1986): 36–38.

Foster, Hal. "Signs Taken for Wonders." *Art in America* 74 (June 1986): 80–91, 139.

Halley, Peter. "Against Post-Modernism: Reconsidering Ortega." *Arts Magazine* 56 (November 1981): 112–15.

———. "A Note on the 'New Expressionism' Phenomenon." *Arts Magazine* 57 (March 1983): 88–89.

———. "Nature and Culture." *Arts Magazine* 58 (September 1983): 64–65.

Jones, Ronald. "Six Artists at the End of the Line: Gretchen Bender, Ashley Bickerton, Peter Halley,

Louise Lawler, Allan McCollum, and Peter Nagy.''
Arts Magazine 60 (May 1986): 49–51.

Nagy, Peter. "From Criticism to Complicity." *Flash Art* 129 (Summer 1986): 46–49.

Siegel, Jeanne. "Geometry Desurfacing: Ross Bleckner, Alan Belcher, Ellen Carey, Peter Halley, Sherrie Levine, Philip Taaffe, James Welling." *Arts Magazine* 60 (March 1986): 26–32.

● Keith Haring

1958
Born in Kutztown, Pennsylvania

1978–79
Attends School of Visual Arts, New York

Lives in New York

Selected Solo Exhibitions

1983
Tony Shafrazi Gallery, New York; exh. cat., *Keith Haring*, essays by Jeffrey Deitch, Robert Pincus-Witten, and David Shapiro

1985
Leo Castelli Gallery, New York

Musée d'Art Contemporain de Bordeaux; exh. cat., *Keith Haring*, essays by Sylvie Couderc, Jean-Louis Froment, and Brion Gysin

1986
Galerie Daniel Templon, Paris

Stedelijk Van Abbemuseum, Eindhoven, Netherlands

Selected Group Exhibitions

1980
Times Square Show, New York

1984
Content: A Contemporary Focus, 1974–1984, Hirshhorn Museum and Sculpture Garden, Washington, D.C.; exh. cat., essays by Howard N. Fox, Miranda McClintic, and Phyllis Rosenzweig

The Human Condition, San Francisco Museum of Modern Art Biennial

1986
Spectrum: The Generic Figure, Corcoran Gallery of Art, Washington, D.C.

Selected Bibliography

Alinovi, Francesca. "Twenty-first Century Slang." *Flash Art* 114 (November 1983): 23–30.

Gablik, Suzi. "Report from New York: The Graffiti Question." *Art in America* 70 (October 1982): 33–36.

Gardner, Paul. "When Is a Painting Finished?" *Art News* 84 (November 1985): 90.

Hapgood, Susan. "Irrationality in the Age of Technology." *Flash Art* 110 (January 1983): 41–43.

Haring, Keith. "Keith Haring." *Flash Art* 116 (March 1984): 20–24.

Moufarrege, Nicolas A. "Lightning Strikes (Not Once but Twice): An Interview with Graffiti Artists." *Arts Magazine* 57 (November 1982): 87–93.

Perrone, Jeff. "Porcelain and Pop." *Arts Magazine* 58 (March 1984): 80–87.

Ricard, Rene. "Radiant Child." *Artforum* 20 (December 1981): 35–43.

Robinson, Walter and McCormick, Carlo. "Slouching toward Avenue D." *Art in America* 72 (Summer 1984): 156–59.

● Roger Herman

1947
Born in Saarbrücken, West Germany

1972–76
Attends Akademie der Künste, Karlsruhe, West Germany

Lives in Los Angeles

Selected Solo Exhibitions

1981
Ulrike Kantor Gallery, Los Angeles

1982
Akademie der Künste

1983
La Jolla Museum of Contemporary Art, California

Peppers Art Gallery, University of Redlands, California; exh. cat., *Roger Herman: Woodcuts*, introduction by Leslie Wolf

Ulrike Kantor Gallery; exh. cat., *Roger Herman: Paintings and Woodcuts*

1986
Larry Gagosian Gallery, Los Angeles

Nave Museum, Victoria, Texas, and tour

University Art Gallery, Southwest Texas State University, San Marcos; exh. cat., *Roger Herman: Woodcuts*, by Andrea Liss

Vollum Center Gallery, Reed College, Portland, Oregon; exh. cat., *Roger Herman: Woodcuts 1983–1985*

Selected Group Exhibitions

1982
Fresh Paint, San Francisco Museum of Modern Art

1984
Images and Impressions: Painters Who Print, Walker Art Center, Minneapolis

1986
Haane Braun Galli, Roger Herman, Max Neumann, Stadtgalerie Saarbrücken; exh. cat.

Selected Bibliography

Brody, J. "Roger Herman: A New Expressionist?" *Print Collectors Newsletter* 15 (January/February 1985): 200–205.

Cohen, Ronny. "Jumbo Prints: Artists Who Paint Big

Want to Print Big." *Art News* 83 (October 1984): 81–87.

Drohojowska, Hunter. "Roger Herman: La Jolla Museum of Contemporary Art and Ulrike Kantor." *Art News* 83 (February 1984): 102.

Gardner, Colin. "Roger Herman: Larry Gagosian Gallery." *Artforum* 35 (September 1986): 142.

Selz, Peter. "Roger Herman." *Arts Magazine* 58 (December 1983): 12.

● Jenny Holzer

1950
Born in Gallipolis, Ohio

1972
Receives B.F.A. from Ohio University, Athens

1977
Receives M.F.A. from Rhode Island School of Design, Providence

1977
Fellow, Independent Study Program, Whitney Museum of American Art, New York

Lives in New York

Selected Solo Exhibitions

1982
Barbara Gladstone Gallery, New York

1983
Institute of Contemporary Art, London

Institute of Contemporary Art, Philadelphia

1984
Dallas Museum of Art

Kunsthalle Basel; exh. cat., *Jenny Holzer*

Seattle Art Museum

Selected Group Exhibitions

1981
Westkunst, Cologne

1982
Annual American Exhibition, Art Institute of Chicago

Dokumenta 7, Kassel, West Germany

Zeitgeist, Martin-Gropius-Bau, West Berlin

1983
Art and Social Change, Allen Memorial Art Museum, Oberlin, Ohio; exh. cat.

Biennial Exhibition, Whitney Museum of American Art; exh. cat.

1984
Content: A Contemporary Focus, 1974–1984, Hirshhorn Museum and Sculpture Garden, Washington, D.C.; exh. cat., essays by Howard N. Fox, Miranda McClintic, and Phyllis Rosenzweig

The Human Condition, San Francisco Museum of Modern Art Biennial

Sydney Biennale, Art Gallery of New South Wales

1985

Biennial Exhibition, Whitney Museum of American Art; exh. cat.

Carnegie International, Museum of Art, Carnegie Institute, Pittsburgh; exh. cat., edited by Saskia Bos and John R. Lane

Secular Attitudes, Los Angeles Institute of Contemporary Art

Selected Bibliography

Foster, Hal. "Subversive Signs." *Art in America* 70 (November 1982): 88–92.

Holzer, Jenny. *Truism and Essays.* Halifax: Nova Scotia College of Design Press, 1983.

Ratcliff, Carter. "Jenny Holzer." *Print Collector's Newsletter* 13 (November–December 1982): 149–52.

Siegel, Jeanne. "Jenny Holzer's Language Games." *Arts Magazine* 60 (December 1985): 64–68.

Smith, Paul. "Election Issues: A Timely Artistic Response." *Arts Magazine* 59 (November 1984): 126–27.

Town, Elke. "Jenny Holzer." *Parachute* 31 (Summer 1983): 51–52.

Weinstock, Jane. "Issues and Commentary: A Lass, a Laugh and a Lad." *Art in America* 71 (Summer 1983): 7–10.

● Douglas Huebler

1924
Born in Ann Arbor, Michigan

1947–48
Attends Académie Julian, Paris

1948
Attends Cleveland School of Art

1952
Receives B.F.A. from University of Michigan, Ann Arbor

1954
Receives M.F.A. from University of Michigan

Lives in Los Angeles

Selected Solo Exhibitions

1981
Leo Castelli Gallery, New York

1984
Museum of Contemporary Art, Los Angeles

1985
Kuhlenschmidt/Simon Gallery, Los Angeles

1986
Leo Castelli Gallery

Selected Group Exhibitions

1980
Contemporary Art in Southern California, High Museum of Art, Atlanta

1982
Castelli and His Artists: Twenty Five Years, La Jolla Museum of Contemporary Art, California, and tour

1984
Summer Exhibition/20 Years of Collecting, Stedelijk Van Abbemuseum, Eindhoven, Netherlands

Verbally Charged Images, Queens Museum, Flushing, New York, and tour

1986
TV Generations, LACE (Los Angeles Contemporary Exhibitions); exh. cat., essays by John Baldessari, Peter D'Agostino, John G. Hanhardt, and Bruce Yonemoto

Selected Bibliography

Gardner, Colin. "Douglas Huebler: Kuhlenschmidt/Simon Gallery." *Artforum* 24 (March 1986): 126–27.

Ratcliff, Carter. "Modernism and Melodrama." *Art in America* 69 (February 1981): 105–9.

Stimson, Paul. "Fictive Escapades: Douglas Huebler." *Art in America* 70 (February 1982): 96–99.

● Jörg Immendorff

1945
Born in Bleckede, West Germany

1963–64
Attends Staatliche Kunstakademie, Düsseldorf

Lives in Düsseldorf

Selected Solo Exhibitions

1980
Kunsthalle, Bern

1981
Stedlijk Van Abbemuseum, Eindhoven, Netherlands

1982
Kunsthalle, Düsseldorf; exh. cat., *Jörg Immendorff: Café Deutschland Adlerhälfte*, text by Jürgen Harten

Sonnabend Gallery, New York

1983
Kunsthaus, Zurich; exh. cat., *Immendorff*, by Toni Stooss and Harald Szeemann

Kunst Sabine, Munich; exh. cat., *Jörg Immendorff: Café Deutschland Gut*, essay by Diedrich Diederichsen

1986
Galerie Michael Werner, Cologne; exh. cat., *Jörg Immendorff: Zwölf Bilder 1978*

Mary Boone Gallery, New York

Selected Group Exhibitions

1983
Expressions: New Art from Germany, Saint Louis Art Museum and tour; exh. cat., essays by Jack Cowart, Siegfried Gohr, and Donald B. Kuspit

1984
Content: A Contemporary Focus, 1974–1984, Hirshhorn Museum and Sculpture Garden, Washington, D.C.; exh. cat., essays by Howard N. Fox, Miranda McClintic, and Phyllis Rosenzweig

The Human Condition, San Francisco Museum of Modern Art Biennial

An International Survey of Recent Art and Sculpture, Museum of Modern Art, New York; exh. cat.

1985
Carnegie International, Museum of Art, Carnegie Institute, Pittsburgh; exh. cat., edited by Saskia Bos and John R. Lane

German Art in the 20th Century, Royal Academy of Arts, London; exh. cat., edited by Christos M. Joachimides, Norman Rosenthal, and Wieland Schmied

Selected Bibliography

Beyer, Lucie. "Jörg Immendorff: Michael Werner, Cologne." *Flash Art* 118 (Summer 1984): 73.

Gambrell, Jamey. "Jörg Immendorff at Sonnabend." *Art in America* 72 (February 1984): 149.

Huber, Jorg. "Jörg Immendorff." *Flash Art* 117 (April/May 1984): 46–47.

Kuspit, Donald B. "Acts of Aggression: German Painting Today, Part II." *Art in America* 71 (January 1983): 90–101, 131–37.

Pohlen, Annelie. "Jörg Immendorff: Kunsthalle Düsseldorf." *Flash Art* 108 (Summer 1982): 68.

Slavin, Arlene. "Jörg Immendorff: Sonnabend." *Arts Magazine* 58 (December 1983): 34.

Sturtevant, Alfred. "Jörg Immendorff: Mary Boone." *Arts Magazine* 60 (April 1986): 126.

Taylor, Paul. "Café Deutschland." *Art News* 85 (April 1986): 68–76.

Vettese, Angela. "Jörg Immendorff: Studio Cannaviello/Milan." *Flash Art* 14 (November 1983): 75.

● Jim Isermann

1955
Born in Kenosha, Wisconsin

1977
Receives B.F.A. from University of Wisconsin, Milwaukee

1980
Receives M.F.A. from California Institute of the Arts, Valencia

Lives in Santa Monica, California

Selected Solo Exhibitions

1981
Riko Mizuno Gallery, Los Angeles

1982
Artists Space, New York

1984
Richard Kuhlenschmidt Gallery, Los Angeles

1986
Kuhlenschmidt/Simon Gallery, Los Angeles

Selected Group Exhibitions

1980
The Young/The Restless, Otis Art Institute of Parsons School of Design, Los Angeles

1983
Cultural Excavations: Recent and Distant, Japanese American Cultural and Community Center, Los Angeles; exh. cat. by Robert L. Pincus

1984
Contextual Furnishings: Isermann, McMakin, Vaughn, Mandeville Art Center, University of California, San Diego; exh. cat.

1985
Future Furniture, Newport Harbor Art Museum, Newport Beach, California

1986
TV Generations, LACE (Los Angeles Contemporary Exhibitions); exh. cat., essays by John Baldessari, Peter D'Agostino, John G. Hanhardt, and Bruce Yonemoto

Selected Bibliography

Drohojowska, Hunter. "Artists the Critics Are Watching: Jim Isermann." *Art News* 85 (May 1986): 80.

Gardner, Colin. "Considering the Banal." *Artweek* 14 (10 September 1983): 7–8.

Knight, Christopher. "'Cultural Excavations': Transforming Pop from the Past into Modern Flakes." *Los Angeles Herald Examiner*, 14 September 1983.

———. "The Return of Flower Power." *Los Angeles Herald Examiner*, 26 January 1985.

Larsen, Susan C.. "Modern Tempo." *Artforum* 20 (April 1982): 85–86.

———. "Cultural Excavations." *Art News* 82 (November 1983): 128.

Pincus, Robert L. "Motel Modern." *Art in America* 71 (March 1983): 164.

———. "Jim Isermann: Richard Kuhlenschmidt." *Artforum* 23 (October 1984): 97.

Rickey, Carrie. "Art Attack." *Art in America* 69 (May 1981): 41–48.

Skelley, Jack, and Dennis Cooper. "Spy-Tiki-Modern: An Interview with Jim Isermann, Mark Kroening and Jeffrey Vallance." *Barney Magazine* 3 (Winter 1983).

● Neil Jenney

1945
Born in Torrington, Connecticut

1964–66
Attends Massachusetts College of Art, Boston

Lives in New York

Selected Solo Exhibitions

1981
University Art Museum, University of California, Berkeley, and tour; exh. cat., *Neil Jenney: Paintings and Sculpture 1967–1980*, by Mark Rosenthal

1984
Oil and Steel Gallery, New York

1985
Carpenter and Hochman, New York

Selected Group Exhibitions

1978
New Image Painting, Whitney Museum of American Art, New York

1983
Back to the USA: Amerikanische Kunst der Siebziger und Achtziger, Kunstmuseum, Lucerne, and tour

1984
An International Survey of Recent Painting and Sculpture, Museum of Modern Art, New York; exh. cat.

1985
Carnegie International, Museum of Art, Carnegie Institute, Pittsburgh; exh. cat., edited by Saskia Bos and John R. Lane

1986
75th American Exhibition, Art Institute of Chicago; exh. cat., essays by Neal Benezra and A. James Speyer

Selected Bibliography

Ammann, Jean-Christophe. "Neil Jenney: Birds and Jets." *Domus* 612 (December 1980): 49.

Cameron, Dan. "Illustration is Back in the Picture." *Art News* 84 (October/November 1985): 114–20.

Carlson, Prudence. "Neil Jenney at Oil and Steel." *Art in America* 73 (April 1985): 206.

Gardner, Paul. "Portrait of Jenney." *Art News* 82 (December 1983): 68–74.

———. "When Is a Painting Finished?" *Art News* 84 (November 1985): 94–95.

Hapgood, Susan. "Neil Jenney: Oil and Steel." *Flash Art* 121 (March 1985): 43.

Lawson, Thomas. "Painting in New York: An Illustrated Guide." *Flash Art* 92–93 (October/November 1979): 4–11.

Oliva, Achille Bonito. "The Bewildered Image." *Flash Art* 96–97 (March/April 1980): 32–41.

Rickey, Carrie. "Naive Nouveau and Its Malcontents." *Flash Art* 98–99 (Summer 1980): 36–39.

Salle, David. "New Image Painting." *Flash Art* 88–89 (March/April 1979): 40–41.

Simon, Joan. "Neil Jenney: Event and Evidence." *Art in America* 70 (Summer 1982): 98–106.

● Philip Johnson

1906
Born in Cleveland

1930
Receives B.A. from Harvard University, Cambridge, Massachusetts

1943
Receives B.Arch. from Harvard Graduate School of Design

Lives in New Canaan, Connecticut

Selected Projects

1953
Museum of Modern Art Sculpture Garden, New York

1973
IDS Center, Minneapolis

1976
Pennzoil Place Building, Houston

1983
Center for the Fine Arts, Miami

1984
AT&T Corporate Headquarters, New York

Selected Group Exhibitions

1985
The Critical Edge: Controversy in Recent American Architecture, Jane Voorhees Zimmerli Art Museum, Rutgers, State University of New Jersey, New Brunswick, and tour; exh. cat., edited by Tod A. Marder

Selected Bibliography

Goldberger, Paul. "Those New Buildings: Promise Versus the Reality." *New York Times*, 9 June 1983.

———. "The New American Skyscraper." *New York Times*, 8 November 1981.

———. "Romanticism Is the New Motif in Architecture." *New York Times*, 23 October 1983.

———. "Celebrating the Restlessness of Philip Johnson." *New York Times*, 8 December 1983.

Hochmann, John L. "Resort Hotel for Tourist Art." *Art News* 83 (May 1984): 127–28.

Irace, Fulvio. "New York Strikes Again." *Domus* 636 (February 1983): 2–10.

Jodidio, Philip. "Architecture: l'Apres Modernisme?" *Connaissance des Arts* 334 (December 1979): 80–85.

Knight, Carleton, III. *Philip Johnson/John Burgee: Architecture 1979–1985*. New York: Rizzoli, 1985.

Lawrence, Sidney. "Clean Machines at the Modern." *Art in America* 72 (February 1984): 127–41, 166–68.

Slavin, Maeve. "The Four Seasons at 25." *Interiors* 143 (July 1984): 128–29.

● Mike Kelley

1954
Born in Dearborn, Michigan

1976
Receives B.F.A. from University of Michigan, Ann Arbor

1978
Receives M.F.A. from California Institute of the Arts, Valencia

Lives in Los Angeles

Selected Solo Exhibitions

1982
Hallwalls, Buffalo, New York
Metro Pictures, New York
Rosamund Felsen Gallery, Los Angeles

1985
Rosamund Felsen Gallery

Selected Group Exhibitions

1983
The First Show: Eight Collections, 1940–1980, Museum of Contemporary Art, Los Angeles; exh. cat.

1984
The First Biennial 1984: Los Angeles Today, Newport Harbor Art Museum, Newport Beach, California

1985
Biennial Exhibition, Whitney Museum of American Art, New York; exh. cat.

B & W, Los Angeles Institute of Contemporary Art

Selected Bibliography

Adams, Brooks. "Mike Kelley at Metro Pictures." *Art in America* 72 (October 1984): 196–97.

Cameron, Dan. "Mike Kelley's Art of Violation." *Arts Magazine* 60 (Summer 1986): 14–17.

Donohue, Marlena. "Looking at Los Angeles." *Artweek* 15 (10 November 1984): 1.

Drohojowska, Hunter. "Artists the Critics Are Watching." *Art News* 83 (November 1984): 89–91.

Eisenman, Stephanie E. "Mike Kelley: Metro Pictures." *Arts Magazine* 57 (November 1982): 57.

Handy, Ellen. "Mike Kelley: Metro Pictures." *Arts Magazine* 58 (April 1984): 41.

Pincus, Robert L. "Michael Kelley at Beyond Baroque and Rosamund Felsen." *Art in America* 71 (September 1983): 181.

Rugoff, Ralph. "High Art Meets Low Culture." *L.A. Style* 1 (October 1985): 22–24.

Wortz, Melinda. "Mike Kelley: Rosamund Felsen Gallery." *Artforum* 24 (December 1985): 94–95.

● Anselm Kiefer

1945
Born in Donaueschingen, West Germany

Lives in Odenwald, West Germany

Selected Solo Exhibitions

1979
Stedelijk Van Abbemuseum, Eindhoven, Netherlands; exh. cat., *Anselm Kiefer*, essay by Rudi H. Fuchs

1980
Venice Biennale

1981
Marian Goodman Gallery, New York
Museum Folkwang, Essen; exh. cat., *Anselm Kiefer*, essay by Zdenek Felix

1982
Whitechapel Art Gallery, London

1983
Musée d'Art Contemporain, Bordeaux; exh cat., *Anselm Kiefer*, essay by Rene Denizot

1984
ARC, Musée d'Art Moderne de la Ville de Paris
Israel Museum, Jerusalem
Städtische Kunsthalle, Düsseldorf; exh. cat., *Anselm Kiefer*, essays by Rudi H. Fuchs, Suzanne Page, and Jürgen Harten

1986
Stedelijk Museum, Amsterdam

Selected Group Exhibitions

1982
Zeitgeist, Martin-Gropius-Bau, West Berlin

1983
Expressions: New Art from Germany, Saint Louis Art Museum and tour; exh. cat., essays by Jack Cowart, Siegfried Gohr, and Donald B. Kuspit

The First Show: Eight Collections, 1940–1980, Museum of Contemporary Art, Los Angeles; exh. cat.

1984
An International Survey of Recent Painting and Sculpture, Museum of Modern Art, New York; exh. cat.

1985
Carnegie International, Museum of Art, Carnegie Institute, Pittsburgh; exh. cat., edited by Saskia Bos and John R. Lane

German Art in the 20th Century, Royal Academy of Arts, London; exh. cat., edited by Christo M. Joachimides, Norman Rosenthal, and Wieland Schmied

1986
Joseph Beuys, Enzo Cucchi, Anselm Kiefer, Jannis Kounellis, Kunsthalle, Basel

Selected Bibliography

Fisher, Jean. "Tale of the German and the Jew." *Artforum* 24 (September 1985): 106–10.

Gachnang, Johannes. "New German Paintings." *Flash Art* 106 (February/March 1982): 33–37.

Godfrey, Tony. "Anselm Kiefer at the Israel Museum, Jerusalem." *Burlington* 126 (Summer 1984): 590–93.

Gohr, Siegfried. "The Situation and the Artists." *Flash Art* 106 (February/March 1982): 38–46.

Huber, Jorg. "Gesamtkunstwerk: The Total Work of Art." *Flash Art* 113 (Summer 1983): 48–51.

Kuspit, Donald B. "Transmuting Externalization in Anselm Kiefer." *Arts Magazine* 59 (October 1984): 84–86.

Oliva, Achille Bonito. "The International Trans-Avantgarde." *Flash Art* 104 (October/November 1981): 36–43.

Schmidt-Wulffen, Stephan. "Anselm Kiefer: Kunsthalle, Düsseldorf." *Flash Art* 118 (Summer 1984): 73.

Taylor, Paul. "Café Deutschland." *Art News* 85 (April 1986): 68–76.

● Komar and Melamid

Vitali Komar

1943
Born in Moscow

Lives in New York

Aleksandr Melamid

1945
Born in Moscow

Lives in Jersey City, New Jersey

Selected Solo Exhibitions

1983
Ronald Feldman Gallery, New York

1985
Ronald Feldman Gallery

1986
Ronald Feldman Gallery

Selected Group Exhibitions

1986
Komar and Melamid, Ann McCoy, David Hollowell, Gallery Paule Anglim, San Francisco

Second Sight, San Francisco Museum of Modern Art Biennial; exh. cat., essay by Graham Beal

Sots Art, New Museum of Contemporary Art, New York; exh. cat., essays by John E. Bowlt, Marcia Tucker, and Margarita Tupitsyn

Selected Bibliography

Carrier, David. "Meditations on a Portrait of Comrade Stalin." *Arts Magazine* 59 (October 1984): 100–102.

Gambrell, Jamey. "Komar and Melamid: From behind the Ironical Curtain." *Artforum* 20 (April 1982): 58–63.

Handy, Ellen. "Komar and Melamid: Sots Art." *Arts Magazine* 57 (December 1982): 32.

———. "Komar and Melamid: Ronald Feldman Gallery." *Arts Magazine* 60 (Summer 1986): 121.

Indiana, Gary. "Komar and Melamid Confidential: Ronald Feldman Gallery." *Art in America* 73 (June 1985): 94–101.

Lerman, Ora. "Soviet Artists Make Open Form an Escape Route in a Closed Society." *Arts Magazine* 58 (February 1984): 115–19.

McCormick, C. "Komar and Melamid: Ronald Feldman Gallery." *Flash Art* 122 (April/May 1985): 39.

Princenthal, Nancy. "Komar and Melamid: Ronald Feldman Fine Arts Gallery." *Art News* 84 (Summer 1985): 117–18.

Schjeldahl, Peter. "Komar and Melamid." *Flash Art* 125 (December 1985–January 1986): 64–65.

Zimmer, William and Nadelman, Cynthia. "I Got What I Wanted in New York: There Are Probably More Foreign-born Artists in New York Today Than in Any Other City." *Art News* 80 (November 1981): 103.

● Jeff Koons

1955
Born in York, Pennsylvania

1972–75
Attends Maryland Institute College of Art, Baltimore

1975–76
Attends School of the Art Institute of Chicago

1976
Receives B.F.A. from Maryland Institute College of Art

Lives in New York

Selected Solo Exhibitions

1980
New Museum of Contemporary Art, New York

1985
Feature Gallery, Chicago

International with Monument, New York

1986
Daniel Weinberg Gallery, Los Angeles

International with Monument

Selected Group Exhibitions

1983
The Los Angeles New York Exchange, LACE (Los Angeles Contemporary Exhibitions)

1985
Affiliations: Recent Sculpture and Its Antecedents, Whitney Museum of American Art, Fairfield County, Connecticut, branch

1986
A Brokerage of Desire, Otis Art Institute of Parsons School of Design, Los Angeles; exh. cat., essays by Howard Halle and Walter Hopps

Contemporary Sculpture, Donald Young Gallery, Chicago

Selected Bibliography

Cameron, Dan. "Pretty as a Product." *Arts Magazine* 60 (May 1986): 22–25.

Craven, David. "Science Fiction and the Future of Art." *Arts Magazine* 58 (May 1984): 129.

Halley, Peter. "The Crisis in Geometry." *Arts Magazine* 58 (June 1984): 114.

Indiana, Gary. "Jeff Koons: International with Monument Gallery." *Art in America* 73 (November 1985): 63–64.

Jones, Alan. "Jeff Koons: John Weber Gallery." *Arts Magazine* 58 (November 1983): 11.

Nagy, Peter. "From Criticism to Complicity." *Flash Art* 129 (Summer 1986): 46–49.

Picot, Pierre. "Packaging Award Winner Urges Third-World Aid." *Industrial Design* 29 (July/August 1982): 12.

Robinson, William. "The New Capitol: White Columns Gallery." *Art in America* 73 (April 1985): 208.

● Jannis Kounellis

1936
Born in Piraeus, Greece

1956
Attends Accademia di Belle Arti, Rome

Lives in Rome

Selected Solo Exhibitions

1980
ARC, Musée d'Art Moderne de la Ville de Paris; exh. cat., *Jannis Kounellis*, by S. Paget, interview by B. Cora

Sonnabend Gallery, New York

1981
Stedelijk Van Abbemuseum, Eindhoven, Netherlands, and tour; exh. cat., *Jannis Kounellis: Retrospective Exhibition*, by Rudi Fuchs

1984
Frederick S. Wight Art Gallery, University of California, Los Angeles

Museum Haus Esters, Krefeld, West Germany; exh. cat., *Jannis Kounellis*, by M. Stockebrand

1985
Städtische Galerie im Lenbachhaus, Munich

1986
Museum of Contemporary Art, Chicago; exh. cat., *Jannis Kounellis: A Retrospective*, by Mary Jane Jacob with essay by Thomas McEvilley

Selected Group Exhibitions

1981
A New Spirit in Painting, Royal Academy of Art, London

1984
Il Modo Italiano, Los Angeles Institute of Contemporary Art

1985
Carnegie International, Museum of Art Carnegie Institute, Pittsburgh; exh. cat., edited by Saskia Bos and John R. Lane

The Knot: Arte Povera, Institute for Art and Urban Resources, P.S. 1., Long Island City, New York

Transformations in Sculpture, Solomon R. Guggenheim Museum, New York

Selected Bibliography

Dimitrijevic, Nena. "Jannis Kounellis: Whitechapel Art Gallery." *Flash Art* 109 (November 1982): 67.

Gambrell, Jamey. "Jannis Kounellis at Sonnabend." *Art in America* 71 (May 1983): 161–62.

Groot, Paul. "Jannis Kounellis: Van Abbemuseum/Eindhoven." *Flash Art* 107 (May 1982): 59.

Pique, Floriana. "Jannis Kounellis: Christian Stein/Turin." *Flash Art* 116 (March 1984): 44.

White, Robin. "Jannis Kounellis: Interview by Robin White." *View* 1 (1979).

● Barbara Kruger

1945
Born in Newark, New Jersey

1967–68
Attends Syracuse University, New York

1968–69
Attends Parsons School of Design, New York, and School of Visual Arts, New York

Lives in New York

Selected Solo Exhibitions

1980
Institute for Art and Urban Resources, P.S. 1, Long Island City, New York

1982
Larry Gagosian Gallery, Los Angeles

1983
Institute of Contemporary Art, London; exh. cat., *We Won't Play Nature to Your Culture*

1985
Contemporary Arts Museum, Houston

Los Angeles County Museum of Art

Wadsworth Atheneum, Hartford, Connecticut

Selected Group Exhibitions

1981
19 Emergent Artists, Solomon R. Guggenheim Museum, New York

1982
Image Scavengers: Photography, Institute of Contemporary Art, Philadelphia; exh. cat. by Paula Marincola

1984
Content: A Contemporary Focus, 1974–1984, Hirshhorn Museum and Sculpture Garden, Washington, D.C.; exh. cat., essays by Howard N. Fox, Miranda McClintic, and Phyllis Rosenzweig

Selected Bibliography

Foster, Hal. "Subversive Signs." *Art in America* 70 (November 1982): 88–92.

Gauss, Kathleen. *New American Photography*. Los Angeles County Museum of Art, 1985.

Indiana, Gary. "Undermining Media." *Village Voice*, 25 February 1986.

Lichtenstein, Therese. "Barbara Kruger." *Arts* 57 (May 1983): 4.

———. "Barbara Kruger." *Arts* 58 (May 1984): 53.

Linker, Kate. "Barbara Kruger." *Flash Art* 121 (March 1985): 36–37.

Norklun, Kathi. "Dark Tensions." *Artweek* 13 (27 March 1982): 8.

Olander, William. "Art and Politics of Arms and the Artists." *Art in America* 73 (June 1985): 59–63.

Owens, Craig. "The Medusa Effect or, The Specular Ruse." *Art in America* 72 (January 1984): 97–105.

● Justen Ladda

1953
Born in Grevenbroich, West Germany

Lives in New York

Selected Solo Exhibitions

1980
ABC NO Rio, New York

1981
P.S. 37, South Bronx, New York

1985
Willard Gallery, New York

1986
Museum of Modern Art, New York

Selected Group Exhibitions

1980
Times Square Show, New York

1984
A Different Climate, Kunsthalle, Düsseldorf

1986
Reality Remade, Kent Fine Art, New York

Selected Bibliography

Gambrell, Jami. "Justen Ladda 'The Thing': Fashion Moda." *Artforum* 20 (January 1982): 81.

Graaf, Vera. "Lower East Side." *Du* 2 (February 1984): 31.

Heartney, Eleanor. "Justen Ladda." *Art News* 85 (May 1986): 69–70.

Levin, Kim. "The Times Square Show." *Arts Magazine* 55 (September 1980): 87–89.

O'Brian, Glenn. "Justen Ladda: Willard Gallery." *Artforum* 24 (December 1985): 92.

Ominous, Anne. "Sex and Death and Shock and Schlock: Times Square Show." *Artforum* 20 (October 1980): 50–55.

Rankin-Reid, Jane. "Justen Ladda: Willard." *Flash Art* 125 (December 1985/January 1986): 43–44.

Robinson, Walter. "The Thing in the Bronx." *Art in America* 70 (March 1982): 135–37.

Silverthorne, Jeanne. "Justen Ladda: Artists' Space." *Artforum* 23 (September 1984): 114.

Teplow, Joshua. "Justen Ladda: Willard Gallery." *Arts Magazine* 60 (November 1985): 131–32.

Upshaw, Reagan. "Justen Ladda at Willard." *Art in America* 73 (November 1985): 161–62.

Zacharopoulos, Denys. "Justen Ladda: Galerie Philip Nelson, Lyon." *Artforum* 23 (January 1985): 99.

● Christopher Le Brun

1951
Born in Portsmouth, England

1970–74
Attends Slade School of Fine Art, London

1974–75
Attends Chelsea School of Art, London

Lives in London

Selected Solo Exhibitions

1980
Nigel Greenwood Inc., London

1983
Sperone Westwater Gallery, New York

1986
Sperone Westwater Gallery

Selected Group Exhibitions

1982
Zeitgeist, Martin-Gropius-Bau, West Berlin

1983
New Art, Tate Gallery, London

1984
Institute of Contemporary Art, Boston

Venice Biennale

1986
Second Sight, San Francisco Museum of Modern Art Biennial; exh. cat., essay by Graham Beal

Selected Bibliography

Collier, Caroline. "Christopher Le Brun: Nigel Greenwood, London." *Flash Art* 124 (October/November 1985): 55–56.

———. "White Horses . . . Christopher Le Brun." *Studio International* 198, no. 1010 (1985): 14–17.

Crichton, Fenella. "Christopher Le Brun and Mick Bennett: Nigel Greenwood." *Art and Artists* 14 (April 1980):

Kent, Sarah. "Between Two Territories: A Way Forward in British Painting." *Flash Art* 113 (Summer 1983): 40–46.

Kohn, Michael. "Christopher Le Brun: Sperone Westwater." *Flash Art* 115 (January 1984): 34–35.

———. "Mannerism and Contemporary Art: The Style and Its Critics." *Arts Magazine* 58 (March 1984): 72–77.

Kuspit, Donald. "Christopher Le Brun: Sperone Westwater." *Artforum* 22 (December 1983): 81–82.

Morgan, Stuart. "The Field of Rhetoric: An Interview with Christopher Le Brun." *Artforum* 21 (December 1982): 48–50.

Robertson, Bryan. "A New Safety Curtain for Covent Garden by Christopher Le Brun." *Burlington* 125 (July 1983): 422–25.

Russell, Francis. "Christopher Le Brun: Nigel Greenwood." *Burlington* 124 (July 1982): 476.

● Mark Lere

1950
Born in La Moure, North Dakota

1973
Receives B.F.A. from Metropolitan State College, Denver

1976
Receives M.F.A. from University of California, Irvine

Lives in Los Angeles

Selected Solo Exhibitions

1980
Riko Mizuno Gallery, Los Angeles

1982
Fine Arts Gallery, California State University, Los Angeles

1985
Museum of Contemporary Art, Los Angeles; exh. cat., *Mark Lere: New and Selected Work*, essays by Kerry Brougher and Frances Colpitt

1986
Margo Leavin Gallery, Los Angeles

Selected Group Exhibitions

1980
Tableaux, Los Angeles Institute of Contemporary Art

1981
Anti-Static, Baxter Art Gallery, California Institute of Technology, Pasadena

Southern California Artists, Los Angeles Institute of Contemporary Art

1985
Mile 4, Chicago Sculpture International

1986
From Los Angeles . . . David Amico, Paintings: Mark Lere, Sculpture, Carnegie-Mellon University Art Gallery, Pittsburgh; exh. cat., interview by Elaine A. King

Selected Bibliography

Bianchi, Tom. "Controlled Violence: Mizuno Gallery, Los Angeles." *Artweek* 14 (23 April 1983): 7.

Komac, Dennis. "Spiralling Forces." *Artweek* 14 (26 November 1983): 4.

Wortz, Melinda. "Mark Lere: Making the Everyday Theatrical." *Art News* 80 (May 1981): 87–88

———. "Mathematical Whimsy." *Art News* 80 (January 1981): 73–77.

● Sherrie Levine

1947
Born in Hazleton, Pennsylvania

1969
Receives B.A. from University of Wisconsin, Madison

1973
Receives M.F.A. from University of Wisconsin, Madison

Lives in New York

Selected Solo Exhibitions

1981
Metro Pictures, New York

1983
Baskerville + Watson Gallery, New York

1984
Gallery Nature Morte, New York

1985
Block Gallery, Northwestern University, Evanston, Illinois

Richard Kuhlenschmidt Gallery, Los Angeles

1986
Daniel Weinberg Gallery, Los Angeles

Selected Group Exhibitions

1982
Documenta 7, Kassel, West Germany

Image Scavengers: Photography, Institute of Contemporary Art, Philadelphia; exh. cat. by Paula Marincola

74th American Exhibition, Art Institute of Chicago

1983
Art and Politics, Allen Memorial Art Museum, Oberlin, Ohio

1984
Difference: On Representation and Sexuality, New Museum of Contemporary Art, New York

1986
Abstract Appropriations, Grey Art Gallery, New York University

Sydney Biennale, Art Gallery of New South Wales

Selected Bibliography

Buchloh, Benjamin H. D. "Allegorical Procedures: Appropriation and Montage in Contemporary Art." *Artforum* 21 (September 1982): 43–56.

Cameron, Dan. "Absence and Allure: Sherrie Levine's Recent Work." *Arts Magazine* 58 (December 1983): 84–87.

Deak, Edit. "The Critic Sees through the Cabbage Patch." *Artforum* 22 (April 1984): 56–60.

Foster, Hal. "The Expressive Fallacy." *Art in America* 71 (January 1983): 82.

Marzorati, Gerald. "Art in the (Re)Making." *Art News* 85 (May 1986): 90–99.

Melville, Stephen W. "Not Painting: The New Work of Sherrie Levine." *Arts Magazine* 60 (February 1986): 23–25.

Nagy, Peter. "From Criticism to Complicity." *Flash Art* 129 (Summer 1986): 46–49.

Oliva, Achille Bonito. "The Bewildered Image." *Flash Art* 96–97 (March–April 1980): 32–41.

Siegel, Jeanne. "Geometry Desurfacing: Ross Bleckner, Alan Belcher, Ellen Carey, Peter Halley, Sherrie Levine, Philip Taaffe, James Welling." *Arts Magazine* 60 (March 1986): 26–32.

————. "After Sherrie Levine." *Arts Magazine* 59 (Summer 1985): 141–44.

● David Levinthal

1949
Born in San Francisco

1970
Receives B.A. from Stanford University, Palo Alto, California

1970
Attends Rochester Institute of Technology, New York

1973
Receives M.F.A. from Yale University, New Haven, Connecticut

1979–81
Attends Massachusetts Institute of Technology, Cambridge

Lives in New York

Selected Solo Exhibitions

1985
Area X Gallery, New York

B.C. Space, Laguna Beach, California

Founders Gallery, University of San Diego; exh. cat., *Modern Romance: David Levinthal*, essay by Barton D. Thurber

1986
Bobbie Greenfield/R Collection, Los Angeles

Selected Group Exhibitions

1983
Marlborough Gallery, New York

Selected Bibliography

Harden, Tracey. "Downtown, You Don't Have to Take Your Art so Seriously." *New York Daily News*, 25 October 1985.

Koland, Cordell. "The Fine Art of Photography Also Makes a Fine Investment." *Business Journal, San Jose*, 15 July 1985.

Levinthal, David and Trudeau, Gary. *Hitler Moves East: A Graphic Chronicle 1941–43*. Kansas City, Kans.: Sheed Andrews and McMeel, 1977.

● Maya Ying Lin

1959
Born in Athens, Ohio

1981
Receives B.A. from Yale College, New Haven, Connecticut

1986
Receives M.A. from Yale School of Art and Architecture

Lives in New York

Selected Projects

1982
Vietnam Veterans Memorial, Washington, D.C.

Selected Group Exhibitions

1985
The Critical Edge: Controversy in Recent American Architecture, Jane Voorhees Zimmerli Art Museum, Rutgers, State University of New Jersey, New Brunswick, and tour; exh. cat., edited by Tod A. Marder

Sites and Solutions: Recent Public Art, Freedman Gallery, Albright College, Reading, Pennsylvania; exh. cat. by Judith Tannenbaum

Selected Bibliography

Blum, Shirley Neilsen. "The National Vietnam War Memorial." *Arts Magazine* 59 (December 1984): 124–28.

Clay, Grady. "Vietnam's Aftermath: Sniping at the Memorial." *Landscape Architecture* 72 (March 1982): 54–56.

Freeman, Allen. "Extraordinary Competition: The Winning Design for the Vietnam Memorial, and Other Entries." *AIA Journal* 70 (August 1981): 47–53.

Gabor, Andrea. "Vietnam Memorial Meets Snags That May Prevent March Groundbreaking." *Architectural Record* 170 (February 1982): 28.

Howett, Catherine M. "The Vietnam Veterans Memorial: Public Art and Politics." *Landscape* 28, no. 2 (1985): 4–9.

● Robert Longo

1953
Born in New York

1975
Receives B.F.A. from State University of New York College at Buffalo

Lives in New York

Selected Solo Exhibitions

1981
Empire: A Performance Trilogy, Corcoran Gallery of Art, Washington, D.C.

Larry Gagosian Gallery, Los Angeles

Metro Pictures, New York

1984

Akron Art Museum, Ohio; exh. cat., *Drawings and Reliefs*, essay by Hal Foster

Larry Gagosian Gallery

1985

Brooklyn Museum, New York

Stedelijk Museum, Amsterdam

1986

Metro Pictures

University Art Museum, California State University, Long Beach, and tour

Selected Group Exhibitions

1982

Eight Artists: The Anxious Edge, Walker Art Center, Minneapolis

Image Scavengers: Painting, Institute of Contemporary Art, Philadelphia; exh. cat. by Lisa Lyons

1983

Directions 1983, Hirshhorn Museum and Sculpture Garden, Washington, D.C.

1984

Automobile and Culture, Museum of Contemporary Art, Los Angeles, and tour; exh. cat.

Content: A Contemporary Focus, 1974–1984, Hirshhorn Museum and Sculpture Garden; exh. cat., essays by Howard N. Fox, Miranda McClintic, and Phyllis Rosenzweig

An International Survey of Recent Painting and Sculpture, Museum of Modern Art, New York; exh. cat.

Selected Bibliography

Blinderman, Barry. "Robert Longo's 'Men in the Cities': Quotes and Commentary." *Arts Magazine* 55 (March 1981): 92–93.

Foster, Hal. "The Art of Spectacle." *Art in America* 71 (April 1983): 144–49, 195–99.

Fox, Howard N. "Desire for Pathos: The Art of Robert Longo." *Sun & Moon* 8 (Fall 1979): 71–74.

Gardner, Paul. "When Is a Painting Finished?" *Art News* 84 (November 1985): 90–91.

Glueck, Grace. "The Very Timely Art of Robert Longo." *New York Times*, 10 March 1985.

Ratcliff, Carter. "Robert Longo." *Flash Art* 103 (Summer 1981): 30–31.

———. "Robert Longo: The City of Sheer Image." *Print Collector's Newsletter* 14 (July/August 1983): 95–98.

Schwartz, Ellen. "Artists the Critics Are Watching." *Art News* 80 (March 1981): 82–83.

Siegel, Jeanne. "Lois Lane and Robert Longo: Interpretation of Image." *Arts Magazine* 55 (November 1980): 154–57.

———. "The New Reliefs." *Arts Magazine* 56 (April 1982): 140–44.

Wallis, Brian. "Governing Authority: Robert Longo's

Performance Empire." *Wedge* 1 (Summer 1982): 64–71.

● Gilbert Lujan

1940

Born in Stockton, California

1962–65

Attends East Los Angeles College

1966–69

Receives B.A. from California State College at Long Beach

1971–73

Receives M.F.A. from University of California, Irvine

Lives in Santa Monica, California

Selected Solo Exhibitions

1983

Galeria Otra Vez, Los Angeles

1984

Galeria Posada, Sacramento

1986

Sonrisa Gallery, Los Angeles

Selected Group Exhibitions

1985

Hightech to Aztec, Centro Cultural, San Diego

Off the Street, Los Angeles Cultural Affairs Department

1986

Lo del Corazón: Heartbeat of a Culture, Mexican Museum, San Francisco

Selected Bibliography

Harper, Hilliard. "Centro Cultural de la Raza Marks Its 15th Anniversary." *Los Angeles Times*, 13 September 1985, San Diego County edition.

Mavor, Anne. "Critic's Choice: Gilbert Lujan." *Los Angeles Reader*, 14 March 1986.

● Markus Lüpertz

1941

Born in Liberec, Czechoslovakia

1955–61

Attends Werkkunstschule, Krefeld, West Germany, and Kunstakademie, Düsseldorf

Lives in Karlsruhe, West Germany

Selected Solo Exhibitions

1981

Marian Goodman Gallery, New York

Waddington Galleries, London

1982

Stedelijk Van Abbemuseum, Eindhoven, Netherlands

1983

daadgalerie, West Berlin

Kestner-Gesellschaft, Hannover; exh. cat., *Markus Lüpertz*, by Carl Haenlein

1984

Waddington Galleries

1986

Galerie Maeght Lelong, Paris

Galerie Maeght Lelong, Zurich

Selected Group Exhibitions

1981

Art Allemand Aujourd'hui, ARC, Musée d'Art Moderne de la Ville de Paris

1983

A New Spirit in Painting, Royal Academy of Arts, London

Expressions: New Art from Germany, Saint Louis Art Museum and tour; exh. cat., essays by Jack Cowart, Siegfried Gohr, and Donald B. Kuspit

New Figuration, Frederick S. Wight Art Gallery, University of California, Los Angeles

1984

An International Survey of Recent Painting and Sculpture, Museum of Modern Art, New York; exh. cat.

1985

German Art in the 20th Century, Royal Academy of Arts; exh. cat. edited by Christo M. Joachimides, Norman Rosenthal, and Wieland Schmied

Selected Bibliography

Bell, Jane. "What Is German about the New German Art?" *Art News* 83 (March 1984): 96–101.

Brock, Bazon. "The End of the Avant-Garde? And So the End of Tradition." *Artforum* 19 (Summer 1981): 62–67.

Clarke, John R. "Up Against the Wall. Trans-avanguardia!" *Arts Magazine* 57 (December 1982): 76–81.

Cowart, Jack. "Nouvel Art Allemand: La Guerre des Styles." *Connaissance des Arts* 377/378 (July/August 1983): 56–57.

Froment, Jean-Louis. "Nouvel Art Allemand: Les Ruines, Le Soir." *Connaissance des Arts* 377/378 (July/August 1983): 52–55.

Gachnang, Johannes. "New German Painting." *Flash Art* 106 (February/March 1982): 33–37.

Kuspit, Donald B. "Acts of Aggression: German Painting Today, Part II." *Art in America* 71 (January 1983): 90–101, 131–35.

Marcelis, Bernard. "German Painters." *Domus* 616 (April 1981): 54–55.

Oliva, Achille Bonito. "The International Trans-Avantgarde." *Flash Art* 104 (October/November 1981): 36–43.

Pincus-Witten, Robert. "Entries: Vaulting Ambition." *Arts Magazine* 57 (February 1983): 70–75.

———. "Entries: Post-Epistemic Dilemma." *Arts Magazine* 58 (September 1983): 110–13.

Winter, Peter. "Markus Lüpertz Bilder 1970–1983." *Kunstwerk* 36 (November 1983): 68–69.

● John Maggiotto

1955
Born in Buffalo, New York

1977
Receives B.S. from State University of New York College at Buffalo

Lives in New York

Selected Solo Exhibitions

1983
Los Angeles Institute of Contemporary Art

1984
LACE (Los Angeles Contemporary Exhibitions)
Media Studies, Buffalo

1985
White Columns, New York

Selected Group Exhibitions

1980
Hallwalls, Five Years, New Museum of Contemporary Art, New York

1983
Italian Americans in Los Angeles, Newspace, Los Angeles

1986
Television's Impact on Contemporary Art, Queens Museum, Flushing, New York

TV Generations, LACE (Los Angeles Contemporary Exhibitions); exh. cat., essays by John Baldessari, Peter D'Agostino, John G. Hanhardt, and Bruce Yonemoto

Selected Bibliography

Johnstone, M. "Transmission of Ideas: Los Angeles Contemporary Exhibition." *Artweek* 15 (31 March 1984): 15.

● Frank Majore

1948
Born in Richmond Hill, New York

1969
Receives B.S. from Philadelphia College of Art

Lives in New York

Selected Solo Exhibitions

1980
Artists Space, New York

1984
Perspectief, Rotterdam

1985
International Center for Photography, New York; exh. cat., *Frank Majore: Between Heaven and Earth*, essay by Willis Hartshorn

Selected Group Exhibitions

1981
Couches, Diamonds and Pie, Institute for Art and Urban Resources, P.S. 1, Long Island City, New York

1982
A Fatal Attraction: Art and the Media, Renaissance Society, University of Chicago

1984
The Family of Man: 1955–1984, Institute for Art and Urban Resources

Innocence and Sophistication, Baskerville + Watson Gallery, New York

Still Life in Photography, Rotterdam Arts Foundation

1985
Biennial Exhibition, Whitney Museum of American Art, New York; exh. cat.

Selected Bibliography

Grundberg, Andy. "Images That Represent Deep Bites of Forbidden Fruit." *New York Times*, 26 January 1986.

Haveman, Mariette. "Frank Majore." *Perspectief* 18/19 (November/December 1985): 45–51.

Heartney, Eleanor. "Frank Majore: International Center of Photography, Nature Morte, 303 Gallery." *Art News* 85 (April 1986): 159.

Levin, Kim. "Hour of the Wolf." *Village Voice*, 17 July 1984.

Liebmann, Lisa. "At the Whitney Biennial, Almost Home." *Artforum* 23 (Summer 1985): 57–61.

Linker, Kate. "On Artificiality." *Flash Art* 111 (March 1983): 33–35.

Lurie, David. "Frank Majore: Nature Morte." *Arts Magazine* 60 (March 1986): 131.

● Carlo Maria Mariani

1931
Born in Rome

Lives in Rome

Selected Solo Exhibitions

1980
Gian Enzo Sperone, Turin

1981
Gian Enzo Sperone, Rome
Sperone Westwater Fischer, New York

1982
Artra, Milan

1983
Artra

1984
Sperone Westwater, New York

Selected Group Exhibitions

1981
Bienal de São Paulo

1982
Documenta 7, Kassel, West Germany

1984
Anachronism, Hypermannerism, "Pittura Colta," Edward Totah Gallery, London

Content: A Contemporary Focus, 1974–1984, Hirshhorn Museum and Sculpture Garden, Washington, D.C.; exh. cat., essays by Howard N. Fox, Miranda McClintic, and Phyllis Rosenzweig

An International Survey of Recent Painting and Sculpture, Museum of Modern Art, New York; exh. cat.

1985
Metaphor and/or Symbol: A Perspective on Contemporary Art, National Museum of Modern Art, Tokyo, and tour

A New Romanticism: Sixteen Artists from Italy, Hirshhorn Museum and Sculpture Garden, Washington, D.C., and tour; exh. cat. by Howard N. Fox with an essay by Carl Brandon Strehlke

1986
Second Sight, San Francisco Museum of Modern Art Biennial; exh. cat., essay by Graham Beal

Selected Bibliography

Balmas, Paolo. "The Anachron'isms' of Art." *Flash Art* 113 (Summer 1983): 32–38.

Blau, Douglas. "Carlo Maria Mariani: Sperone Westwater Fischer." *Flash Art* 105 (December/January 1981/82): 57–58.

Casademont, Joan. "Carlo Maria Mariani." *Art Forum* 20 (February 1982): 84–85.

Cherubini, Laura. "Carlo Maria Mariani: Mario Diacono/Rome." *Flash Art* 108 (Summer 1982): 69.

Collier, Caroline. "La Pittura Colta: Edward Totah Gallery." *Studio International* 197, no. 1006 (1984): 44–45.

Gambrell, Jamey. "Carlo Maria Mariani at Sperone Westwater." *Art in America* 72 (May 1984): 165–66.

Heartney, Eleanor. "Apocalyptic Visions, Arcadian Dreams." *Art News* 85 (January 1986): 86–93.

Kohn, Michael. "Mannerism and Contemporary Art: The Style and Its Critics." *Arts Magazine* 58 (March 1984): 72–77.

———. "Carlo Maria Mariani: Sperone Westwater." *Flash Art* 117 (April/May 1984): 36.

Liebman, Lisa. "Carlo Maria Mariani at Sperone Westwater Fischer." *Art in America* 70 (February 1982): 143–44.

Madoff, Steven Henry. "What Is Postmodern About Painting; The Scandinavia Lectures, III." *Arts Magazine* 60 (November 1985): 63–73.

———. "Fashion Conscious." *Art News* 83 (October 1984): 168–70.

Parmesani, Loredana. "From Life to Death from Death to Life." *Flash Art* 117 (April/May 1984): 56–61.

Ratcliff, Carter. "On Iconography and Some Italians." *Art in America* 70 (September 1982): 157–58.

● Allan McCollum

1944
Born in Los Angeles

Lives in New York

Selected Solo Exhibitions

1980
Artists Space, New York

Galerie Yvon Lambert, Paris

1981
Hal Bromm Gallery, New York

1983
Marian Goodman Gallery, New York

1984
Richard Kuhlenschmidt Gallery, Los Angeles

1985
Lisson Gallery, London; exh. cat., *Allan McCollum: Surrogates*, essay by Craig Owens

1986
Institute of Contemporary Art, University of Pennsylvania, Philadelphia

Kuhlenschmidt/Simon Gallery, Los Angeles

Selected Group Exhibitions

1984
Aleurs et Autrement, Musée d'Art Moderne de la Ville de Paris

A Different Climate: Aspects of Beauty in Contemporary Art, Städtische Kunsthalle, Düsseldorf

1986
A Life of Signs, Michael Klein Gallery, New York

Selected Bibliography

Gardner, Colin. "Discarding the Image." *Artweek* 15 (13 October 1984): 5.

Jones, Ronald. "Six Artists at the End of the Line: Gretchen Bender, Ashley Bickerton, Peter Halley, Louise Lawler, Allan McCollum, and Peter Nagy." *Arts Magazine* 60 (May 1986): 49–51.

Lawson, Thomas. "Allan McCollum: Marian Goodman Gallery." *Artforum* 22 (September 1983): 70–71.

Mahoney, Robert. "Allan McCollum: Diane Brown." *Arts Magazine* 60 (March 1986): 138.

Owens, Craig. "Allan McCollum: Repetition and Difference." *Art in America* 71 (September 1983): 130–32.

Pincus, Robert L. "Allan McCollum: Richard Kuhlenschmidt Gallery." *Los Angeles Times*, 28 September 1984.

Rinder, Larry. "Laurie Simmons and Allan McCollum: Nature Morte." *Flash Art* 125 (December 1985–January 1986): 44–45.

Robbins, D. A. "An Interview with Alan McCollum." *Arts Magazine* 60 (October 1985): 40–44.

Smith, Roberta. "Allan McCollum and Laurie Simmons at Nature Morte." *Art in America* 74 (Janaury 1986): 139.

Smith, Valerie. "Allan McCollum: Marian Goodman." *Flash Art* 113 (Summer 1983): 65.

Watson, Gray. "Allan McCollum." *Artscribe International* 55 (December–January 1985–1986): 65–67.

● Stephen McKenna

1939
Born in London

1959–64
Attends Slade School of Fine Art, University College, London

Lives in Brussels and London

Selected Solo Exhibitions

1980
Association for Museum of Contemporary Art, Ghent, Belgium

Sander Gallery, Washington, D.C.

1981
Orchard Gallery, Londonderry, Northern Ireland; exh. cat., *Stephen McKenna: Subjects, Scenes and Stories*, interview by Barry Barker

1983
Galerie Isy Brachot, Brussels

Museum of Modern Art, Oxford, England; exh. cat., *Stephen McKenna*, essays by David Elliot, R. H. Fuchs, and Ian Jeffrey

1985
Institute of Contemporary Arts, London; exh. cat., *Stephen McKenna*

Raab Galerie, West Berlin; exh. cat., *Stephen McKenna: Stilleben und Zeichnungen*, essay by Jon Thompson

Sander Gallery, New York

1986
Kunsthalle Düsseldorf; exh. cat., *Stephen McKenna*, essays by Jürgen Harten, Martin Mosebach, and Marie Luise Syring

Selected Group Exhibitions

1980
British Art 1940–80, Hayward Gallery, London

1982
Documenta 7, Kassel, West Germany

1983
New Art, Tate Gallery, London

1984
The Hard Won Image, Tate Gallery

1986
Second Sight, San Francisco Museum of Modern Art Biennial; exh. cat., essay by Graham Beal

Selected Bibliography

Collier, Caroline. "La Pittura Colta at Edward Totah." *Studio International* 197, no. 1006 (1984): 44–45.

Feaver, William. "Stephen McKenna: Edward Totah Gallery and the ICA, London." *Art News* 85 (January 1986): 119.

Grimes, Nancy. "Stephen McKenna: Sander." *Art News* 85 (February 1986): 122–23.

Liebmann, Lisa. "Misty Channels." *Artforum* 24 (October 1985): 114–17.

Schmidt-Wulffen, Stephan. "Stephen McKenna: Raab, Berlin." *Flash Art* 123 (Summer 1985): 59.

● Ana Mendieta

1948
Born in Havana

1972
Receives B.A. from University of Iowa, Iowa City

1973
Receives M.F.A. from University of Iowa

1985
Dies in New York

Selected Solo Exhibitions

1980
University of Vermont, Burlington

1981
A.I.R. Gallery, New York

1984
Galleria Primo Piano, Rome

Selected Group Exhibitions

1981
Ritual and Landscape, Kunsthalle, Lund, Sweden

Streetworks, Washington Projects for the Arts, Washington, D.C.

1983
Contemporary Latin American Artists, Chrysler Museum, Norfolk, Virginia

Seven Women: Image/Impact, Institute for Art and Urban Resources, P.S. 1, Long Island City, New York

1984
Land Marks, Bard College, Annandale-on-Hudson, New York

American Academy in Rome

MacArthur Park Public Art Program, Otis Art Institute of the Parsons School of Design, Los Angeles

Selected Bibliography

Free Spirits: Annals of the Insurgent Imagination, vol. 1: 121. San Francisco: City Lights, 1982.

Gallery of New Concepts, School of Art and Art History. *Intermedia*. Edited by Hans Breder and Stephen C. Foster. Iowa City: University of Iowa, 1980.

Lippard, Lucy R. *Overlay: Contemporary Art and the Arts of Prehistory*, 45, 48–49. New York: Pantheon, 1983.

Lucie-Smith, Edward. *Art in the Seventies*, 108. Oxford, England: Phaidon, 1980.

● Charles Moore

1925
Born in Benton Harbor, Michigan

1947
Receives B.Arch. from University of Michigan, Ann Arbor

1956
Receives M.A. from Princeton University, New Jersey

1957
Receives Ph.D. from Princeton University

Lives in Austin, Texas, and Los Angeles

Selected Projects

1978
Piazza d'Italia, New Orleans

1984
Site planning and theme buildings, World's Fair, New Orleans

1985
Hood Museum of Art, Dartmouth College, Hanover, New Hampshire

1986
Beverly Hills Civic Center, California

San Antonio Art Insitute, Texas (in progress)

Selected Solo Exhibitions

1986
Williams College, Williamstown, Massachusetts, and tour; exh. cat., *The Architecture of Charles Moore: Buildings and Projects 1949–1986*, edited by Eugene Johnson

Selected Group Exhibitions

1985
Biennial Exhibition, Whitney Museum of American Art, New York; exh. cat.

The Critical Edge: Controversy in Recent American Architecture, Jan Voorhees Zimmerli Art Museum, Rutgers, State University of New Jersey, and tour; exh. cat., edited by Tod A. Marder

Selected Bibliography

Curtis, W. J. R. "Principle Versus Pastiche: Perspectives on Some Recent Classicisms." *Architectural Review* 176 (August 1984): 16–17.

Hart, Claudia. "Spray-on America." *Industrial Design* 31 (July/August 1984): 20–29.

Hines, Thomas S. "Architecture: Charles Moore and William Turnbull, Jr." *Architecural Digest* 41 (July 1984): 118–25.

Ivy, Robert A. "In New Orleans, Warehouses and Forms from an Idealized World." *Architecture* 73 (July 1984): 10–12.

Jodidio, Philip. "Tout oser." *Connaissance des Arts* 379 (September 1983): 80–81.

Kohn, Michael. "Mannerism and Contemporary Art: The Style and Its Critics." *Arts Magazine* 58 (March 1984): 75.

Miller, N. "Sweet and Sour: House, Southern California." *Progressive Architecture* 62 (September 1981): 182–83.

Nairn, Janet. "Conference Dissects Works of Five Very Different Architects." *Architecture* 73 (October 1984): 18.

● Jim Morphesis

1948
Born in Philadelphia

1970
Receives B.F.A. from Tyler School of Art, Philadelphia

1972
Receives M.F.A. from California Institute of Arts, Valencia

Lives in Los Angeles

Selected Solo Exhibitions

1982
Traction Gallery, Los Angeles

1983
Freidus/Ordover Gallery, New York

1986
Acme Art, San Francisco

Fisher Gallery, University of Southern California, Los Angeles

Tortue Gallery, Santa Monica, California

Selected Group Exhibitions

1980
It's All Called Painting, Los Angeles Municipal Art Gallery

1983
Young Talent Awards, 1963–1983, Los Angeles County Museum of Art; exh. cat. by Anne Carnegie Edgerton and Maurice Tuchman

1984
Selections from the Merry and Bill Norris Collection, Fine Arts Gallery, University of California, Irvine; exh. cat., essay by Melinda Wortz

1985
Concerning the Spiritual: The Eighties, Emanuel Walker/Atholl McBean Gallery, San Francisco Art Institute; exh. cat., essay by David S. Rubin

Off the Street, Old City Print Shop, Los Angeles

The Spiritual Eye: Religious Imagery in Contemporary Los Angeles Art, Loyola Law School, Los Angeles

Selected Bibliography

Brown, Betty. "Jim Morphesis." *Arts Magazine* 57 (April 1983): 45.

Clothier, Peter. "Jim Morphesis at Traction Gallery." *Art in America* 70 (Summer 1982): 149.

Levy, Mark. "Invoking the Spiritual." *Artweek* 16 (7 September 1985): 3.

Menzies, Neal. "Versions of Empathy." *Artweek* 12 (31 October 1981): 16.

————. "Jim Morphesis: The Triumph of Spiritual Expression." *Artweek* 14 (5 March 1983): 1.

Pincus, Robert L. "Art as Artifact." *Flash Art* 123 (Summer 1985): 39–40.

Van Proyer, Mark. "Paint and Symbol." *Artweek* 17 (25 January 1986): 3.

Wortz, Melinda. "Jim Morphesis." *Art News* 81 (April 1982): 174–75.

● Robert Morris

1931
Born in Kansas City, Missouri

1966
Receives M.F.A. from Hunter College, New York

Lives in New York

Selected Solo Exhibitions

1980
Art Institute of Chicago

1981
Contemporary Arts Museum, Houston

1982
Sterling and Francine Clark Art Institute, Williamstown, Massachusetts; exh. cat., *The Drawings of Robert Morris*, by Thomas Krens

1983
Rijksmuseum Kröller-Müller, Otterlo, Netherlands

1984
Konsthall, Malmö, Sweden; exh. cat., *Robert Morris*, by Eje Högestätt

Portland Center for the Visual Arts, Oregon

1985
Leo Castelli Gallery and Sonnabend Gallery, New York

1986
Museum of Contemporary Art, Chicago, and tour; exh. cat., *Robert Morris: Works of the Eighties*, by Edward Fry and Donald Kuspit

Selected Group Exhibitions

1980
United States Pavilion, Venice Biennale

1981
Metaphor: New Projects by Contemporary Sculptors, Hirshhorn Museum and Sculpture Garden, Washington, D.C.; exh. cat. by Howard N. Fox

1982
Zeitgeist, Martin-Gropius-Bau, West Berlin

1983
Blam! The Explosion of Pop, Minimal and Performance 1958–1964, Whitney Museum of American Art, New York

The End of the World: Contemporary Views of the Apocalypse, New Museum of Contemporary Art, New York

1984
Content: A Contemporary Focus, 1974–1984, Hirshhorn Museum and Sculpture Garden; exh. cat., essays by Howard N. Fox, Miranda McClintic, and Phyllis Rosenzweig

1986
Directions 1986, Hirshhorn Museum and Sculpture Garden

Selected Bibliography

Baigell, Matthew. "Robert Morris's Latest Works: Slouching toward Armageddon." *Art Criticism* 2 (1985): 1–9.

Fineberg, Jonathan. "Robert Morris Looking Back: An Interview." *Arts Magazine* 55 (September 1980): 110–15.

MacGreevy, Linda F. "Robert Morris Metaphorical Nightmare: The Journado del Muerto." *Arts Magazine* 58 (September 1983): 107–9.

Margolis, Joseph. "Robert Morris: His Art and His Theory." *Art Criticism* 1 (1979): 13–28.

Morris, Robert. "American Quartet." *Art in America* 69 (December 1981): 92–105.

Patton, Phil. "Robert Morris and the Fire Next Time." *Art News* 82 (December 1983): 84–91.

Princenthal, Nancy. "Robert Morris." *Art News* 84 (Summer 1985): 115–16.

Ratcliff, Carter. "Robert Morris: A Saint Jerome for Our Times." *Artforum* 23 (April 1985): 60–63.

● Josef Felix Müller

1955
Born in Eggersriet, Saint Gall, Switzerland

Lives in Saint Gall

Selected Solo Exhibitions

1983
Kunsthaus, Zurich

1984
Musée d'Art et d'Histoire, Geneva

1985
Maison des Arts Plastiques, Lyons; exh. cat., *Josef Felix Müller*, essay by Jean-Christophe Ammann

Museum fur Gegenwartskunst, Basel; exh. cat., *Josef Felix Müller Skulpturen*, essay by Jörg Zutter

Selected Group Exhibitions

1982
Carlos Figuiera, Federico Winkler, Matthias Aeberli, Josef Felix Müller, Anna Winteler, Jürg Stauble, Kunsthalle Basel

1984
Private Symbol: Social Metaphor, Sydney Biennale, Art Gallery of New South Wales

1985
FRI-ART, Institute for Art and Urban Resources, Clocktower, New York

Schwarz auf Weiss: Von Manet bis Kiefer, Galerie Beyeler, Basel

Von Twombly bis Clemente: Ausgewählte Werke einer Privatsammlung, Kunsthalle Basel

Selected Bibliography

Ammann, Jean-Christophe. "Josef Felix Müller." *Kunst-Bulletin* 5 (May 1981): 2–4.

Müller, Felix. *Kreuzernachtigall*. N.p., 1983.

Schenker, Christophe. "Joseph Felix Müller: Museum fur Gegenwartskunst/Stampa, Basel." *Flash Art* 126 (February/March 1986): 58–59.

Stooss, Toni. "Felix: Six Moments of Encounter with a Being of the Third Kind." *Parkett* 2 (1984): 84–95.

● Matt Mullican

1951
Born in Santa Monica, California

1974
Receives B.F.A. from California Institute of the Arts, Valencia

Lives in New York

Selected Solo Exhibitions

1980
Mary Boone Gallery, New York

1982
Galerie Chantal Crousel, Paris

Luigi di Ambrogi, Milan

1983
Texas Gallery, Houston

1984
Centre d'Art Contemporain, Geneva

Mary Boone/Michael Werner Gallery, New York; exh. cat., *Matt Mullican: Invisible*, essay by Germano Celant

1985
Richard Kuhlenschmidt Gallery, Los Angeles

Selected Group Exhibitions

1983
Modern Objects, Barbara Toll Fine Arts, New York

1986
The Spiritual in Art: Abstract Painting 1890–1985, Los Angeles County Museum of Art and tour; exh. cat.

Selected Bibliography

Blau, Douglas. "Matt Mullican at Mary Boone." *Art in America* 71 (March 1983): 152–53.

Bleckner, Ross. "Transcendent Anti-fetishism." *Artforum* 17 (March 1979): 50–55.

Brooks, Valerie F. "Matt Mullican: Mary Boone." *Flash Art* 111 (March 1983): 62.

Celant, Germano. "Between Atlas and Sisyphus." *Artforum* 24 (November 1985): 76–79.

Friedman, Jon R. "Modern Objects." *Arts Magazine* 58 (September 1983): 9.

Lawson, Thomas. "The Uses of Representation: Making Some Distinctions." *Flash Art* 88/89 (March–April 1979): 37–39.

Lewis, Jo Ann. "Mullican's Signs of the Times." *Washington Post*, 26 October 1985.

McCollum, Allan. "Matt Mullican's World." *Real Life* (Winter 1980): 4–13.

Silverthorne, Jeannie. "Matt Mullican at Mary Boone." *Artforum* 21 (September 1982): 77–78.

● Bruce Nauman

1941
Born in Fort Wayne, Indiana

1964
Receives B.S. from University of California, Davis

1966
Receives M.A. from University of California, Davis

Lives in Pecos, New Mexico

Selected Solo Exhibitions

1972
Los Angeles County Museum of Art and tour; exh. cat., *Bruce Nauman: Work from 1965–1972*, essays by Jane Livingston and Marcia Tucker

1981
Rijksmuseum Kröller-Müller, Otterlo, Netherlands; exh. cat., *Bruce Nauman, 1972–1981*, essays by Siegmar Holsten, Ellen Joosten, and Katharina Schmidt

1982
Baltimore Museum of Art

1983
Blum Helman Gallery, New York

Museum Haus Esters, Krefeld, West Germany

Museum of Fine Arts, Santa Fe, New Mexico

1984
Baltimore Museum of Art; exh. cat., *Bruce Nauman: Neons*, essay by Brenda Richardson

1985
Leo Castelli Gallery and Sperone Westwater Gallery, New York

Selected Group Exhibitions

1981
Art in Los Angeles, Seventeen Artists in the Sixties, Los Angeles County Museum of Art; exh. cat. by Maurice Tuchman with essays by Anne Bartlett Ayres, Michele D. De Angelus, Christopher Knight, and Susan C. Larsen

1982
Documenta 7, Kassel, West Germany

60–80: Attitudes/Concepts/Images, Stedelijk Van Abbemuseum, Eindhoven, Netherlands

1984
Content: A Contemporary Focus, 1974–1984, Hirshhorn Museum and Sculpture Garden, Washington, D.C.; exh. cat., essays by Howard N. Fox, Miranda McClintic, and Phyllis Rosenzweig

1985
Biennial Exhibition, Whitney Museum of American Art, New York; exh. cat.

Carnegie International, Museum of Art, Carnegie Institute, Pittsburgh; exh. cat., edited by Saskia Bos and John R. Lane

Selected Bibliography

Armstrong, Richard. "Bruce Nauman: Blum Helman Gallery." *Artforum* 22 (September 1983): 68–69.

Bischoff, Ulrich. "Halle 6: Objekt Skulptur Installation (Kampfnägel-Fabrik, Hamburg)." *Pantheon* 40 (July/September 1982): 239.

Jones, Ronald. "Bruce Nauman: Leo Castelli Gallery, Sperone Westwater Gallery, New York." *Arts Magazine* 59 (February 1985): 4.

Princenthal, Nancy. "Bruce Nauman: Sperone Westwater Gallery and Leo Castelli Gallery." *Art News* 84 (January 1985): 137.

Ratcliff, Carter. "Bruce Nauman: Castelli Greene Street Gallery; Sperone Westwater Gallery." *Art in America* 73 (March 1985): 151.

Van Bruggen, Coosje. "Entrance Entrapment Exit." *Artforum* 24 (Summer 1986): 88–97.

Yau, John. "Bruce Nauman: Leo Castelli." *Flash Art* 126 (February–March 1986): 48.

● Odd Nerdrum

1945
Born in Oslo

Lives in Oslo

Selected Solo Exhibitions

1980
Kunstnerforbundet, Oslo

1984
Martina Hamilton Gallery, New York

1985
Delaware Art Museum, Wilmington

1986
Martina Hamilton Gallery and Germans Van Eck Gallery, New York

Selected Group Exhibitions

1980
Norwegen Heute, Kunsthalle zu Kiel, Hessische Landesmuseum, Darmstadt, West Germany

1985
The Classic Spirit 1985, Martina Hamilton Gallery

The Classic Tradition in Painting and Sculpture, Aldrich Museum of Contemporary Art, Ridgefield, Connecticut

1986
Second Sight, San Francisco Museum of Modern Art Biennial; exh. cat., essay by Graham Beal

Selected Bibliography

Heartney, Eleanor. "Apocalyptic Visions, Arcadian Dreams." *Art News* 85 (January 1986): 86–93.

Kuspit, Donald B. "Odd Nerdrum: The Aging of the Immediate." *Arts Magazine* 59 (September 1984): 122–23.

Poirier, Maurice. "Odd Nerdrum: Martina Hamilton." *Art News* 84 (September 1985): 140.

Testerman, Margarella F. "Odd Nerdrum." *Arts Magazine* 60 (September 1985): 18.

● Sabina Ott

1955
Born in New York

1979
Receives B.F.A. from San Francisco Art Institute

1981
Receives M.F.A. from San Francisco Art Institute

Lives in Los Angeles

Selected Solo Exhibitions

1982
A.R.E. Gallery, San Francisco

1983
Los Angeles Institute of Contemporary Art

1985
Attack Gallery, Los Angeles

Charles Cowles Gallery, New York

1986
Acme Art, San Francisco

Selected Group Exhibitions

1984
Cotton Exchange Show, LACE (Los Angeles Contemporary Exhibitions)

Night of the Mask, Newport Harbor Art Museum, Newport Beach, California

1985
Astonishing Horizons, Los Angeles Visual Arts, Pacific Design Center

8th Annual Downtown Artists Show, LACE (Los Angeles Contemporary Exhibitions)

Selected Bibliography

Dubin, Zan. "Awardees: One Paints, the Other Radios." *Los Angeles Times Calendar*, 16 June 1986.

French, D. S. "An Eclectic Selection: Los Angeles Contemporary Exhibitions." *Artweek* 16 (11 May 1985): 5.

———. "Reading the Images: Attack Gallery, Los Angeles." *Artweek* 16 (1 June 1985): 6.

Gardner, Colin. "Attack: Los Angeles, Piezo Electric, New York." *Arts Magazine* 59 (March 1985): 13.

● Nam June Paik

1932
Born in Seoul

1956
Receives B.A. from University of Tokyo

1956–57
Attends University of Munich

1957–58
Attends Conservatory of Music, Freiburg, West Germany

1958
Attends University of Cologne

Lives in New York

Selected Solo Exhibitions

1980
Laser Video, Städtische Kunsthalle, Düsseldorf

New American Filmmakers Series, Whitney Museum of American Art, New York

1981
Sony Hall, Tokyo

1982
Whitney Museum of American Art; exh. cat., *Nam June Paik*, by John G. Hanhardt

1986
Carl Solway Gallery, Cincinnati, Ohio; exh. cat., *Nam June Paik: Family of Robot*, essay by Carl Solway

Holly Solomon Gallery, New York

Selected Group Exhibitions

1981
Biennial Exhibition, Whitney Museum of American Art; exh. cat.

Westkunst, Cologne

1984

Content: A Contemporary Focus, 1974–1984, Hirshhorn Museum and Sculpture Garden, Washington, D.C.; exh. cat., essays by Howard N. Fox, Miranda McClintic, and Phyllis Rosenzweig

Selected Bibliography

Baker, Kenneth. "Currents: Institute of Contemporary Arts, Boston." *Art News* 84 (February 1985): 114.

Gardner, Paul. "Tuning in to Nam June Paik." *Art News* 81 (May 1982): 64–73.

Gever, Martha. "Pomp and Circumstances: The Coronation of Nam June Paik." *Afterimage* 10 (October 1982): 12–16.

Hagen, Charles. "Good Morning, Mr. Orwell." *Artforum* 22 (March 1984): 98–99.

Kurtz, Bruce. "Paikvision: Whitney Museum." *Artforum* 21 (October 1982): 52–55.

Renouf, R. "Nam June Paik: Historical Juxtapositions." *Artweek* 13 (16 January 1982): 4.

Rice, Shelley. "The Luminous Image: Video Installations at the Stedelijk Museum." *Afterimage* 12 (December 1984): 14.

Sturken, Marita. "Video Guru." *American Film* 7 (May 1982): 13–16.

● Mimmo Paladino

1948

Born in Paduli, Benevento, Italy

Lives in Milan and Paduli

Selected Solo Exhibitions

1980

Annina Nosei Gallery, New York

Marian Goodman Gallery, New York

1981

Galleria d'Arte Moderna, Bologna

Kunstmuseum, Basel

1982

Louisiana Museum of Modern Art, Humlebaek, Denmark

Waddington Galleries, London

1983

Newport Harbor Art Museum, Newport Beach, California

1984

Waddington Galleries; exh. cat., *Mimmo Paladino*, introduction by Mimmo Paladino and Norman Rosenthal

1985

Sperone Westwater Gallery, New York; exh. cat., *Mimmo Paladino*

Städtische Galerie im Lenbachhaus, Munich; exh. cat., *Mimmo Paladino: Arbeiten von 1977 bis 1985*, essays by Helmut Friedel, Thomas Lehnerer, and

Donald Kuspit

Selected Group Exhibitions

1981

A New Spirit in Painting, Royal Academy of Art, London

1982

Documenta 7, Kassel, West Germany

Sydney Biennale, Art Gallery of New South Wales

Transavantgarde International, Giancarlo Politi, Milan; exh. cat. by Achille Bonia Oliva

Zeitgeist, Martin-Gropius-Bau, West Berlin

1983

New Art, Tate Gallery, London

Terraemotus, Institute of Contemporary Art, Boston

1984

Content: A Contemporary Focus, 1974–1984, Hirshhorn Museum and Sculpture Garden, Washington, D.C.; exh. cat., essays by Howard N. Fox, Miranda McClintic, and Phyllis Rosenzweig

Il modo italiano, Los Angeles Institute of Contemporary Art; exh. cat., essay by Germano Celant

An International Survey of Recent Painting and Sculpture, Museum of Modern Art, New York; exh. cat.

1985

A New Romanticism: Sixteen Artists from Italy, Hirshhorn Museum and Sculpture Garden, and tour; exh. cat. by Howard N. Fox with essay by Carl Brandon Strehlke

Selected Bibliography

Amman, Jean-Christophe. "Paladino: Diamonds and Secret Cards." *Flash Art* 109 (November 1982): 22–23.

Berger, Danny. "Mimmo Paladino: An Interview." *Print Collector's Newsletter* 14 (May–June 1983): 48–51.

Collier, Caroline. "Mimmo Paladino." *Flash Art* 108 (Summer 1982): 66.

Groot, Paul. "Mimmo Paladino." *Flash Art* 107 (May 1982): 59–60.

Hawthorne, Don. "Prints from the Alchemist's Laboratory." *Art News* 85 (February 1986): 89–95.

Heartney, Eleanor. "Apocalyptic Visions, Arcadian Dreams." *Art News* 85 (January 1986): 86–93.

● Giulio Paolini

1940

Born in Genoa

Lives in Turin

Selected Solo Exhibitions

1980

Museum of Modern Art, Oxford, England; exh. cat., *Giulio Paolini*, by D. Elliott and H. Szeemann

1981

Galerie Paul Maenz, Cologne

Kunstmuseum, Lucerne; exh. cat., *Giulio Paolini*, by M. Kunz, G. Paolini, and M. Wechsler

1982

Galerie Paul Maenz

Raum für Kunst, Hamburg; exh. cat., *Giulio Paolini*, by M. Kramer 1983

1984

Le Nouveau Musée, Lyon-Villeurbanne, France; exh. cat., *Giulio Paolini*, by Giulio Paolini

Los Angeles Institute of Contemporary Art

Studio Marconi, Milan; exh. cat., *Giulio Paolini*, by G. Paolini and F. Poli

1985

Pinacoteca Comunale, Ravenna, Italy; exh. cat., *Paolini*, by M. Bandini, B. Cora, and S. Vertone

1986

Marian Goodman Gallery, New York

Selected Group Exhibitions

1982

Documenta 7, Kassel, West Germany

1984

An International Survey of Recent Painting and Sculpture, Museum of Modern Art, New York; exh. cat.

1986

Second Sight, San Francisco Museum of Modern Art Biennial; exh. cat., essay by Graham Beal

Selected Bibliography

Paolini, Giulio. "Triumph of Representation, a Project." *Artforum* 22 (December 1983): 43–47.

———. "Tout Paolini." *Connaissance des Arts* 384 (February 1984): 24.

Taylor, S. "A Conversation with Giulio Paolini." *Print Collector's Newsletter* 15 (November/December 1984): 165–69.

● Anne and Patrick Poirier

Anne Poirier

1942

Born in Marseilles

Patrick Poirier

1942

Born in Nantes, France

1963–66

Both attend Ecole Nationale Superieure des Arts Décoratifs, Paris

Both live in Paris

Selected Solo Exhibitions

1980

Carpenter Center for Visual Arts, Harvard University, Cambridge, Massachusetts

Sonnabend Gallery, New York

1981
Galerie Daniel Templon, Paris
Galerie des Ponchettes, Nice

1983
Musée d'Art Contemporain, Montreal

1984
Brooklyn Museum, New York
Galerie Daniel Templon
Sonnabend Gallery

1985
Sonnabend Gallery

Selected Group Exhibitions

1980
Architectural References in the Seventies, Los Angeles Institute of Contemporary Art
Architectural Sculpture, Los Angeles Institute of Contemporary Art

1982
Connections, Institute of Contemporary Art, University of Pennsylvania, Philadelphia
Twelve Contemporary French Artists, Albright-Knox Art Gallery, Buffalo, New York

1985
The Classic Tradition in Recent Painting and Sculpture, Aldrich Museum of Contemporary Art, Ridgefield, Connecticut

Selected Bibliography

Dienst, Rolf-Günter. "Vergangenheit-Gegenwart-Zukunft." *Kunstwerk* 35 (October 1982): 42.

Dimitrijevic, Nena. "Sculpture after Evolution (A New Notion of Image-based Sculpture)." *Flash Art* 117 (May 1984): 30.

Gintz, Claude. "Ruins and Rebellion: La Salpetrière Hospital, Paris; Installation." *Art in America* 72 (April 1984): 148–51.

Heartney, Eleanor. "Poirier: Sonnabend Gallery; Brooklyn Museum." *Art News* 84 (January 1985): 137.

Huth, Michel. "Raiders of the Lost Ruins." *Connaissance des Arts* 24 (January 1982): 52–57.

Masheck, Joseph. "Judy Rifka and Postmodernism in Architecture." *Art in America* 72 (December 1984): 158.

Morgan, Stuart. "Anne and Patrick Poirier: Sonnabend Gallery." *Artforum* 23 (January 1985): 83–84.

Syring, Marie Luise. "Denkmaler wie gehabt: neue Kunst-projekte der Sozialisten in Frankreich." *Du* 1 (1985): 12–21.

● Sigmar Polke

1941
Born in Oels, Germany

1959–60
Attends Düsseldorf Academy

1961–67
Attends Staatliche Kunstakademie, Düsseldorf

Lives in Hamburg and Cologne

Selected Solo Exhibitions

1982
Holly Solomon Gallery, New York

1983
Museum Boymans-van Beuningen, Rotterdam

1984
Kunsthaus, Zurich
Kunstmuseum, Bonn

1985
Anthony d'Offay Gallery, London
Mary Boone Gallery, New York

Selected Group Exhibitions

1981
A New Spirit in Painting, Royal Academy of Arts, London

1982
Documenta 7, Kassel, West Germany

1983
New Art, Tate Gallery, London
Zeitgeist, Martin-Gropius-Bau, West Berlin

1985
Carnegie International, Museum of Art, Carnegie Institute, Pittsburgh; exh. cat., edited by Saskia Bos and John R. Lane
German Art in the 20th Century, Royal Academy of Arts; exh. cat. edited by Christo M. Joachimides, Norman Rosenthal, and Wieland Schmied

Selected Bibliography

Berlind, Robert. "Sigmar Polke: Mary Boone Gallery; Michael Werner Gallery." *Art in America* 73 (April 1985): 201–2.

Beyer, L. "Sigmar Polke: Klein, Bonn, Germany." *Flash Art* 117 (April/May 1984): 41–42.

Buchloh, Benjamin H. D. "Parody and Appropriation in Francis Picabia, Pop and Sigmar Polke." *Artforum* 20 (March 1982): 28–34.

Frailey, Stephen. "Sigmar Polke: Photographic Obstruction." *Print Collector's Newsletter* 16 (July/August 1985): 78–80.

Frey, Patrick. "Sigmar Polke." *Flash Art* 118 (Summer 1984): 44–47.

Glintz, Claude. "Polke's Slow Dissolve." *Art in America* 73 (December 1985): 102–9.

Grimes, Nancy. "Sigmar Polke: Mary Boone Gallery." *Art News* 84 (April 1985): 136–37.

Kuspit, Donald B. "Acts of Aggression: German Painting Today." *Art in America* 71 (January 1983): 131–32.

Pohlen, Annelie. "Sigmar Polke: Galerie Michael

Werner, Cologne." *Artforum* 22 (November 1983): 90–91.

Silverthorne, Jeanne. "Sigmar Polke." *Artforum* 23 (October 1984): 89–90.

Taylor, Paul. "Café Deutschland." *Art News* 85 (April 1986): 68–76.

● William Raaum

1947
Born in Williston, North Dakota

Lives in Minneapolis

● Arnulf Rainer

1929
Born in Baden, Austria

1950
Studies at Akademie der Bildenden Künste, Vienna

Lives in Vienna

Selected Solo Exhibitions

1980
Nationalgalerie, West Berlin
Stedelijk Van Abbemuseum, Eindhoven, Netherlands
Walker Art Center, Minneapolis
Whitechapel Art Gallery, London

1981
Staatliche Kunsthalle, Baden-Baden

1982
Galerie Ulysses, Vienna; exh. cat., *Arnulf Rainer: Hand- and Finger-Paintings*, essays by Rudi Fuchs, Werner Hoffman, and Arnulf Rainer
Louisiana Museum, Humblebaek, Denmark

1983
Konsthall, Malmö, Sweden

1984
Musée National d'Art Moderne, Centre Georges Pompidou, Paris
Städtisches Museum, Mönchengladbach, West Germany
Kunsthaus, Zurich
Stedelijk Van Abbemuseum; exh. cat., *Arnulf Rainer: Finger- und Hand-Malerei 1981–1983*, by R. H. Fuchs

1985
Galerie Maeght Lelong, Zurich; exh. cat., *Rainer: Fotoübermalungen 1969–1973, Hand- und Fingermalerei 1973–1984*, essay by Johannes Gachnang
Galerie Ulysses; exh. cat., *Arnulf Rainer Totenmasken*, by Werner Hoffman and Arnulf Rainer

1986
Burnett Miller Gallery, Los Angeles
Galerie Maeght Lelong, New York; exh. cat., *Arnulf Rainer*, prefaces by Jacques Dupin and Johannes Gachnang
Grey Art Gallery, New York University

Ritter Art Gallery, Boca Raton, Florida, and tour; exh. cat., *Arnulf Rainer Self Portraits*, essays by David W. Courtney and Arnulf Rainer

Selected Group Exhibitions

1980
Zeichen des Glaubens Geist der Avantgarde, Staatliche Schlösser und Garten, Schloss Charlottenburg, West Berlin

1984
Content: A Contemporary Focus, 1974–1984, Hirshhorn Museum and Sculpture Garden, Washington, D.C.; exh. cat., essays by Howard N. Fox, Miranda McClintic, and Phyllis Rosenzweig

Selected Bibliography

Gachnang, J. "Arnulf Rainer: Interview." *Flash Art* 122 (April/May 1985): 48–51.

Kocher, Helga. "Anders sind wir unerreichbar: Arnulf Rainers Hiroshima-Bilder." *Du* 5 (1983): 80.

● Roland Reiss

1929
Born in Chicago

1955
Receives B.A. from University of California, Los Angeles

1957
Receives M.A. from University of California, Los Angeles

Lives in Claremont, California

Selected Solo Exhibitions

1980
Ace Gallery, Venice, California

1981
Pittsburgh Arts and Crafts Center

Santa Barbara Museum of Art, California

1986
Flow Ace Gallery, Los Angeles

Selected Group Exhibitions

1980
Contemporary Art in Southern California, High Museum, Atlanta

Sculpture in California, 1975–80, San Diego Museum of Art

1981
Art in Los Angeles, The Museum as Site: Sixteen Projects, Los Angeles County Museum of Art; exh. cat. by Stephanie Barron

Humor in Art, Los Angeles Institute of Contemporary Art

1983
Directions in Contemporary Art, Institute of Contemporary Art, Boston

Documenta 7, Kassel, West Germany

20 American Artists: Sculpture 1982, San Francisco Museum of Modern Art

1984
Return of the Narrative, Palm Springs Desert Museum, California

Selected Bibliography

Bordeaux, Jean-Luc. "Los Angeles, a New Contemporary Art Center." *Connaissance des Arts* 22 (November 1981): 98–99.

Larsen, Susan C. "Cultural Excavations: Japanese American Cultural and Community Center, Los Angeles." *Art News* 82 (November 1983): 128.

Schipper, Merle. "Theaters of Vision." *Artweek* 11 (16 February 1980): 1.

———. "Roland Reiss: Flow Ace." *Art News* 85 (Summer 1986): 127.

Singerman, Howard. "Art in Los Angeles: Los Angeles County Museum of Art." *Artforum* 20 (March 1982): 76.

Weisberg, Ruth. "Tales of the Corporate World: Flow Ace Gallery, Los Angeles." *Artweek* 14 (14 May 1983): 5.

Winter, Peter. "Phantasie aus dem Lande Lilliput: Aspekte der kleinen Dimension in der Plastik." *Kunstwerk* 35 (August 1982): 38.

Wortz, Melinda. "Art in Los Angeles: 17 Artists, 16 Projects." *Art News* 80 (November 1981): 161–65.

● Gerhard Richter

1932
Born in Dresden

1951–56
Attends Academy of Fine Arts, Dresden·

1961–63
Attends Academy of Fine Arts, Düsseldorf

Lives in Cologne

Selected Solo Exhibitions

1980
Museum Folkwang, Essen

Sperone Westwater Fischer, New York

1981
Kunsthalle, Düsseldorf

1982
Kunsthalle Bielefeld, West Germany, and tour

1984
Musée d'Art et d'Industrie, Saint-Étienne, France

Staatsgalerie, Stuttgart

1985
Marian Goodman Gallery and Sperone Westwater Gallery, New York; exh. cat., *Gerhard Richter*, essay by Benjamin H. D. Buchloh

1986
Städtische Kunsthalle, Düsseldorf, and tour; exh. cat., *Gerhard Richter: Paintings 1962–1985*, edited by Jurgen Harten

Selected Group Exhibitions

1980
Venice Biennale

1981
Art Allemand Aujourd'hui, ARC, Musée d'Art Moderne de la Ville de Paris

A New Spirit in Painting, Royal Academy of Arts, London

Westkunst, Cologne

1982
Documenta 7, Kassel, West Germany

1984
An International Survey of Recent Painting and Sculpture, Museum of Modern Art, New York; exh. cat.

1985
The European Iceberg, Art Gallery of Ontario, Toronto

Selected Bibliography

Buchloh, Benjamin. "Parody and Appropriation in Francis Picabia, Pop and Sigmar Polke." *Artforum* 20 (March 1982): 31–34.

Ellis, Stephen. "The Elusive Gerhard Richter." *Art in America* 74 (November 1986): 130.

Grasskamp, Walter. "Gerhard Richter: An Angel Vanishes." *Flash Art* 128 (May–June 1986): 30–35.

Harris, Susan A. "Gerhard Richter: Sperone Westwater Fischer." *Arts Magazine* 57 (March 1983): 35.

Kunz, Martin. "The Development of Physical Action into a Psychic Intensity of the Picture." *Flash Art* 98–99 (Summer 1980): 12–17.

Linker, Kate. "Gerhard Richter: Sperone Westwater Fischer Gallery." *Artforum* 21 (April 1983): 71–72.

Pohlen, Annelie. "Gerhard Richter: Städtische Kunsthalle." *Artforum* 24 (May 1986): 148.

Schwabsky, Barry. "Gerhard Richter: Marian Goodman; Sperone Westwater." *Arts Magazine* 59 (May 1985): 41.

Taylor, Paul. "Café Deutschland." *Art News* 85 (April 1986): 68–76.

Winter, Peter. "Gerhard Richter Abstrakte Bilder 1976–1981." *Kunstwerk* 2 (April 1982): 64–65.

● Scott Richter

1943
Born in Atlanta

1965
Receives B.F.A. from Parsons School of Design, New York

Lives in New York

Selected Solo Exhibitions

1981
Joy Horwich Gallery, Chicago

1983

Institute for Art and Urban Resources, P.S. 1, Long Island City, New York

1985

Zabriskie Gallery, New York

Selected Group Exhibitions

1983

Group Show, Gallery Nature Morte, New York

1984

Invitational Exhibition, Grace Borgenicht Gallery, New York

20th Century Three Dimensional Portraits, Cleveland Center for Contemporary Art

1985

Affiliations: Recent Sculpture and Its Antecedents, Whitney Museum of American Art, Fairfield County, Connecticut, branch

Body and Soul, Contemporary Arts Center, Cincinnati, Ohio

Figure It Out: Exploring the Figure in Contemporary Art, Laguna Gloria Museum, Austin, Texas

Wall Sculpture, Saxon-Lee Gallery, Los Angeles

Selected Bibliography

Kramer, Kathryn. "Life Signs." *Arts Magazine* 58 (February 1984): 18.

Nadelman, Cynthia. "The New American Sculpture." *Art News* 83 (January 1984): 63.

Princenthal, Nancy. "Young American." *Art News* 84 (January 1985): 141–42.

Upshaw, Reagan. "Figuratively Sculpting at P.S. 1." *Art in America* 70 (March 1982): 143.

Westphal, Stephen. "Scott Richter at Zabriskie." *Art in America* 3 (December 1985): 124.

● Susan Rothenberg

1945

Born in Buffalo, New York

1967

Receives B.F.A. from Cornell University. Ithaca, New York

Lives in New York

Selected Solo Exhibitions

1980

Mayor Gallery, London

1981

Akron Art Museum, Ohio

1982

Stedelijk Van Abbemuseum, Eindhoven, Netherlands

1983

Los Angeles County Museum of Art and tour; exh. cat., *Susan Rothenberg*, by Maurice Tuchman

1985

Willard Gallery, New York

Selected Group Exhibitions

1978

New Image Painting, Whitney Museum of American Art; exh. cat. by Richard Marshall

1980

Drawings: The Pluralist Decade, United States Pavilion, Venice Biennale

1981

Moskowitz, Rothenberg, Schnabel, Kunsthalle Basel and tour; exh. cat., essay by Peter Blum

1982

New Figuration in America, Milwaukee Art Museum; exh. cat. by Russell Bowman with essay by Peter Schjeldahl

Zeitgeist, Martin-Gropius-Bau, West Berlin

1984

An International Survey of Recent Painting and Sculpture, Museum of Modern Art, New York; exh. cat.

1985

Biennial Exhibition, Whitney Museum of American Art, New York; exh. cat.

Carnegie International, Museum of Art, Carnegie Institute, Pittsburgh; exh. cat., edited by Saskia Bos and John R. Lane

Selected Bibliography

Danoff, Michael. "Susan Rothenberg." *Dialogue* 4 (November–December 1981): 42–43.

Herrera, Hayden. "In a Class by Herself." *Connoisseur* 214 (April 1984): 112–17.

Koether, Jutta. "Pure Invention." *Flash Art* 127 (April 1986): 48–51.

Nilson, Lisbet. "Susan Rothenberg: Every Brushstroke Is a Surprise." *Art News* 85 (February 1984): 46–54.

Ratcliff, Carter. "Art Stars for the Eighties." *Saturday Review* 8 (February 1981): 12–20.

Russell, John. "Art: 9-Painting Show That's Best of Season." *New York Times*, 28 January 1983.

Storr, Robert. "Spooks and Floats." *Art in America* 71 (May 1983): 153–59.

● David Salle

1952

Born in Norman, Oklahoma

1973

Receives B.F.A. from California Institute of the Arts, Valencia

1975

Receives M.F.A. from California Institute of the Arts

Lives in New York

Selected Solo Exhibitions

1980

Annina Nosei Gallery, New York

Galerie Bruno Bischofberger, Zurich

1981

Larry Gagosian Gallery, Los Angeles

Mary Boone Gallery, New York

1983

Addison Gallery of American Art, Phillips Academy, Andover, Massachusetts

Museum Boymans-van Beuningen, Rotterdam

1984

Leo Castelli Gallery, New York

1985

Gallery Michael Werner, Cologne; exh. cat., *David Salle: Sieben Bilder*, essay by Peter Schjeldahl

Mary Boone Gallery

Selected Group Exhibitions

1981

Westkunst, Cologne

1982

Dokumenta 7, Kassel, West Germany

Zeitgeist, Martin-Gropius-Bau, West Berlin

1983

Biennial Exhibition, Whitney Museum of American Art, New York; exh. cat.

New Art, Tate Gallery, London

1984

Content: A Contemporary Focus, 1974–1984, Hirshhorn Museum and Sculpture Garden, Washington, D.C.; exh. cat., essays by Howard N. Fox, Miranda McClintic, and Phyllis Rosenzweig

The Human Condition, San Francisco Museum of Modern Art Biennial

An International Survey of Recent Painting and Sculpture, Museum of Modern Art, New York; exh. cat.

1985

Biennial Exhibition, Whitney Museum of American Art; exh. cat.

Selected Bibliography

Madoff, Steven Henry. "What Is Postmodern about Painting: The Scandinavia Lectures." *Arts Magazine* 60 (September 1985): 116–21.

Millet, Catherine. "David Salle." *Flash Art* 123 (Summer 1985): 30–34.

Pincus-Witten, Robert. "Interview with David Salle." *Flash Art* 123 (Summer 1985): 35–36.

Ratcliff, Carter. "David Salle." *Interview* 14 (February 1982): 64–66.

Salle, David. "Images That Understand Us: A Conversation with David Salle and James Welling." *Journal* 27 (June/July 1980): 41–44.

Schjeldahl, Peter. "David Salle Interview." *Journal* (September/October 1981): 15–21.

———. "The Real Salle." *Art in America* 72 (September 1984): 180–87.

Schwartz, Sanford. "David Salle: The Art World." *New Yorker* 60 (30 April 1984): 104–11.

● Thomas Schindler

1959
Born in Braunschweig, West Germany

Lives in West Berlin

Selected Solo Exhibitions

1981
Galerie Gruppe Weisses Pferd, Hannover

1983
Raab Galerie, West Berlin

1984
Sharpe Gallery, New York

1985
Raab Galerie; exh. cat., *Schindler*, essay by Giovanni Tostori

1986
Sharpe Gallery

Selected Group Exhibitions

1982
Ecole des Beaux-Arts, Paris

1985
Idol, Raab Galerie

Selected Bibliography

Bismarck, Beatrice V. "Thomas Schindler: Holtmann Gallery, Cologne." *Flash Art* 117 (April/May 1984): 43.

———. "Thomas Schindler: Raab, Berlin." *Flash Art* 125 (December 1985–January 1986): 49.

● Ilene Segalove

1950
Born in Los Angeles

1972
Receives B.F.A. from University of California, Santa Barbara

1975
Receives M.A. from Loyola University, Los Angeles

Lives in Venice, California

Selected Solo Exhibitions

1984
Selected Video Works by Segalove, Film Anthology Archives, New York

Nightflight, USA Television Network, New York

1986
Retrospective, Montreal Film Festival

Selected Group Exhibitions

1980
Video Art, Museum of Contemporary Art, Chicago

1983
American Video, Sydney Biennale, Art Gallery of New South Wales

New Narratives, Museum of Modern Art, New York

1985
Video Feature, International Center of Photography, New York

Video from Vancouver to San Diego, Museum of Modern Art

1986
TV Generations, LACE (Los Angeles Contemporary Exhibitions); exh. cat., essays by John Baldessari, Peter D'Agostino, John G. Hanhardt, Bruce Yonemoto

Selected Bibliography

Bob, Paul. "Ilene Segalove." *Esquire* 104 (October 1985): 236.

Drohojowska, Hunter. "Too Much TV Never Harmed Ilene Segalove." *Los Angeles Herald Examiner*, 16 February 1985.

Dubin, Zan. "Awardees: One Paints, the Other Radios." *Los Angeles Times Calendar*, 16 June 1986.

Larsen, Susan C. "Cultural Excavations." *Art News* 82 (November 1983): 128.

Ohlander, Gloria. "Segalove's Latest Is a Riot." *L.A. Weekly*, 27 April 1984.

Pincus, Robert L. "Video Works from Public Domain." *Los Angeles Times Calendar*, 3 February 1985.

———. "Video Artists Hide New Message." *San Diego Union*, 23 June 1985.

Podheiser, Linda. "Ilene Segavloe, Girl Video Artist." *Boston Review* 9 (June 1984): 11–14.

Robinson, Jennifer. "Cable Connection." *American Film* 10 (October 1984): 75–76.

● Rafael Serrano

1954
Born in Havana

1980
Receives B.F.A. from California State University, Long Beach

1982
Receives M.F.A. from Otis Art Institute of Parsons School of Design, Los Angeles

Lives in Los Angeles

Selected Group Exhibitions

1981
Fix-it-up, LACE (Los Angeles Contemporary Exhibitions)

1985
Alumni Group Show, Otis Art Institute of Parsons School of Design

1986
All California Biennial, Riverside Art Center and Museum, California

Artists for the Homeless, Eilat Gordin Gallery, Los Angeles

● Peter Shelton

1951
Born in Troy, Ohio

1973
Receives B.A. from Pomona College, Claremont, California

1974
Receives trade certifications from Hobart School of Welding Technology, Troy

1979
Receives M.F.A. from University of California, Los Angeles

Lives in Los Angeles

Selected Solo Exhibitions

1981
Malinda Wyatt Gallery, Venice, California

1982
Artists Space, New York

Santa Barbara Contemporary Arts Forum, California; exh. cat., *Peter Shelton*, introduction by Christopher Knight, interview by Barbara Fischer

1983
L.A. Louver Gallery, Venice, California

Malinda Wyatt Gallery, New York

1984
Portland Center for the Visual Arts, Oregon

1985
University of Arizona, Tucson

1986
L.A. Louver Gallery

University Gallery, Fine Arts Center, University of Massachusetts, Amherst

Selected Group Exhibitions

1980
Architectural Sculpture: A Survey of Its History and Documents, Los Angeles Institute of Contemporary Art

Brownrooms, LACE (Los Angeles Contemporary Exhibitions)

1982
Maquettes and Models: Art with Architectural Concerns, Los Angeles Municipal Art Gallery

Une Experience Muséographique: Exchange Entre Artistes 1931–1982 Pologne-U.S.A., Musée d'Art Moderne de la Ville de Paris

Selected Bibliography

Timberman, Marcy. "Peter Shelton: The Power of the Ordinary." *Artweek* 13 (27 November 1982): 1, 16.

Wortz, Melinda. "Peter Shelton — Contemporary Arts Forum, Santa Barbara: 'Sweathouse and Little Principals 1977–82.' " *Art News* 82 (May 1983): 133–36.

● Cindy Sherman

1954
Born in Glenridge, New Jersey

1976
Receives B.F.A. from State University of New York College at Buffalo

Lives in New York

Selected Solo Exhibitions

1980
Kitchen Center for Video, Music, Dance, Performance, and Film, New York

Metro Pictures, New York

1982
Larry Gagosian Gallery, Los Angeles

Stedelijk Museum, Amsterdam, and tour

1983
Saint Louis Art Museum

1985
Metro Pictures

Westfälischer Kunstverein, Münster, West Germany; exh. cat., *Cindy Sherman*, essay by Marianne Stockebrand

1986
Portland Art Museum, Oregon

Wadsworth Atheneum, Hartford, Connecticut

Selected Group Exhibitions

1982
Documenta 7, Kassel, West Germany

Image Scavengers: Photography, Institute of Contemporary Art, Philadelphia; exh. cat. by Paula Marincola

1983
Biennial Exhibition, Whitney Museum of American Art, New York; exh. cat.

New Art, Tate Gallery, London

1985
Biennial Exhibition, Whitney Museum of American Art; exh. cat.

Carnegie International, Museum of Art, Carnegie Institute, Pittsburgh; exh. cat., edited by Saskia Bos and John R. Lane

L'Autoportrait, Musée Cantonal des Beaux-Arts, Lausanne; exh. cat.

Self-Portrait, Museum of Modern Art, New York

1986
75th American Exhibition, Art Institute of Chicago; exh. cat., essays by Neal Benezra and A. James Speyer

Jenny Holzer/Cindy Sherman, Contemporary Art Center, Cincinnati, Ohio

Selected Bibliography

Foster, Hal. "The Expressive Fallacy." *Art in America* 71 (January 1983): 80–83, 137.

Gambrell, Jamey. "Marginal Acts." *Art in America* 72 (March 1984): 114–19.

Karmel, Pepe. "Photography Looking at the Big Picture." *Art in America* 71 (September 1983): 35–39.

Melville, Stephen W. "The Time of Exposure: Allegorical Self-Portraiture in Cindy Sherman." *Arts Magazine* 60 (January 1986): 17–21.

Ratcliff, Carter. "Contemporary American Art." *Flash Art* 108 (Summer 1982): 32–35.

Revenal, John B. "Cindy Sherman." *Arts Magazine* 58 (January 1984): 21.

Schjeldahl, Peter. "Shermanettes." *Art in America* 70 (March 1982): 110–11.

Sherman, Cindy, and Peter Schjeldahl. *Cindy Sherman: Photographs*. New York: Pantheon, 1984.

Sischy, Ingrid. "On Location." *Artforum* 24 (December 1985): 4.

Taylor, Paul. "Cindy Sherman." *Flash Art* 124 (October/November 1985): 78–79.

● Alexis Smith

1949
Born in Los Angeles

1970
Receives B.A. from University of California, Irvine

Lives in Venice, California

Selected Solo Exhibitions

1980
Rosamund Felsen Gallery, Los Angeles

1981
Holly Solomon Gallery, New York

1982
Institute for Art and Urban Resources, Clocktower, New York

Margo Leavin Gallery, Los Angeles

Rosamund Felsen Gallery

1983
Holly Solomon Gallery

1985
Margo Leavin Gallery

Selected Group Exhibitions

1981
Art in Los Angeles, The Museum as Site: Sixteen Projects, Los Angeles County Museum of Art; exh. cat.

by Stephanie Barron

Biennial Exhibition, Whitney Museum of American Art, New York; exh. cat.

Humor in Art, Los Angeles Institute of Contemporary Art

1983
New Directions 1983, Hirshhorn Museum and Sculpture Garden, Washington, D.C.

Young Talent Awards, 1963–83, Los Angeles County Museum of Art; exh. cat. by Anne Carnegie Edgerton and Maurice Tuchman

1984
An International Survey of Recent Painting and Sculpture, Museum of Modern Art, New York; exh. cat.

1985
Niagara, Art Park, Lewiston, New York

Selected Bibliography

Armstrong, Richard. "Alexis Smith: Rosamund Felsen and L.A.C.E./Los Angeles." *Flash Art* 102 (March/April 1981): 44–45.

Berman, Avis. "A Decade of Progress, but Could a Female Chardin Make a Living?" *Art News* 79 (October 1980): 73–79.

Casademont, Joan. "Alexis Smith: Holly Solomon Gallery." *Artforum* 19 (April 1981): 65–66.

Gabrielson, Walter. "Westward Ha!" *Art in America* 70 (January 1982): 108–10.

Knight, Christopher. "Alexis Smith: 'Satan's Satellites,' Rosamund Felsen Gallery, and 'Christmas Eve, 1943,' Margo Leavin Gallery." *Artforum* 21 (January 1983): 81–82.

————. "Los Angeles: Art on the Move." *Art News* 82 (January 1983): 72–75.

Plagens, Peter. "Site Wars." *Art in America* 70 (January 1982): 91–98.

Singerman, Howard. "Art in Los Angeles: Los Angeles County Museum of Art." *Artforum* 20 (March 1982): 75–77.

Smith, Valerie de F. D. "Alexis Smith: Holly Solomon." *Flash Art* 102 (March/April 1981): 39.

Weisberg, Ruth. "Alexis Smith: A Forties Escapism." *Artweek* 13 (16 October 1982): 1.

● T. L. Solien

1949
Born in Fargo, North Dakota

1973
Receives B.A. from Moorhead State University, Minnesota

1977
Receives M.F.A. from University of Nebraska, Lincoln

Lives in Pelican Rapids, Minnesota

Selected Solo Exhibitions

1980
Fort Worth Museum of Art, Texas

1983
American Center, Paris

1985
Getler/Pall Saper, New York

1986
John C. Stoller & Co., Minneapolis

Selected Group Exhibitions

1982
The Bewildered Image, Minneapolis Institute of Art

1983
The American Artist as Printmaker, Brooklyn Museum, New York

Biennial Exhibition, Whitney Museum of American Art, New York; exh. cat.

1984
Images and Impressions: Painters Who Paint, Walker Art Center, Minneapolis; exh. cat.

1985
The 39th Biennial Exhibition of Contemporary American Painting, Corcoran Gallery, Washington, D.C.; exh. cat.

Selected Bibliography

Riddle, Mason. "T. L. Solien: John C. Stoller & Co." *Artforum* 24 (May 1986): 144.

Woodville, Louisa. "T. L. Solien." *Arts Magazine* 59 (September 1984): 11.

● Haim Steinbach

1944
Born in Israel

1968
Receives B.F.A. from Pratt Institute, Brooklyn, New York

1973
Receives M.F.A. from Yale University, New Haven, Connecticut

Lives in New York

Selected Solo Exhibitions

1979
Artists Space, New York

1982
Concord Gallery, New York

1985
Cable Gallery, New York

Selected Group Exhibitions

1984
Timeline, Group Material, Institute for Art and Urban Resources, P.S. 1, Long Island City, New York

1985
Infotainment (18 Artists from New York), Gallery Nature Morte, New York, and tour; exh. cat., essays by Thomas Lawson and George W. S. Trow

Objects in Collision, Kitchen Center for Video, Music, Dance, Performance, and Film, New York

Post Production, Feature Gallery, Chicago

1986
A Brokerage of Desire, Otis Art Institute of Parsons School of Design, Los Angeles; exh. cat., essays by Howard Halle and Walter Hopps

Contemporary Sculpture, Donald Young Gallery, Chicago

Damaged Goods, New Museum for Contemporary Art, New York

Paravision, Margo Leavin Gallery, Los Angeles

Post Pop Art, Michael Kohn Gallery, Los Angeles

Selected Bibliography

Cameron, Dan. "Pretty as a Product." *Arts Magazine* 60 (May 1986): 22–25.

Klein, Michael R. "Haim Steinbach: Concord Contemporary Art, New York." *Arts Magazine* 57 (September 1982): 7.

Nagy, Peter. "From Criticism to Complicity." *Flash Art* 129 (Summer 1986): 46–49.

Smith, Roberta. "Haim Steinbach at Cable." *Art in America* 75 (February 1986): 128.

Wallach, Alan P. "CAPS Sculptors: City Gallery, New York." *Arts Magazine* 58 (December 1983): 21.

● Pat Steir

1938
Born in Newark, New Jersey

1960
Receives B.A. from Boston University

1962
Receives B.F.A. from Pratt Institute, Brooklyn, New York

Lives in New York and Amsterdam

Selected Solo Exhibitions

1980
Max Protetch Gallery, New York

1983
Contemporary Arts Museum, Houston, and tour

1984
Brooklyn Museum; exh. cat., *Pat Steir: The Brueghel Series (A Vanitas of Style)*, by Charlotta Kotik

1985
University Art Museum, Berkeley, California

1986
Dallas Museum of Art

Kuhlenschmidt/Simon Gallery, Los Angeles

Selected Group Exhibitions

1983
Biennial Exhibition, Whitney Museum of American Art, New York; exh. cat.

Language, Drama, Source, and Vision, New Museum of Contemporary Art, New York

1984
Art of the Seventies, Whitney Museum of American Art and tour

Content: A Contemporary Focus, 1974–1984, Hirshhorn Museum and Sculpture Garden, Washington, D.C.; exh. cat., essays by Howard N. Fox, Miranda McClintic, and Phyllis Rosenzweig

1985
New Work on Paper, 3, Museum of Modern Art, New York

1986
Second Sight, San Francisco Museum of Modern Art Biennial; exh. cat., essay by Graham Beal

Selected Bibliography

Brenson, Michael. "Art: Pat Steir's Brueghel Series." *New York Times*, 14 December 1984.

——. "Critics' Choices: Art." *New York Times*, 21 April 1985.

Castle, Frederick Ted. "Pat Steir and the Science of the Admirable." *Artforum* 20 (May 1982): 47-55.

——. "Pat Steir: Ways of Marking." *Art in America* 72 (Summer 1984): 124–29.

Dickinson, Nancy. "Pat Steir: Vital Painting." *Rhode Island Review* (October 1981): 12.

Greenspan, Stuart. "Pat Steir: The Brueghel Series (A Vanitas of Style)." *Art & Auction* 7 (February 1985): 56–59.

Horstfield, Kate. "On Art and Artists: Pat Steir." *Profile* 1 (November 1981): 1–22.

Paine, Sylvia. "A Vanitas of Style." *Arts Magazine* 59 (April 1985): 11–13.

Ratcliff, Carter. *Pat Steir Paintings*. New York: Abrams, 1986.

Simon, Joan. "Expressionism Today: An Artists' Symposium: Pat Steir." *Art in America* 70 (December 1982): 74–75.

Woodville, Louisa. "Three Painters, Three Decades." *Arts Magazine* 59 (January 1985): 19.

● Mitchell Syrop

1953
Born in Yonkers, New York

1975
Receives B.F.A. from Pratt Institute, Brooklyn, New York

1978
Receives M.F.A. from California Institute of the Arts, Valencia

Lives in Los Angeles

Selected Solo Exhibitions

1984
Richard Kuhlenschmidt Gallery, Los Angeles

1985

West Beach Café, Venice, California

1986

Kuhlenschmidt/Simon Gallery, Los Angeles

Selected Group Exhibitions

1980

By Products, LACE (Los Angeles Contemporary Exhibitions)

1983

Group Show, Richard Kuhlenschmidt Gallery

Los Angeles/New York Exchange, Artists Space, New York

1984

Video: A Retrospective 1974–84, Long Beach Museum of Art, California

1986

TV Generations, LACE (Los Angeles Contemporary Exhibitions); exh. cat., essays by John Baldessari, Peter D'Agostino, John G. Hanhardt, and Bruce Yonemoto

Selected Bibliography

Knight, Christopher. "Mitchell Syrop's Art: Ads with a Graphic Twist." *Los Angeles Herald Examiner*, 2 May 1984.

———. "Darwin Meets Madison Avenue in Mitchell Syrop's 'A Plied Art.'" *Los Angeles Herald Examiner*, 2 November 1986.

Relyea, Lane. "Pick of the Week: Controlled Substance." *L.A. Weekly*, 22–28 March 1985.

Stodder, John and Natasha Stodder. "Thirty Seconds in Prime Time." *Artweek* 10 (10 November 1979): 13.

Syrop, Mitchell. "Demenstruation." *Journal* 5 (Spring 1985): 57–64.

● Mark Tansey

1949

Born in San Jose, California

1969

Receives B.F.A. from Art Center College of Design, Pasadena, California

1974

Attends summer session, Institute in Arts Administration, Harvard University, Cambridge, Massachusetts

1975–78

Graduate studies in painting at Hunter College, New York

Lives in New York

Selected Solo Exhibitions

1982

Grace Borgenicht Gallery, New York

1984

John Berggruen Gallery, San Francisco

1984–85

Contemporary Arts Museum, Houston

1986

Curt Marcus Gallery, New York

Selected Group Exhibitions

1981

Not Just for Laughs, New Museum for Contemporary Art, New York; exh. cat., essay by Marcia Tucker

1982

Painting and Sculpture Today 1982, Indianapolis Museum of Art

1983

Biennial Exhibition, Whitney Museum of American Art, New York; exh. cat.

Inaugural Exhibition, New Museum for Contemporary Art

1984

Automobile and Culture, Museum of Contemporary Art, Los Angeles, and tour; exh. cat.

An International Survey of Recent Painting and Sculpture, Museum of Modern Art, New York; exh. cat.

1985

Figure in 20th Century American Art, Metropolitan Museum of Art, New York

1986

Second Sight, San Francisco Museum of Modern Art Biennial; exh. cat., essay by Graham Beal

Selected Bibliography

Armstrong, Richard. "Mark Tansey: Grace Borgenicht Gallery." *Artforum* 21 (February 1983): 75–76.

Cameron, Dan. "Report from the Front." *Arts Magazine* 60 (Summer 1986): 86–93.

Cone, Michele. "Mark Tansey: Curt Marcus." *Flash Art* 129 (Summer 1986): 69.

Friedman, Jon R. "Mark Tansey." *Arts Magazine* 57 (January 1983): 10.

Indiana, Gary. "Apotheosis of the Non-moment." *Village Voice*, 6 May 1986.

Linker, Kate. "Multiple Choice." *Artforum* 22 (September 1983): 77.

Martin, Richard. " 'Rust Is What Our Metal Substitutes For Tears': The New Paintings of Mark Tansey." *Arts Magazine* 60 (April 1986): 18–19.

Owens, Craig. "Mark Tansey: Grace Borgenicht Gallery." *Art in America* 71 (February 1983): 137–38.

Phillips, Deborah C. "Mark Tansey: Grace Borgenicht Gallery." *Art News* 82 (February 1983): 144.

Russell, John. "Mark Tansey: Curt Marcus Gallery." *New York Times*, 2 May 1986.

● Masami Teraoka

1936

Born in Onomichi, Japan

1959

Receives B.A. from Kwansei Gwakuin University, Kobe

Lives in Honolulu and Los Angeles

Selected Solo Exhibitions

1979

Whitney Museum of American Art, New York

1980

Downtown Center, Fine Arts Museum of San Francisco

Honolulu Academy of Arts

Newport Harbor Art Museum, Newport Beach, California

1981

Zolla/Lieberman Gallery, Chicago

1983

Jacksonville Art Museum

Japanese American Community and Cultural Center, Los Angeles

Oakland Museum, California

1985

Santa Barbara Contemporary Arts Forum, California

Space Gallery, Los Angeles

1986

Space Gallery

Selected Group Exhibitions

1983

Corcoran Biennial of American Painting and Second Western States Exhibitions, Corcoran Gallery, Washington, D.C., and tour

1986

Sydney Biennale, Art Gallery of New South Wales

Tokyo: Form and Spirit, Walker Art Center, Minneapolis, and tour; exh. cat.

Selected Bibliography

Dellabough, Robin. "Modern Life Invading Art/Masami Teraoka." *Museum of California* 7 (July/August 1983): 12–14.

Fleming, Lee. "The Corcoran Biennial/Second Western States Exhibition." *Art News* 82 (May 1983): 127–28.

Gabrielson, Walter. "Westward Ha!" *Art in America* 70 (January 1982): 108–10.

Glueck, Grace. "Two Biennials: One Looking East and the Other West." *New York Times*, 27 March 1983.

———. "Childe Hassam's Legacy Continues to Flower." *New York Times*, 27 November 1983.

Lifton, Sarah. "Making Waves with Culture Clash." *Los Angeles Reader*, 15 February 1985.

McKenna, Kristine. " 'East/West': A Collison of Cultures." *Los Angeles Times*, 27 March 1986.

Muchnic, Suzanne. "Teraoka and the Art of Culture Shock." *Los Angeles Times*, 12 January 1985.

Woodward, Josef. "Cross-Cultural Erotica." *Artweek* 16 (23 February 1985): 7.

Wortz, Melinda. "Trompe L'Audience." *Art News* 79 (February 1980): 183–87.

Yim, Susan. "20th Century Floating World." *Honolulu Star Bulletin*, 5 February 1984.

● Imants Tillers

1950
Born in Sydney

1972
Receives B.S. from University of Sydney

Lives in Sydney

Selected Solo Exhibitions

1983
Yuill/Crowley, Sydney

1984
Bess Cutler Gallery, New York

1985
Bess Cutler Gallery

Selected Group Exhibitions

1982
Documenta 7, Kassel, West Germany

Eureka! Artists from Australia, Serpentine Gallery, London

1984
Accents/Expressions, Corcoran Gallery of Art, Washington, D.C.

An Australian Accent: Three Artists, Institute for Art and Urban Resources, P.S. 1, Long Island City, New York, and tour

Selected Bibliography

Cone, Michele. "Imants Tillers at Bess Cutler." *Flash Art* 125 (December 1985–January 1986): 45.

Heartney, Eleanor. "Imants Tillers: Bess Cutler." *Art News* 85 (January 1986): 130.

Kuspit, Donald B. "Imants Tillers at Bess Cutler." *Art in America* 73 (March 1985): 158.

Levin, Kim. "Upstarts from Down Under." *Village Voice*, 5 October 1984.

Linker, Kate. "Imants Tillers." *Artforum* 23 (December 1984): 89–90.

McEvilley, Thomas. "On the Manner of Addressing Clouds." *Artforum* 22 (Summer 1984): 61.

———. "An Australian Accent." *Artforum* 23 (October 1984): 85.

Rooney, Robert. "Tall Poppies." *Flash Art* 114 (November 1983): 74.

Sofer, Ken. "Views from Down Under." *Art News* 83 (December 1984): 157.

● Venturi, Rauch and Scott Brown

Live in Philadelphia

Robert Venturi

1925
Born in Philadelphia

1947
Receives B.A. from Princeton University, New Jersey

1950
Receives M.F.A. from Princeton University

1954–56
Receives Rome Prize Fellowship, American Academy in Rome

John Rauch

1930
Born in Philadelphia

1951
Attends Wesleyan University, Middletown, Connecticut

1957
Receives B.Arch. from University of Pennsylvania, Philadelphia

Denise Scott Brown

1931
Born in Nkana, Zambia

1955
Receives diploma from Architectural Association, London

1960
Receives M.C.P. from University of Pennsylvania

1965
Receives M.Arch. from University of Pennsylvania

Selected Projects

1966
Fire Station No. 4, Columbus, Indiana

1967
Football Hall of Fame, New Brunswick, New Jersey

1967–72
Dixwell Fire Station, New Haven, Connecticut

1975
Brant-Johnson House, Vail, Colorado

1979
Museum of Decorative Arts, Frankfurt, West Germany

1981
Gordon Wu Hall, Butler College, Princeton University

1986
Extension to National Gallery, London (commission awarded)

Selected Group Exhibitions

1984–86
Venturi, Rauch and Scott Brown: A Generation of Architecture, Krannert Art Museum, University of Illinois, Champaign-Urbana; exh. cat. by Rosemarie Haag Bletter

Selected Bibliography

Filler, Martin. "Learning from Venturi." *Art in America* 68 (April 1980): 95–101.

Masheck, Joseph. "Judy Rifka and 'Postmodernism' in Architecture." *Art in America* 72 (December 1984): 148–63.

Phillips, Patricia C. "Robert Venturi." *Artforum* 23 (November 1984): 97–98.

Venturi, Robert. *Complexity and Contradiction in Architecture*. New York: Museum of Modern Art, 1966.

———, et al. *Learning from Las Vegas*. Rev. ed. Cambridge, Mass.: MIT Press, 1977.

———, and Denise Scott Brown. *A View from the Campidoglio*. Edited by Peter Arnell, Ted Bickford, and Catherine Bergart. New York: Harper and Row, 1984.

● Bill Viola

1951
Born in New York

1973
Receives B.F.A. from Syracuse University, New York

Lives in Long Beach, California

Selected Solo Exhibitions

1980
Long Beach Museum of Art

1982
Whitney Museum of American Art, New York

1983
ARC, Musée d'Art Moderne de la Ville de Paris

1985
San Francisco Museum of Modern Art

Selected Group Exhibitions

1980
Projects, Museum of Modern Art, New York

1981
Biennial Exhibition, Whitney Museum of American Art; exh. cat.

1982
Sydney Biennale, Art Gallery of New South Wales

1983
Biennial Exhibition, Whitney Museum of American Art; exh. cat.

1984
The Luminous Image, Stedelijk Van Abbemuseum, Eindhoven, Netherlands

Video: A Retrospective, Long Beach Museum of Art 1974–1984, Long Beach Museum of Art; exh. cat., essay by Bill Viola

1985
Biennial Exhibition, Whitney Museum of American Art; exh. cat.

Summer 1985, Museum of Contemporary Art, Los Angeles

Selected Bibliography

Hoberman, J. "Video: The Arts." *Omni* 5 (May 1983): 32, 147.

Sturken, Marita. "Temporal Interventions: The Videotapes of Bill Viola." *Afterimage* 10 (Summer 1982): 28–31.

Viola, Bill. "Will There Be Condominiums in Data Space?" *Video 80* (Fall 1982): 36–41.

———. "Sight Unseen: Enlightened Squirrels and Fatal Experiments." *Video 80* (Spring 1982): 31–33.

● Julie Wachtel

1956
Born in Ossining, New York

1977
Receives B.A. from Middlebury College, Vermont

1978
Attends School of Visual Arts, New York

Lives in New York

Selected Solo Exhibitions

1981
Fashion Moda, New York

1984
Gallery Nature Morte, New York

1985
Diane Brown Gallery, New York

Gallery Nature Morte

Selected Group Exhibitions

1982
Fifth Anniversary Exhibition, Drawing Center, New York

1984
Emblem, LACE (Los Angeles Contemporary Exhibitions)

Neo York: Report on a Phenomenon, University Art Museum, University of California, Santa Barbara

Timeline, Group Material, Institute for Art and Urban Resources, P.S. 1, Long Island City, New York

1985
Infotainment (18 Artists from New York), Gallery Nature Morte and tour; exh. cat., essays by Thomas Lawson and George W. S. Trow

Selected Bibliography

Lichtenstein, Therese. "Julie Wachtel: Nature Morte."
Arts Magazine 59 (September 1984): 44.

Mahoney, Robert. "Julie Wachtel: Diane Brown." *Arts Magazine* 60 (February 1986): 127.

Sturtevant, Alfred. "Group Show: Metro Pictures." *Arts Magazine* 60 (April 1986): 128.

● Yuriko Yamaguchi

1948
Born in Osaka

1975
Receives B.A. from University of California, Berkeley

1975–76
Attends Princeton University, New Jersey

1979
Receives M.F.A. from University of Maryland, College Park

Lives in Falls Church, Virginia

Selected Solo Exhibitions

1981
Foundry Gallery, Washington, D.C.

1982
Gallery 10, Washington, D.C.

1984
Washington Project for the Arts, Washington, D.C.

Selected Group Exhibitions

1983
Options '83, Washington's Emerging Artists, Washington Project for the Arts

1984
Content: A Contemporary Focus, 1974–1984, Hirshhorn Museum and Sculpture Garden, Washington, D.C.; exh. cat., essays by Howard N. Fox, Miranda McClintic, and Phyllis Rosenzweig

1985
Washington Show, Corcoran Gallery of Art, Washington, D.C.

Selected Bibliography

Fleming, Lee. "Yuriko Yamaguchi: Both Physical and Spiritual." *Washingtonian* 20 (November 1984): 70.

Smith, Linda Thern. "An Interview with Washington Sculptor Yuriko Yamaguchi." *Washington Review* 10 (April/May 1985): 85.

Smith, Roberta. "Endless Meaning at the Hirshhorn." *Artforum* 23 (April 1985): 83.

Private Lenders

Thomas Ammann, Zurich
Laurie Anderson, New York
Siah Armajani, Minneapolis
John Baldessari, Santa Monica, California
Gretchen Bender, New York
Jonathan A. Berg, New York
Mike Bidlo, New York
Ruth and Jake Bloom, Marina del Rey, California
Ricardo Bofill, Barcelona
Jonathan Borofsky, Venice, California
Norman and Irma Braman, Miami
Eli and Edythe L. Broad, Los Angeles
Suzanne Caporael, Los Angeles
Nan and Gene Corman, Beverly Hills
Stefano di Stasio, Rome
Brad Durham, Los Angeles
Gerald S. Elliott Collection, Chicago
Vernon Fisher, Fort Worth
Elizabeth Freeman, Santa Monica, California
Arthur and Carol Goldberg
Janet Green, London
Robert H. Halff, Beverly Hills
Elliott and Adrienne Horwitch, Beverly Hills
Jim Isermann, Santa Monica, California
Robert and Nancy Kaye, New York
Mike Kelley, Los Angeles
Scott H. Lang, Chicago
Mark Lere, Los Angeles
David Levinthal, New York
Roberta and Richard Lieberman, Chicago
Gilbert Lujan, Santa Monica, California
Harry and Linda Macklowe, New York
Steve Martin
Stephen McKenna, Brussels and London
Joan Simon Menkes
Byron Meyer, San Francisco
Kurt and Rosalie Meyer, Los Angeles
Jeanne Meyers, Los Angeles
Mr. and Mrs. Earl Millard, Belleville, Illinois

Michael A. Morris
Josef Felix Müller, Saint Gall, Switzerland
Matt Mullican, New York
Dr. Aaron and Ann Nisenson, Santa Barbara, California
Clayton M. Press, Jr., Los Angeles
William Raaum, Minneapolis
Mr. and Mrs. Stewart Resnick, Beverly Hills and Newtown Square, Pennsylvania
Mr. Fredrik Roos, London
Michael H. Schwartz, New York
Ilene Segalove, Venice, California
Boake and Marian Sells, Wayzata, Minnesota
Rafael Serrano, Los Angeles
Peter Shelton, Los Angeles
Don C. Sherwood, Los Angeles
Robert Harshorn Shimshak, Berkeley, California
Maxine and Jerry Silberman, Chicago
Alexis Smith, Venice, California
Lisa Spellman, New York
Speyer Family Collection, New York
Emily and Jerry Spiegel
Pat Steir, New York and Amsterdam
Marc and Livia Straus, Chappaqua, New York
Chip and Laurie Tom, Chicago
Daniel Weinberg, Los Angeles
Mr. and Mrs. Walter L. Weisman, Woodland Hills, California
Anonymous lender

Institutional Lenders

Allen Memorial Art Museum, Oberlin College, Ohio
The Art Institute of Chicago
AT&T, New York
The Edward R. Broida Trust, Los Angeles
Electronic Arts Intermix, New York
The Eli Broad Family Foundation, Los Angeles
Estate of Ana Mendieta
Federal Reserve Bank of San Francisco, Los Angeles Branch
First Banks Collection of Contemporary Art, Minneapolis/St. Paul
The Kitchen Center for Video, Music, Dance, Performance, and Film, New York
Los Angeles County Museum of Art
Morat-Institut, Freiburg im Breisgau, West Germany
Museum of Contemporary Art, Chicago
PaineWebber Group Inc. Collection, New York
The Prudential Insurance Company of America
San Francisco Museum of Modern Art
Whitney Museum of American Art, New York

Galleries

Barbara Gladstone Gallery, New York
Carl Solway Gallery, Cincinnati
Charles Cowles Gallery, New York
Curt Marcus Gallery, New York
DiLaurenti Gallery, New York
Edward Totah Gallery, London
Flow Ace Gallery, Los Angeles
Galerie Michael Werner, Cologne
Galerie Paul Maenz, Cologne
Galerie Ulysses, Vienna
Gallery Nature Morte, New York
Jan Turner Gallery, Los Angeles
John C. Stoller & Company, Minneapolis
Krygier/Landau Contemporary Art,
 Los Angeles
Kuhlenschmidt/Simon Gallery, Los Angeles
L.A. Louver Gallery, Venice, California
Larry Gagosian Gallery, Los Angeles
Leo Castelli Gallery, New York
Margo Leavin Gallery, Los Angeles
Marian Goodman Gallery, New York
Martina Hamilton Gallery, New York
Marvin Heiferman, Photographs, New York
Mary Boone/Michael Werner Gallery,
 New York
Max Protetch Gallery, New York
Metro Pictures, New York
Michael Klein, Inc., New York
New Strategies, Los Angeles
R Collection/Bobbie Greenfield,
 Los Angeles
Raab Galerie, West Berlin
Ronald Feldman Fine Arts, New York
Rosamund Felsen Gallery, Los Angeles
Salvatore Ala Gallery, Milan/New York
Sonnabend Gallery, New York
Space Gallery, Los Angeles
303 Gallery, New York
Zolla/Lieberman Gallery, Chicago

Cat. nos.

52	Magdalena Abakanowicz	46–47	Douglas Huebler	89	Thomas Schindler
75–76	Marina Abramović and Ulay	73	Jörg Immendorff	57–58	Rafael Serrano
88	Jean-Michel Alberola	66	Jim Isermann and Ilene Segalove	111	Peter Shelton
90	Hermann Albert	53	Neil Jenney	102–3	Cindy Sherman
59	Terry Allen	78	Philip Johnson	48	Alexis Smith
40–42	Laurie Anderson	45	Mike Kelley	98	T. L. Solien
62	Siah Armajani	130	Anselm Kiefer	12	Haim Steinbach
128	Alice Aycock	101	Komar and Melamid	1	Pat Steir
39	John Baldessari	13	Jeff Koons	36–38	Mitchell Syrop
117	Roberto Barni	80	Jannis Kounellis	23	Mark Tansey
74	Jean-Michel Basquiat	50	Barbara Kruger	67–71	Masami Teraoka
29	Gretchen Bender	14	Justen Ladda	2	Imants Tillers
4	Mike Bidlo	125	Christopher Le Brun	61	Venturi, Rauch and Scott Brown
77	Ricardo Bofill	109	Mark Lere	104	Bill Viola
121	Erwin Bohatsch	7	Sherrie Levine	27	Julie Wachtel
97	Jonathan Borofsky	18–19	David Levinthal	108	Yuriko Yamaguchi
26	Troy Brauntuch	60	Maya Ying Lin		
92	Steven Campbell	124	Robert Longo		
93	Suzanne Caporael	72	Gilbert Lujan		
91	Peter Chevalier	118	Markus Lüpertz		
20	Michael Clegg and Martin Guttmann	30–31	John Maggiotto		
		15–17	Frank Majore		
95	Francesco Clemente	83	Carlo Maria Mariani		
119	Chema Cobo	10	Allan McCollum		
56	Sue Coe	86	Stephen McKenna		
126	Enzo Cucchi	106	Ana Mendieta		
28	Ronnie Cutrone	79	Charles Moore		
21–22	Walter Dahn	115	Jim Morphesis		
8	David Diao	123	Robert Morris		
84	Stefano di Stasio	107	Josef Felix Müller		
116	Jiři Georg Dokoupil	129	Matt Mullican		
96	Peter Drake	51	Bruce Nauman		
112	Brad Durham	85	Odd Nerdrum		
94	Eric Fischl	43	Sabina Ott		
44	Vernon Fisher	63–65	Nam June Paik		
32–35	Stephen Frailey	127	Mimmo Paladino		
113	John Frame	81	Giulio Paolini		
87	Gérard Garouste	82	Anne and Patrick Poirier		
11	Robert Gober	24	Sigmar Polke		
55	Leon Golub	120	William Raaum		
110	Antony Gormley	122	Arnulf Rainer		
54	Hans Haacke	100	Roland Reiss		
9	Peter Halley	5–6	Gerhard Richter		
99	Keith Haring	114	Scott Richter		
3	Roger Herman	105	Susan Rothenberg		
49	Jenny Holzer	25	David Salle		

All photographs are reproduced courtesy of the works' owners. In addition the following credits are specified for the indicated artists.

Adam Avila, Los Angeles: *Lujan*

Courtesy Barbara Gladstone Gallery, New York: *Fisher*

Ben Blackwell Photography, Oakland, California: *Albert, Le Brun, Mariani, Nerdrum*

Peter Brenner: *Allen, Morris, Paladino*

Mimmo Capone, Rome: *Mendieta*

Geoffrey Clements, New York: *Holzer*

Jeff Conley: *Frailey, Levine, Maggiotto, McCollum, Morphesis, Serrano, Syrop, Teraoka*

Anthony Cuñha: *Isermann*

D. James Dee, New York: *Komar and Melamid, G. Richter (cat. no. 5), Tillers*

Douglas M. Parker Studio, Los Angeles: *Baldessari, Caporael, Gober, Lere, Rothenberg*

Glenn Steigelman Inc., Photography, New York: *Garouste*

Timothy Hursley, Little Rock, Arkansas: *Johnson*

Courtesy International with Monument Gallery, New York: *Halley, Koons*

Alan Karchmer: *Moore*

Christopher Lark: *Lin*

David Lubarsky, New York: *Steinbach*

Courtesy Michael Klein, Inc., New York: *Mullican*

William Nettles: *Shelton*

Courtesy Öffentliche Kunstsammlung Basel Hausaufnahme: *Müller*

Steve Oliver: *Huebler*

Pelka/Noble Photography, New York: *Drake*

Kira Perov: *Abramović and Ulay, Viola*

Eric Pollitzer, New York: *Jenney*

Ivan Dalla Tana: *Haring*

Michael Tropea, Highland Park, Illinois: *Schindler, Yamaguchi*

John Webb: *McKenna*

Nell Ytsma, Minneapolis: *Ladda*

Dorothy Zeidman: *Nauman*

Zindman/Fremont, New York: *Campbell, Kounellis, Polke*

Edited by Edward Weisberger
Designed by Kiran RajBhandary

Text set by Continental Typographics, Chatsworth, California, in Linotype Walbaum, designed by Günter Gerhard Lang in 1976, based upon the original design by J. E. Walbaum in 1800. Type set by Andresen Typographics, Los Angeles: display type and headlines in various Futura typefaces, designed by Paul Renner in 1930; and folios in Univers 49, designed by Adrian Frutiger in 1957.

Printed on 100 lb. Mountie Matte by Typecraft, Inc., Pasadena, California.